W9-DIM-950

F.V.

WITHDRAWN

St. Louis Community College

Forest Park
Florissant Valley
Meramec

Instructional Resources
St. Louis, Missouri

Art in the Age of Queen Victoria

Treasures from the Royal Academy of Arts
Permanent Collection

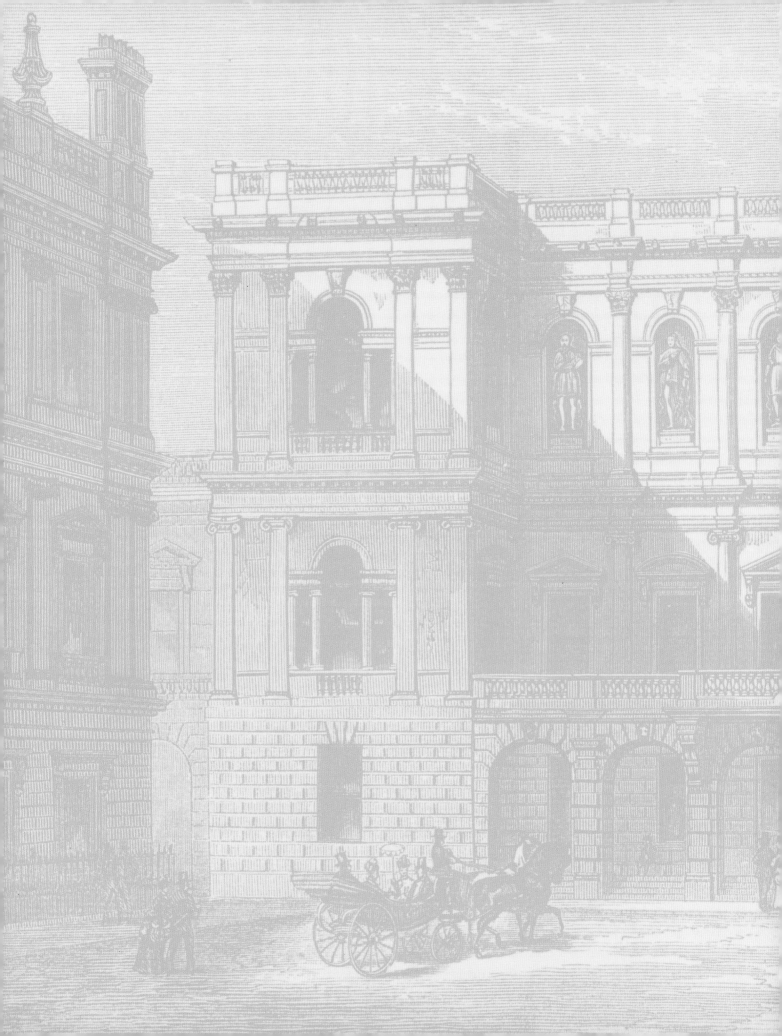

Art in the Age of Queen Victoria

Treasures from the Royal Academy of Arts Permanent Collection

Edited by Helen Valentine

Royal Academy of Arts, London
in association with Yale University Press
New Haven and London

This exhibition has been organised by the Royal Academy of Arts, London and toured with the assistance of the Denver Art Museum.

15 May–15 August 1999	Denver Art Museum, Denver, Colorado
17 September 1999–2 January 2000	Frye Art Gallery, Seattle, Washington
15 January –12 March 2000	Norton Museum, West Palm Beach, Florida
6 April –4 June 2000	National Academy Museum, New York City
14 July –24 September 2000	Cincinnati Art Museum, Cincinnati, Ohio

The exhibition has received financial support from the American Associates of the Royal Academy Trust and the Benjamin West Group. Additional support has come from individual donors.

The exhibition was granted an indemnity by the United States Federal Council on the Arts and the Humanities.

Royal Academy Organisation
The Exhibition:
Curators: MaryAnne Stevens, Helen Valentine with Malcolm Warner (Yale Center for British Art, New Haven)
Registrar: Freda Matassa
Photographic co-ordinator: Patricia Eaton

Library of Congress Catalog Card Number: 99-61349

ISBN: 0-300-07997-4

Designed by Joanne Barker
Colour origination by Precise Litho
Printed in Italy

Front jacket:
John William Waterhouse
A Mermaid (detail, cat. 34)

Back jacket:
Sir Lawrence Alma-Tadema
A Family Group (detail, cat. 58)

Jacket flap:
Charles West Cope
The Night Alarm: The Advance (detail, cat. 59)

Frontispiece:
'Burlington House as altered for the Royal Academy, 1869'
wood engraving
from unidentified illustrated magazine
Royal Academy of Arts

p. 8
Edward John Gregory
'Après?' (detail, cat. 30)

p. 10–11
William Powell Frith
The Sleeping Model (detail, cat. 48)

Contents

Acknowledgements

The conception and realisation of the exhibition, *Art in The Age of Queen Victoria*, and the catalogue, have benefited from the advice and assistance of many people. MaryAnne Stevens and Helen Valentine wish to thank all those who have in so many ways made it possible for the exhibition to be seen in several distinguished art galleries and museums in the United States of America and for the catalogue to be produced.

Dr Malcolm Warner, Curator at the Yale Center for British Art, New Haven shared his knowledge of Victorian art in the initial stages of the selection. The exhibition was impeccably organised by Freda Matassa, Registrar to the Permanent Collection. Painting conservation was undertaken by Isabel Horovitz, Amanda Paulley, Jennifer Richenberg, Carol Willoughby, Andi Gall, Elisabeth Reissner, with additional work by Helen Glanville and by students of the Courtauld Institute of Art, London. The frame conservator was Annie Ablett with technical assistance from Mark Finnamore, Christina Mulvihill and Sara Stoll. Sculpture was conserved by Jehannine Mauduech. Technical research into several paintings was carried out by Helen Glanville, with analysis undertaken by Catherine Hassall and Libby Sheldon at University College London Painting Analysis Ltd., and technical photography by Dr Nicholas Eastaugh.

All the works were rephotographed after conservation; this operation was expertly organised by Patricia Eaton, Curator of Photographs at the Royal Academy of Arts, who also undertook extensive research into, and retrieval of, contemporary photographs of Royal Academicians to accompany the biographies in the catalogue.

The preparation of the catalogue has involved the staff of the Royal Academy's Library and Archive, including Nicholas Savage and Andrew Potter. Rebecca Virag, a graduate student at the Courtauld Institute of Art, London, researched and produced the artists' biographies.

The catalogue was produced by the Royal Academy Publications Department and we would like to thank Catherine Max, Publications Manager and Sophie Lawrence, Production Editor who worked so enthusiastically on this project. We would also like to thank the designer Joanne Barker and the copy-editor, Clare Orchard.

The organisation of the exhibition tour has relied heavily upon the early participation of the Denver Museum of Art. In particular, we would like to thank Lewis Sharp, Director, Carolyn L. Campbell, Exhibition Director and Lori Iliff, Registrar for their ongoing advice and support as well as for securing an indemnity from the Federal Council on the Arts and the Humanities. The other four institutions at which the exhibition will be shown have also made significant contributions to the enterprise. We extend our thanks to Richard West, Director at the Frye Art Museum, Seattle, to David Setford, Senior Curator at the Norton Museum of Art, West Palm Beach, to Dr Annette Blaugrund, Director at the National Academy Museum, New York, and to Dr John Wilson, Curator of European Art, at the Cincinnati Art Museum.

Benefactors

The Royal Academy of Arts acknowledges the generous support of The American Associates of the Royal Academy Trust and their Hugh and Margaret Casson Fund, for enabling this exhibition to travel to the United States:

Benefactors

Mrs Katherine K Lawrence
The Starr Foundation

The Hon and Mrs Walter H Annenberg
Mrs Vincent Astor
Mr and Mrs Stephen D Bechtel Jr
Mrs Thomas S Brush
Mr and Mrs Douglass Campbell
Ms Anne S Davidson
Mr William M Dietel
Mr Walter Fitch III
Mr and Mrs Christopher Forbes
Professor and Mrs Dale L Gibbs FAIA
Mrs Roswell L Gilpatric
Mrs Elizabeth Goldsmith
Miss Geraldine L Gore
Mrs Judith Heath
Mrs Henry J Heinz II
Mr C Hugh Hildesley
Mr William W Karatz
Mr Leon Levy and Ms Shelby White
Mr and Mrs Robert Magowan
Sir Edwin and Lady Manton
Mr Peter Matthews
Mrs Eugene McDermott
Mrs Julian F McGowin
Mrs John P McGrath
Mrs Paul Mellon
Ms Barbara T Missett
Mrs William Otterson
Ms Beatrice E Rangel
Mr and Mrs Arthur Ross
Mr and Mrs Edmond J Safra
Ms Kathleen D Smith
Mr and Mrs A Alfred Taubman
Mrs Susan E Van de Bovenkamp
Mrs William W Wood Prince

The Royal Academy also expresses its gratitude to the Benjamin West Group which was founded in March 1998 for Americans living temporarily or permanently in Britain. The group takes its name from Benjamin West, a founder Member of the Royal Academy and the first American artist to become an Academician who also served as President, from 1790 to 1805 and from 1806 to his death in 1820. In particular, the Academy would like to acknowledge the following members of the group who have generously contributed donations of £1,000 or more towards the conservation of works of art in this exhibition:

Mrs Wendy Becker Payton
Mr and Mrs William Berger
Mr and Mrs Paul Collins
Mr and Mrs John Gore
Mrs Robin Hambro
Lady Harvie-Watt
Mr and Mrs Peter Holstein
Mr and Mrs Donald Moore
Sir William and Lady Purves
Mrs Robert Rose
Mrs Sylvia Scheuer
Mr and Mrs Paul Shang
Mr and Mrs Mitchell Shivers
Barbara and Allen Thomas

The Academy also wishes to thank other organisations and individuals who have generously invested in the conservation of these paintings, in particular the Joseph Strong Frazer Charitable Trust, Mr and Mrs Martin Beisley, Pamela Littman, and all members of the Docent Programme at the Royal Academy.

President's Foreword

The Government Commission appointed in 1863 to review the position of the Royal Academy of Arts as the national representative body of artists and educator in the visual and plastic arts noted that the institution was 'of great service to the country, in assisting to keep up and to cultivate a taste for Art'. Ever since its foundation in 1768 under direct royal patronage, the Royal Academy of Arts had been a self-governing body of artists which provided professional training for painters, sculptors and architects, held Annual Exhibitions of works by living artists and represented the interests of the artistic community on a national level. Shortly after the Commission's pronouncement of 1863, the institution acquired a further role, that of mounting Annual Loan Exhibitions of works by Old Masters. Throughout the 19th century, despite the vagaries of taste and the emergence of rival organisations, the Royal Academy held a central position as a national institution in receipt of no State funding. It both commanded respect and inevitably provoked controversy and criticism.

This exhibition maps the history of this remarkable institution during the reign of Queen Victoria. It charts the role of its democratically elected presidents, from Martin Archer Shee and Charles Lock Eastlake to Frederic Leighton and John Everett Millais. It reflects the changing character of its elected Membership over this period, from genre painters such as William Powell Frith and Richard Redgrave to Members such as Lawrence Alma-Tadema and Edward Poynter whose work subordinated subject to formal considerations. It also records the fact that, while the first generation of Pre-Raphelite artists such as D. G. Rossetti, William Holman Hunt and Ford Madox Brown never wavered in their antipathy to the institution, a younger generation of their followers, such as J. W. Waterhouse and Frank Cadogan Cowper, were elected Royal Academicians and thus gave the style official, institutional status. These themes are most readily recorded in the Diploma Works which form the majority of the exhibition's contents. Since the foundation of the institution, each artist was required to deposit a work fully framed (where appropriate) with the Royal Academy on election to the status of Royal Academician. In addition to such Diploma Works, the exhibition also includes some works given by Members which expand our understanding of the Royal Academy's aspirations and achievements during the period.

This exhibition is part of a programme to highlight selected phases in the history of the Royal Academy since 1768. Previous exhibitions include *Paintings from the Royal Academy: Two Centuries of British Art*, which toured the United States in 1982, and *The Edwardians and After: The Royal Academy 1900–1950*, which was shown in four venues around the United States between 1988 and 1990. *Art in the Age of Queen Victoria* will be presented in five American cities. We are most grateful to Richard West of the Frye Art Museum, Seattle, David Setford of the Norton Museum of Art, West Palm Beach, Dr Annette Blaugrund of the National Academy Museum, New York and Dr John Wilson of the Cincinnati Art Museum for their commitment to and support of the project. We extend special thanks to Lewis Sharp and his staff at the Denver Art Museum who have organised US Federal Indemnity and are overseeing the tour. At the Royal Academy, the exhibition was selected by MaryAnne Stevens and Helen Valentine in consultation with Dr Malcolm Warner. It has been organised by Freda Matassa, and the photographic programme has been undertaken by Patricia Eaton. Preparation for this exhibition has involved an exhaustive conservation programme of the sculptures, paintings and frames. This could not have been achieved without invaluable financial support from the American Associates of the Royal Academy Trust and the Royal Academy's Benjamin West Group. We would wish to register our sincere thanks to the members of these groups of devoted supporters.

With the welcome revival of interest in Victorian art, we trust that this exhibition celebrating the Membership and achievements of the era's pre-eminent artistic institution will bring pleasure and enlightenment to its visitors across the North American continent.

Sir Philip Dowson CBE
President, Royal Academy of Arts

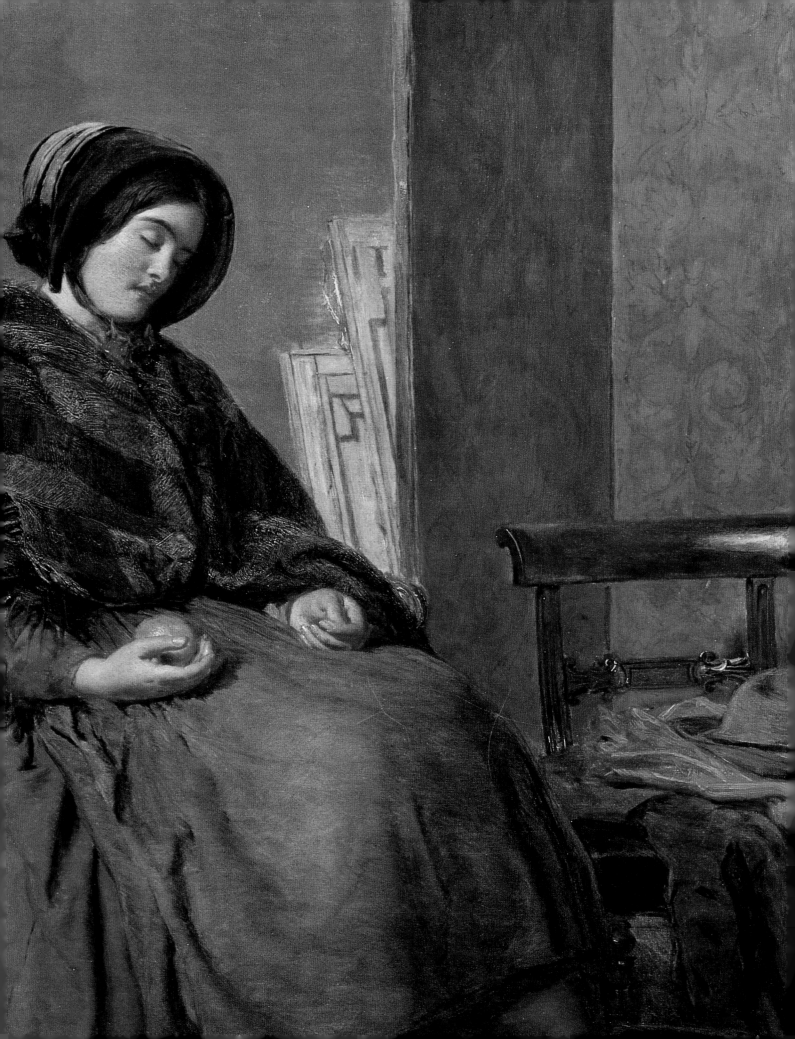

ESSAYS

A BRIEF SURVEY OF VICTORIAN PAINTING

Julian Treuherz

The Victorian age was one of national self-confidence and stability. There was peace at home, towns and cities mushroomed as industry expanded, the population rose, education and literacy increased and the middle class grew in number, influence and wealth. All this provided the social and economic conditions for art to prosper.[1]

Queen Victoria ruled for 64 years, longer than any British monarch before or since. During her reign several generations of painters produced work of immense variety: the term 'Victorian' denotes a period not a style, for Victorian painting comprises many different styles. When the Queen came to the throne, artists of the Romantic Movement such as David Cox and J. M. W. Turner were still at the height of their powers; the closing decades of the period saw the emergence of younger artists who were to contribute to the 20th-century British avant-garde. In between came successive groups of painters, some copying outward appearance, others painting imaginary inner worlds, some painters inspired by everyday life, yet others by history or classical mythology, some working in detailed, realistic styles, others more decorative or atmospheric.

This exhibition cannot be entirely representative of all aspects of Victorian painting, as it is drawn from the Royal Academy's Diploma Collection, consisting only of works given to the institution by its Members. The Academy was the focal point of the Victorian art world, but it discouraged innovation, and the most advanced artists never became Members. This essay seeks to put these works into the broader picture of Victorian painting by describing the main trends of the period, with a special emphasis on the movements not represented in the Diploma collection. Though the essay concentrates on painting, the development of architecture, sculpture and the decorative arts was equally fertile. There was some crossover between the different art forms, with certain painters working as sculptors or designing stained glass, furniture and textiles, and occasionally painters, sculptors, architects and decorative artists collaborated to create buildings where all the arts came together on equal terms, an ideal promoted by the critic John Ruskin, by architects of the Gothic Revival, and by the designer William Morris.

The single most important factor in the development of Victorian art was a change in the pattern of patronage, leading to the emergence of a new and enlarged market for painting.[2] This change had its origins in the Industrial Revolution of the late 18th century, which created a new class of

1 For fuller accounts of Victorian painting see Julian Treuherz, *Victorian Painting*, London, 1993, and Malcolm Warner, *The Victorians. British Painting 1837–1901*, exhibition catalogue, National Gallery of Art, Washington, 1997.
2 Dianne Sachko Macleod, *Art and the Victorian Middle Class: Money and the Making of Cultural Identity*, Cambridge, 1996; see also Edward Morris, 'John Naylor and other Collectors of Modern Paintings in Nineteenth Century Britain', *Walker Art Gallery Annual Report and Bulletin*, vol. V, Liverpool, 1974–5.

wealthy middle-class merchants and manufacturers. In the 18th century, the aristocracy had taken the leading role in picture collecting, buying Old Masters while travelling in Europe on the grand tour; in contrast, the new Victorian patrons bought the work of living British artists. The middle-class collectors also had a taste for recognisable subject matter rather than obscure allegory, and bought narrative paintings and scenes of everyday life in large numbers, especially in the first decades of the reign. A good example is the Yorkshire wool manufacturer John Sheepshanks, whose collection is now in the Victoria and Albert Museum, London (fig. 1).[3] The taste for realism and narrative lasted throughout the age, though alongside it there later grew up a more sophisticated and poetical art of suggestion and decorative effect, collected by a select group of aesthetes. These, however, were for the most part, like the early Victorian collectors, businessmen, drawn from the new late Victorian plutocracy of financiers, shipping magnates and entrepreneurs.

The Victorian age saw a broadening of subject matter available to the painter. In the 18th century there was a strong market for portraits and, to a lesser extent, landscapes and sporting scenes, especially showing horses, but theorists felt that such subjects were intellectually inferior to 'history painting', imposing scenes of mythical or heroic events painted in a generalised and monumental style modelled on the grand manner of Old Masters such as Raphael, Titian and Rubens. 'Genre' painting (scenes of daily life) was held to be inferior as it was concerned with the mundane and the particular.[4] Early Victorian critics inherited the prejudice against scenes of everyday life, but the period saw a gradual breaking down of this view, as painters began to realise the potential and the public appeal of modern life scenes. A typical Victorian Academy exhibition included portraits, landscapes, scenes of rustic life, and historical subjects, treated anecdotally, rather than in the elevated manner of 'history painting'; from the 1850s there was an increasing number of contemporary images showing crowded modern city streets, fashionable social occasions, leisure pursuits and, to a lesser extent, the life of the urban poor.

Victorian painting also saw a widening in the audience for art. Attendances at the annual Royal Academy Summer Exhibitions and those in the provincial cities soared, and large one-off exhibitions such as the Manchester Art Treasures Exhibition of 1857 and the London International Exhibition of 1862 attracted a vast new popular audience for art. The growth of illustrated magazines and specialised art journals stimulated public interest, while the development of new methods of reproduction such as steel engraving and, later in the century, photogravure ensured that a single image could be reproduced thousands of times with no diminution in quality of printing.[5] Artists benefited from selling engraving rights as well as the paintings themselves, and could command extremely high prices. The most successful painters rose from modest backgrounds to

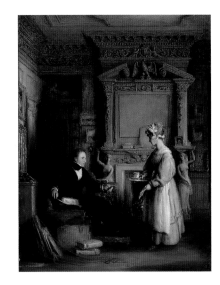

Fig. 1
William Mulready RA (1786–1863)
An Interior including a Portrait of John Sheepshanks at his Residence in Old Bond Street 1832–4
Oil on panel, 50.8 x 40 cm.
Victoria and Albert Museum, London

3 Ronald Parkinson, *Catalogue of British Oil Paintings 1820–1860*, Victoria and Albert Museum, London, 1990, p. xviii and *passim*.
4 The classic statement of these views was made by Sir Joshua Reynolds in his *Discourses*, lectures to students at the Royal Academy Schools prize-giving ceremonies, 1769–90.
5 C. N. Williamson, 'Illustrated Journalism in England: Its Development', *Magazine of Art*, London, 1890, pp. 297–301, 334–40, 391–6; Anthony Dyson, *Pictures to Print. The Nineteenth Century Engraving Trade*, London, 1984.

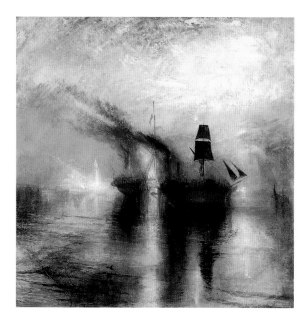

Fig. 2
J. M. W. Turner RA (1775–1851)
Peace – Burial at Sea RA 1842
Oil on canvas, 87 x 86.5 cm
Tate Gallery, London

positions of great wealth and social prestige, were ennobled with knighthoods or peerages, and built lavishly appointed studio houses.[6]

At the beginning of the period, most artists sought to exhibit at the Royal Academy. But some of the more progressive talents, finding the institution resistant to change, eventually decided to make their careers outside the Academy. A feature of the period is the emergence of alternative exhibition venues such as dealers' galleries and artists' exhibition societies. In the 1870s and '80s, these began to challenge the Academy's dominance, and, by the end of the century, the Academy was no longer the arbiter of taste it had once been.

Early Victorian painting, from 1837 to the 1850s, can be characterised as moving from the poetry and visionary grandeur of early 19th-century Romanticism to a less ambitious, and more prosaic style. In landscape painting, for example, critics found Turner's atmospheric and painterly late work difficult to understand; his *Peace – Burial at Sea* (fig. 2) was described as 'two round blotches of *rouge et noir*'.[7] People preferred the more down-to-earth, descriptive landscapes of Creswick, Lee and Cooper, and the Dutch-inspired marines of Clarkson Stanfield (fig. 3). A few artists, among them Eastlake (cat. 12), continued to produce history paintings, emulating the grand manner and elevated subjects of Renaissance and Baroque masters. But such high art rapidly went out of fashion in favour of countless scenes of familiar domestic incidents, mothers and babies, peasants going to market, rustic cottages, village schools and children at play. This type of subject was inspired by the work of Sir David Wilkie who in the early 19th century had introduced a fashion for Dutch and Flemish-style scenes of peasant life.[8]

Fig. 3
W. Clarkson Stanfield RA (1793–1867)
The Day after the Wreck; a Dutch East India-man on Shore in the Ooster Schelde – Zierickzee in the Distance
RA 1844
Oil on canvas, 153 x 232.4 cm
Sheffield Galleries and Museums Trust

6 Paula Gillett, *The Victorian Painter's World*, Gloucester, 1990, pp. 18–68.
7 *Spectator*, London, 7 May 1842.
8 Lindsay Errington, 'The Genre Paintings of Wilkie', in *Sir David Wilkie of Scotland*, exhibition catalogue, North Carolina Museum of Art, Raleigh, 1987, pp. 3–19.

Early Victorian genre paintings were usually small in scale, suitable for the middle-class home, and depicted the idealised, old-fashioned country world of Wilkie's native Scotland, sometimes illustrating Scottish vernacular poetry and folk wisdom as in the paintings by Allan and Gordon (cat. 45, 43). As with high art, painting was still regarded as a moral teacher, but the genre paintings embodied the new values of their middle-class buyers, the virtues of piety, charity and hard work, the innocence of children or young lovers and the sanctity of family life (cat. 52). Meticulous finish and humorous characterisation were much admired in these scenes, which were designed to be closely read, like books, to extract meaning from gesture, facial expression and anecdotal detail.[9]

Events from literature and history were also popular with the genre painters, treated in a similarly detailed anecdotal style, as were imaginary scenes from past times, such as Hart's *An Early Reading from Shakespeare* (cat. 16). Shakespeare's comedies, such as the *Two Gentlemen of Verona* (cat. 17) were illustrated more often than his tragedies, and light-hearted scenes from such authors as Molière, Goldsmith and Addison were depicted with wearisome frequency. Many paintings were based on incidents from popular history books and historical novels, depicting scenes of national glory or glamorous heroes and heroines such as Henry VIII, Elizabeth I, Mary Queen of Scots, Charles I, Cromwell and the Civil War (cat. 20).[10] An original variant on genre painting was developed by Sir Edwin Landseer who depicted narrative situations acted out by animals, skilfully endowing them with human character and feeling, his dogs evoking comedy or pathos (cat. 13), his stags expressing the romantic freedom of nature.

The industrial expansion of the 1840s led to poverty, disease, unemployment and hardship, subjects that received striking expression in the novels of Dickens, Disraeli and Mrs Gaskell. Hardly any painters responded to these issues.[11] An exception was Richard Redgrave, an artist particularly interested in women's social problems: his *The Outcast* (cat. 47) was one of a number of works painted, as he put it, 'to call attention to the trials and struggles of the poor and oppressed'.[12] But most genre painters kept to innocuous and light-hearted themes.

Throughout the 1830s and '40s there were calls for state intervention to provide public commissions for artists as a way of improving standards of taste, on the model of French and German practice. At this period, German painting was at its most influential across Europe; the British adopted the fairy subjects of German Romanticism,[13] and when in 1834 the old Palace of Westminster (where the Houses of Parliament sat) burned down, this was seen as an opportunity to create a new government building decorated with grand historical murals, similar to Ludwig of Bavaria's public buildings in Munich. The moving forces behind the Westminster murals was the young Prince Albert, recently arrived from Germany to

9 Lindsay Errington, *Sunshine and Shadow. The David Scott Collection of Victorian Paintings*, exhibition catalogue, National Galleries of Scotland, Edinburgh, 1991.
10 Roy Strong, *And When did you last see your Father? The Victorian Painter and British History*, London, 1978.
11 Julian Treuherz, *Hard Times. Social Realism in Victorian Art*, exhibition catalogue, Manchester City Art Gallery, 1987, pp. 9–28.
12 *Art Journal*, London, 1850, p. 48.
13 William Vaughan, *German Romanticism and British Art*, New Haven, CT and London, 1979; *Victorian Fairy Painting*, exhibition catalogue, Royal Academy of Arts, London, 1997.

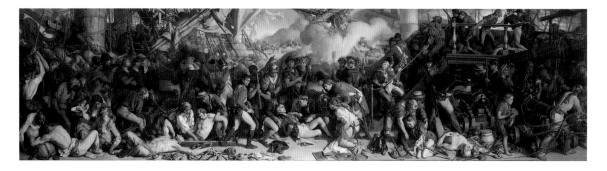

Fig. 4
Daniel Maclise RA (1806–70)
Trafalgar: The Death of Nelson 1863–5,
(finished study for mural in the House
of Lords)
Oil on canvas, 95.9 x 353.1 cm
Walker Art Gallery, Liverpool

marry the Queen, together with Charles Lock Eastlake, later to be President of the Royal Academy.[14]

Following a series of competitions starting in 1842, the interiors of the new Houses of Parliament were adorned with frescoes of British historical subjects. The most successful murals, such as those by Maclise (fig. 4), were painted not in the anecdotal style but with a clarity and heroic monumentality derived from German art. However, many of the artists were unable to rise to the demands of large-scale mural composition or to the technical challenge of fresco, which proved to be unsuitable for the damp English climate. By the 1860s the murals had blistered, cracked and darkened, resisting all attempts at restoration.

The 1840s saw another attempt to raise the level of seriousness of British painting, ultimately more far-reaching and successful than the Westminster project. This was the foundation in 1848 of the Pre-Raphaelite Brotherhood, an informal group of seven young friends, mainly but not exclusively painters; the most important and influential members were Dante Gabriel Rossetti, John Everett Millais and William Holman Hunt. The Brotherhood never had clear aims; the original Brothers were united principally by youthful inexperience and idealism, and motivated by their dislike of the dead hand of academic convention, which they felt had made much contemporary painting trite, stale and repetitive. As the group developed, the work produced by the original members, and later by the many followers they gathered as their ideas became more widespread, included a diversity of styles and subjects, which can appear confusing. Nevertheless, throughout the Pre-Raphaelite movement there ran a consistent seriousness of purpose, a fresh and original vision, and an intensity of expression, which challenged and refreshed mainstream Victorian painting.[15]

The Brotherhood adopted the term 'Pre-Raphaelite' because they wanted to return painting to the purity of vision of the early Italian period, unsullied by later academic teaching. German influence was again important through the example of the Nazarenes, a brotherhood of German artists resident in Rome earlier in the century, who had sought to emulate early Italian simplicity and spirituality; Rossetti's friend and teacher, Ford Madox Brown, who made a highly original contribution to the Pre-Raphaelite movement, had known the work of the Nazarenes at first hand, as had William Dyce (cat. 11),[16] who gave early encouragement

14 David Robertson, *Sir Charles Eastlake and the Victorian Art World*, Princeton, NJ, 1978; this book includes the best recent account of the Westminster mural scheme.

15 *The Pre-Raphaelites*, exhibition catalogue, Tate Gallery, London, 1984, is the best recent general publication.

16 Teresa Newman and Ray Watkinson, *Ford Madox Brown and the Pre-Raphaelite Circle*, London, 1991, p. 25; William Vaughan, *German Romantic Painting*, New Haven, CT and London, 1980, pp. 182–3.

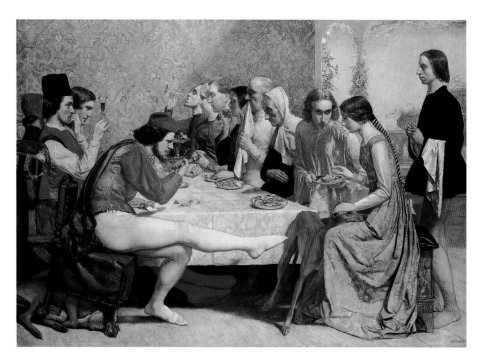

Fig. 5
Sir John Everett Millais PRA (1829–96)
Lorenzo and Isabella RA 1849
Oil on canvas, 102.9 x 142.9 cm
Walker Art Gallery, Liverpool

to the young Pre-Raphaelites, and was later to learn from them. The early work of the Pre-Raphaelites was deliberately archaic, giving it an expressiveness that marked it out from contemporary narrative painting; *Isabella* by Millais (fig. 5), one of the first paintings of the Brotherhood to be publicly exhibited, is startlingly angular, flat and linear in style. Its subject is also early Italian, from a story by the Italian 14th-century writer Boccaccio, as retold by the English Romantic poet John Keats. Both of these were unusual sources for artists, testifying to the young Pre-Raphaelites' passionate enthusiasm for books, in contrast to the predictable literary subjects of the genre painters.

In the early 1850s, partly under the influence of the critic John Ruskin, Pre-Raphaelite art became more naturalistic as the artists developed a minutely painted, brilliantly coloured style, copying directly from nature and lavishing attention in their landscape settings on the fine detail of ivy-covered walls, mosses, flowers, grasses, animals and birds, all seen in equally sharp focus, no matter how far from or near to the eye. This was a completely new kind of landscape painting, as Holman Hunt wrote of his *The Hireling Shepherd* (fig. 6): 'not Dresden china *bergers*, but a real shepherd, and a real shepherdess, and a landscape in full sunlight, with all the colour of luscious summer, without the faintest fear of the precedents of any landscape painter who has rendered Nature before'.[17] This picture also demonstrates how closely the paintings of the Brotherhood were bound up with current religious controversy, for it is also an allegory on the failure of the Anglican church to meet the spiritual needs of its people. The use of symbols such as the sheep escaping from the meadow into the cornfield, the death's-head moth caught by the shepherd, and the half-eaten apple on the girl's knee are typical examples of Pre-Raphaelite 'symbolic realism', where symbols are not visually intrusive, but make sense literally at the

17 Letter, coll. Manchester City Art Gallery, cited in Julian Treuherz, *Pre-Raphaelite Paintings from the Manchester City Art Gallery*, Manchester, 1980, p. 37; see also Allen Staley, *The Pre-Raphaelite Landscape*, Oxford, 1973.

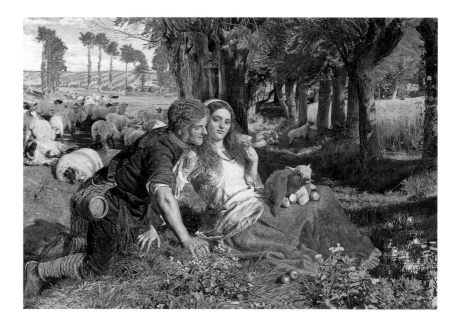

Fig. 6
William Holman Hunt (1827–1910)
The Hireling Shepherd RA 1852
Oil on canvas, 76.4 x 109.5 cm
Manchester City Art Galleries

same time as containing coded meanings. The Pre-Raphaelites also used the new, detailed style to paint contemporary subjects in modern dress, with a social or moral dimension, highlighting issues of sexuality, spiritual crisis or, in the case of Ford Madox Brown's densely packed *Work* (fig. 7), labour, class and urban society.[18]

To begin with, the Pre-Raphaelite Brotherhood sought to show at the Summer Exhibitions of the Academy, where their work began to attract notoriety and unfavourable criticism. By the mid-1850s, the principal artists had gone in their own separate directions. Millais stayed with the Academy, accepting the Associateship in 1853. He soon became one of its most successful painters; alongside his more serious work, he turned to subjects of popular appeal such as pairs of young lovers, and his technique became

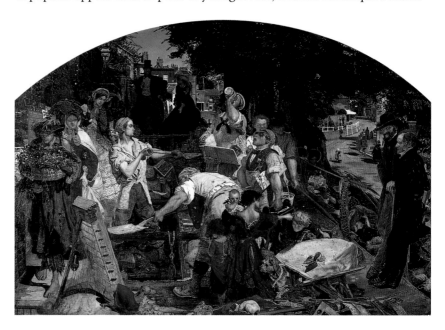

Fig. 7
Ford Madox Brown (1821–93)
Work 1852–65
Oil on canvas, 137 x 197.3 cm
Manchester City Art Galleries

18 Gerald Curtis, 'Ford Madox Brown's *Work*. An Iconographical Analysis', *The Art Bulletin*, December 1992, pp. 623–36; see also Alastair Grieve, *The Art of Dante Gabriel Rossetti. 1. Found. 2. The Pre-Raphaelite Modern Subject*, Norwich, 1976.

looser. Holman Hunt showed occasionally at the Academy, but continued to paint in the sharply detailed, brightly coloured style of the early Brotherhood long after the others had left it behind; he made four journeys to Palestine, the first in 1854–6, to search out authentic biblical settings for his religious subjects. The results of these expeditions were paintings like *The Scapegoat* (Lady Lever Art Gallery, Port Sunlight) and *The Shadow of Death* (Manchester City Art Gallery), which combined symbolic realism with original iconography, re-interpreting the Christian message for the Victorian age. Rossetti abandoned the Academy, ceasing to exhibit in public after 1850 and retreating into a private world, selling only to a restricted circle of collectors. Impatient with the demands of detailed realism, he became more and more concerned with creating a poetic and imaginary world, emphasising not truth to nature but decorative effect, as for instance in the heraldic patterns and flattened spaces of his medieval-style water-colours. His charismatic personality fired a group of younger followers, including William Morris and Edward Burne-Jones, to join with him in decorating the Oxford Union building, designed in the Gothic Revival style, with scenes from the legend of King Arthur. These, like the Westminster murals, faded rapidly because of poor technique. They nevertheless helped to establish a taste for fantastical visions of an enchanted middle ages among the next generation of artists.[19] In the meantime, Pre-Raphaelitism began to attract many followers who adopted the brightly coloured, detailed style of the early 1850s for landscapes and narrative paintings.

Under the influence of Pre-Raphaelite modern life paintings, many of the artists of historical genre turned to contemporary subject matter.[20] Chief among these was William Powell Frith who created a sensation at the Academy with a series of large crowd scenes, *Life at the Seaside* (Royal Collection), *The Derby Day* (Tate Gallery, London) and *The Railway Station* (fig. 8). Modern dress was still regarded by many as ugly, and the inclusion of low-life types such as Cockneys, beggars, loose women and pickpockets led to accusations of vulgarity; Frith's panoramas were of a size to rival traditional history painting, yet they lacked any elevated moral lessons. Nevertheless, they were a huge success with the public, giving rise to a rash of imitations in the later 1850s and early '60s, featuring busy street scenes, railway platforms, omnibuses, post offices, wedding parties and other situations involving crowds of people in fashionable dress. Frith and his

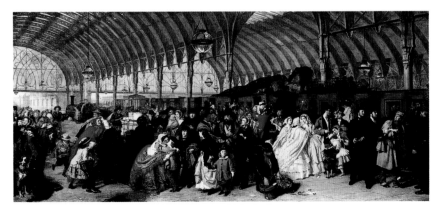

Fig. 8
William Powell Frith RA (1819–1909)
The Railway Station RA 1862
Oil on canvas, 116.7 x 256.4 cm
Royal Holloway College, University of London, Egham, Surrey

19 *William Morris and the Middle Ages*, exhibition catalogue, Whitworth Art Gallery, Manchester, 1984.
20 Christopher Wood, *Victorian Panorama. Paintings of Victorian Life*, London, 1976; Mary Cowling, *The Artist as Anthropologist. The Representation of Type and Character in Victorian Art*, Cambridge, 1976.

contemporaries also painted smaller pictures of up-to-date urban life, vying with each other to find subjects that were quintessentially modern, such as a crossing sweeper, a cigarette smoker, croquet players, street sellers or a box at the theatre. Subjects taken from the contemporary art world were also popular, including crowds at an exhibition or incidents in the artist's studio (cat. 48). Pictures of children were highly saleable and a group of artists, known as the Cranbrook Colony, after the picturesque Kent village where they lived, specialised in genre scenes of children, whom they painted in their own homes. One of this group was J. C. Horsley who depicted the interior of his house at Cranbrook in *A Pleasant Corner* (cat. 49).

Many artists searched further afield for subjects; J. F. Lewis and David Roberts spent considerable periods abroad in the 1830s and '40s, Roberts travelling in Spain and the Middle East, and Lewis living in Cairo for ten years. They accumulated collections of sketches, which they used as the basis of paintings made in their London studios long after their return. Such paintings fed on the growing interest in foreign travel and tourism, and developed from the purely topographical and architectural views of Roberts (cat. 61) to the exotic genre painting of Lewis and Goodall (cat. 63, 64).

A change came over British painting from about 1860, in reaction to the emphasis on narrative, moral teaching and detail seen both in academic genre painting and the early work of the Pre-Raphaelites. The more progressive artists of the later Victorian period placed greater emphasis on formal values and on colour, tone, line and pattern; and instead of faithfully copying surface appearance they aimed to express inner truth by representing an imaginary world of poetry and beauty, often highly personal in its allusions. This development became known as the Aesthetic Movement, and was associated with the phrase 'art for art's sake', originally coined in French literary circles. The writer who did most to put these ideas before the British public was the critic Walter Pater, whose writings challenged the Ruskinian view that art must express moral and spiritual truths. Pater stated that art was independent of morality, and that the essence of painting was its physical form rather than its subject; his most famous dictum was that 'all art constantly aspires to the condition of music'.[21]

Fig. 9
J. A. M. Whistler (1834–1903)
Symphony in White, No. 3 1865–7
Oil on canvas, 51.1 x 76.8 cm
Barber Institute of Fine Arts,
The University of Birmingham

This was well understood by the painter most closely associated with aestheticism, James McNeill Whistler; his paintings, to which he often gave musical titles such as 'Symphonies' and 'Nocturnes', show a feeling for rhythm, interval and mood. Born in America, Whistler came to London in 1859 after studying in Paris, where he had come into contact with the French avant-garde. His paintings of the 1860s and '70s demonstrate aestheticism at is purest. *Symphony in White, No. 3* (fig. 9) tells no story: though it shows two girls with recognisably modern hairstyles and dresses, it eliminates detail, simplifies outline, restricts local colour and flattens

21 Walter Pater, *The Renaissance. Studies in Art and Poetry*, London, 1910, p. 135.

space, in order to create an artificial arrangement of shapes and colours, not a literal description. The bold shape of the left-hand girl and the spray of blossom show Whistler had learned from the study of Japanese wood-block prints, much admired in advanced circles for their stylised effects of pattern and outline. Whistler's later works, including portraits and views of the Thames at night are similarly simplified and abstracted, conveying the essence rather than the particularities of a subject.[22]

The work of the later phase of Pre-Raphaelitism, after about 1860, can also be seen as part of the Aesthetic Movement, in its rejection of truth to nature. In the late 1850s and '60s Rossetti painted a series of pictures of beautiful women, homages to female allure rather than individual portraits. Less spare and economical than Whistler's paintings, Rossetti's pictures of female beauties included elaborate accessories, ornate jewellery, flowers, patterned costumes and luxuriantly flowing hair. Rossetti's late paintings, though always self-consciously decorative, were more concerned with subject than those of Whistler; from the late '60s until his death, Rossetti painted a series of cruel *femmes fatales* and heroines doomed to unhappy love, such as Beatrice, Proserpine or *Mariana* (fig. 10) , incorporating much symbolism and personal allusion. These late paintings have an uncomfort-able, obsessive quality about them, and were criticised for their overtones of sensuality and decadence. The women are painted in the distinctive likeness of William Morris's wife, Jane, with whom Rossetti was deeply in love; the paintings feature gloomy, muted colour schemes, mannered execution and heavy, rhythmical curves, foreshadowing the flamelike lines of art nouveau.[23]

In the 1860s and '70s the younger artists of Rossetti's circle, such as Frederick Sandys and Simeon Solomon, developed his ideas, painting medieval and poetic subjects, and enigmatic beauties with cruel or soulful expressions. This type of Pre-Raphaelite woman inspired many later artists with no direct connection to Rossetti, well into the 20th century (cat. 28, 27, 34), by which time the originally disturbing erotic charge had all but evaporated. Of Rossetti's direct followers, Burne-Jones emerged as the

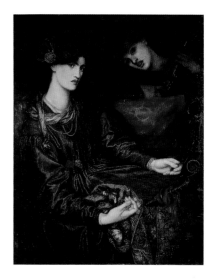

Fig. 10
Dante Gabriel Rossetti (1828–82)
Mariana 1868–70
Oil on canvas, 102.9 x 88.9 cm
Aberdeen Art Gallery and Museums

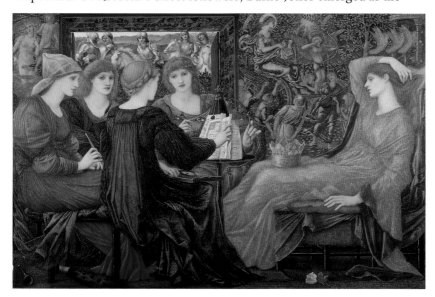

Fig. 11
Sir Edward Burne-Jones (1833–98)
Laus Veneris 1873–8
Oil on canvas, 122 x 183 cm
Laing Art Gallery, Newcastle upon Tyne

22 Richard Dorment, *James McNeill Whistler*, exhibition catalogue, Tate Gallery, London, 1994, p. 18.
23 *The Age of Rossetti, Burne-Jones and Watts. Symbolism in Britain, 1860–1910*, exhibition catalogue, Tate Gallery, London, 1997, pp. 157–60.

most original. Without formal training, his talent was nurtured by the study of Italian Renaissance painting and by developing his genius for decoration through his prolific designs for stained glass, furniture, tiles and textiles, made for Morris & Company.[24] Burne-Jones's major paintings such as *Laus Veneris* ('In praise of Venus'; fig. 11) combine richness of texture and flowing lines with a powerful expression of world-weary beauty and repressed sexuality. The world he created exerted a hypnotic appeal: 'I mean by a picture,' he wrote, 'a beautiful romantic dream of something that never was, never will be – in a light better than any light that ever shone – in a land no one can define or remember, only desire – and the forms divinely beautiful.'[25]

Rossetti never became a Member of the Academy; his work was too unorthodox, his way of life too Bohemian. Burne-Jones was persuaded to join, but soon resigned; his preferred place of exhibition was the Grosvenor Gallery, which opened in 1877 as an alternative to the Royal Academy.[26] The Grosvenor picture hang was less crowded and more artistic, with like works grouped together, and for a time the world of fashion flocked to its exhibitions, which became a showcase for aesthetic painters. It was at the first exhibition of the Grosvenor that Whistler showed his *Nocturne in Black and Gold: The Falling Rocket* (Detroit Institute of Arts) which Ruskin attacked for its lack of surface finish, accusing its artist of 'flinging a pot of paint in the public's face'. Whistler sued the critic for libel, and although he won his case, he was awarded the insulting damages of one farthing; even his barbed wit was unable to convince the British establishment to accept aestheticism.[27]

A new movement entered British art in the 1870s, the Classical Revival. Its main protagonist was Frederic Leighton who, as a young man, had for a time adopted the aesthetic manner, painting decorative pictures of females with beautiful accessories, creating a sense of harmony without any element of narrative or symbolic meaning. Leighton never lost his awareness of decorative values, but his mature work was concerned with re-interpreting the idealised art of ancient Greece for the Victorian age. He painted processional subjects based on the Greek frieze, but brought to them a truly modern feeling for sumptuous colour, and though his figure style showed a deep knowledge of classical Greek sculpture, his draperies took on a decorative quality all of their own. Though some of his work was inspired by biblical and historical sources, Leighton selected his most characteristic subjects from Greek mythology and poetry to convey stories of tragedy and heroism, more personal themes such as loneliness and mourning, or the power of art and beauty. *The Garden of the Hesperides* (fig. 12), depicts the languorously reclining daughters of Zeus guarding the tree with the golden apples, a classical equivalent to the tree of knowledge in the garden of Eden. The undulating lines of

Fig. 12
Frederic, Lord Leighton PRA (1830–96)
The Garden of the Hesperides RA 1892
Oil on canvas, diameter 169 cm
Lady Lever Art Gallery, Port Sunlight

24 Originally Morris, Marshall, Faulkner & Co. For Burne-Jones's decorative work see *William Morris*, exhibition catalogue, Victoria and Albert Museum, London, 1996.
25 Quoted in *Burne-Jones*, exhibition catalogue, Hayward Gallery, London, 1975, p. 11.
26 Christopher Newall, *The Grosvenor Gallery Exhibitions. Change and Continuity in the Victorian Art World*, Cambridge, 1995; S. P. Casteras and C. Denney, ed.,*The Grosvenor Gallery. A Palace of Art in Victorian England*, exhibition catalogue, Yale Center for British Art, New Haven, CT, 1996.
27 Linda Merrill, *A Pot of Paint. Aesthetics on Trial in Whistler v. Ruskin*, Washington and London, 1992.

the composition within the circular tondo shape favoured by Raphael and Michelangelo, demonstrates that a study of the Italian High Renaissance informed Leighton's art.[28] Leighton was also a distinguished sculptor whose small bronzes (cat. 40, 42), led the way from the bland modelling of neo-classical sculpture to the lively surfaces of the late Victorian movement known as 'The New Sculpture', exemplified in the work of Hamo Thornycroft and Onslow Ford (cat. 39, 6, 7).[29]

Of the other painters associated with the Classical Revival, Poynter and Richmond (cat. 3, 35) attempted, like Leighton, to recreate the perfection of the classical ideal. G. F. Watts shared with Leighton the view that art should elevate the viewer, and painted subjects from classical mythology; he also achieved distinction as a portraitist of great men and women of the age (cat. 9), but his most original paintings were his invented allegories in which he sought to create a universally accessible language, independent of religion or creed.[30] The best known is *Hope* (fig. 13), an image of a blindfolded female seated on a globe, trying to make music from a broken lyre. Albert Moore's paintings of statuesque females in Grecian-style draperies, exquisitely arranged with decorative accessories, are more akin to the subjectless figure groups of Whistler, than to the mythological or poetic art of Leighton.[31] The paintings of Alma-Tadema (cat. 31, 32) are different again. They were based on an extensive knowledge of Greek and Roman archaeology, and incorporated numerous accurately painted details copied from antique remains but are genre paintings in classical disguise, describing everyday events rather than embodying elevated truths. Nevertheless, their skill in depicting marble and sunlight, and their feeling for colour and luxury make them seductively convincing. Tadema also successfully applied his meticulous technique to portraits, mainly of his own family (cat. 56, 58).

In contrast to artists of the Aesthetic Movement, who directed their art at a cultivated élite of art worshippers, or the Classical Revival painters, who wanted to uplift the public by exposing them to ideal beauty, many Academicians deliberately courted popularity by painting undemanding, accessible subjects such as children, animals, historical scenes and landscapes that were easy on the eye. These painters chose to speak a language that could be understood by people of widely differing social and educational levels, aiming not to lead public taste but to provide entertainment, the Victorian equivalent of bestselling novels or Hollywood epic films. This is evident in the later work of Millais, which lacks the startling originality and spiritual depth of his Pre-Raphaelite period. He achieved fame and wealth by painting stirring historical scenes, society portraits, melancholic Scottish landscapes and sentimental pictures of children (cat. 51). Though his subjects could be trite, the best of Millais's late paintings are marked out from those of his contemporary Academicians by his bravura brushwork, derived from a study of Titian and Velazquez (cat. 54).

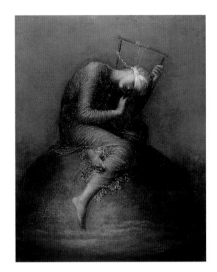

Fig. 13
George Frederic Watts (1817–1904)
Hope 1886
Oil on canvas, 142.2 x 111.8 cm
Tate Gallery, London

28 *Victorian High Renaissance*, exhibition catalogue, Manchester City Art Gallery and Minneapolis Institute of Art, 1978, pp. 11–12, 95–127; *Frederic, Lord Leighton*, exhibition catalogue, Royal Academy, London, 1996.
29 Susan Beattie, *The New Sculpture*, New Haven, CT and London, 1983; Benedict Read, *Victorian Sculpture*, London and New Haven, CT, 1982, pp. 289-326.
30 Barbara Bryant, 'G.F. Watts and the Symbolist Vision', in *The Age of Rossetti, Burne-Jones and Watts. Symbolism in Britain, 1860–1910*, op. cit., pp. 65–81.
31 *Victorian High Renaissance*, op. cit., pp. 129–55.

Many late Victorian painters lacked the range of Millais, becoming subject specialists. Some landscape painters became known for Highland hillsides (cat. 69), or snow scenes (cat. 68), others for marine subjects. Henry Moore, brother of Albert Moore, specialised in empty seascapes, with simple compositions concentrating on light, colour and the movement of the rolling sea (cat. 71); others painted coastal scenes or rivers busy with shipping, appealing to British pride in seafaring tradition (cat. 72, 77). The mantle of Landseer was inherited by Briton Riviere, painter of impressive wild animals such as lions and tigers as well as sentimental dogs (cat. 65). Birds were the speciality of Stacy Marks (cat. 50), a member of the St John's Wood Clique, an informal group of artists, which also included P. H. Calderon, who painted historical anecdotes, often with a laboured sense of humour (cat. 15).

Much more sophisticated were the historical scenes of John Pettie (cat. 19), able to suggest movement, drama and intrigue by the atmospheric use of empty space and dynamic figure grouping. Pettie and Orchardson (cat. 78) had both been trained at the Trustees' Academy in Edinburgh and their work was distinguished by its subtly muted colour schemes and use of thin, transparent paint. A number of painters produced elaborately illusionistic reconstructions of historical events, which achieved fame through frequent reproduction in popular school textbooks (cat. 29, 23, 21). Elizabeth Thompson, later Lady Butler, was one of those who specialised in battle scenes from recent history. Despite the merits of her work, she narrowly missed being elected to Associate Membership of the Academy, demonstrating the difficulties facing women artists in a male-dominated age.

Modern life subjects were also seen at the late Victorian Academy. In the 1870s the social panoramas pioneered by Frith were given a modish French gloss by Tissot's paintings of fashionable balls and soirées.[32] Later, Orchardson, in his pointed social comedies, showed the tensions and marital strife behind the opulent façade of high society, as described in the novels of George Eliot and John Galsworthy. Both Tissot and Orchardson also depicted the rituals of courtship in Regency dress, a fashion taken up by Marcus Stone, painter of chocolate-boxy flirting couples (cat. 24). In complete contrast was the social realism of the 1870s and '80s.[33] Luke Fildes, Frank Holl and Hubert von Herkomer had been providing drawings of the urban working-class poor for *The Graphic*, an illustrated magazine founded in 1869. From the mid-1870s they used their drawings as the basis for large paintings exhibited at the Academy. In 1874, Fildes caused an outrage with his *Applicants for Admission to a Casual Ward* showing a queue of down-and-outs waiting to get into an overnight refuge. Many who saw it were shocked by the subject, considering it ugly and unfit for art, but subsequently social realist works became acceptable despite controversial subject matter such as prisons, unemployment and strikes (cat. 60). Social realist paintings remained, however, relatively few in number and Fildes, Holl and Herkomer increasingly relied on portrait commissions to make a living.

In the 1880s and '90s, there was a good deal of dissatisfaction with the Royal Academy Schools among aspiring painters and many went to study in Paris or Antwerp, spending their summers in Britanny painting in the open

32 Michael Wentworth, *James Tissot*, Oxford, 1984.
33 Julian Treuherz, *Hard Times. Social Realism in Victorian Art*, exhibition catalogue, Manchester City Art Gallery, 1987, pp. 53–118 (with Lee M. Edwards).

air. They admired Millet and the Barbizon School and above all the French artist Jules Bastien-Lepage, whose peasant subjects, depicted in a grey, overcast light, painted with square brushstrokes to convey tonal gradations, were widely imitated by younger landscape painters across Europe. The British painters who adopted this style included Stanhope Forbes, Henry Herbert La Thangue and George Clausen.[34] Forbes settled in the Cornish fishing village of Newlyn and became a founder of the Newlyn School, an artists' colony dedicated to recording the daily life of the fishermen and their families. Newlyn subjects were regularly seen at the Royal Academy.[35] La Thangue and Clausen travelled around various parts of England painting agricultural labourers at work, among other subjects. In 1886 the New English Art Club was established as an exhibition society where the painters of French-inspired rustic subjects could show as an alternative to the Academy. Clausen's *The Stone Pickers* (fig. 14), heavily influenced by Bastien-Lepage, was shown there in 1887.

In the 1890s both La Thangue and Clausen adopted a looser style, influenced by the French Impressionists, and eventually began to exhibit at the Academy, Clausen also painted portraits (cat. 55, 57). In the meantime, a new, more radical group of French-influenced painters had emerged in England led by Walter Sickert, formerly a pupil of Whistler and of Degas.[36] Sickert rejected rustic subjects, preferring, unfashionably, to find his material in London. His paintings of the London music halls, such as *The Gallery of the Old Bedford* (fig. 15) lacked conventional surface finish and depicted what were then regarded as disreputable places of working-class entertainment; a complete contrast and a challenge to what was contemporaneously being shown at the Academy.

Such contrasts are typical of Victorian painting; just as in France where first the Realists and then the Impressionists challenged what was officially accepted, so too in Britain began the split between establishment and progressive taste that created the modern idea of the avant-garde. Yet it would be a mistake to classify painters like Whistler or Sickert as isolated phenomena, as pioneers of a modern sensibility because their work introduced simplification and stylisation into an age of ornate complexity and literal representation. Such diversity was part and parcel of Victorian culture. In the field of furniture and interiors, reformers such as E. W. Godwin and Philip Webb produced elegant, stripped-down designs to challenge the befringed, draped and buttoned upholstery of fashionable interior decorators. In architecture, a single building such as St Pancras Station, London, could embody the contrast between the sculptural façade and busy skyline of the hotel and the soaring curve of the metal glass train shed. Even in literature, the age produced the poetry of both Tennyson and Gerard Manley Hopkins. In the aftermath of the Victorian period, its visual arts were derided and misunderstood, but now, with the perspective of history, Victorian painting can be more fairly assessed as reflecting the ambition, the moral aspirations, and the eclecticism and diversity of the age.

Fig. 14
Sir George Clausen RA (1852–1944)
The Stone Pickers 1887
Oil on canvas, 106.5 x 79 cm
Laing Art Gallery, Newcastle upon Tyne

Fig. 15
Walter Sickert (1860–1942)
The Gallery of the Old Bedford
(The Boy I Love is up in the Gallery) 1895
Oil on canvas, 76.2 x 59.7 cm
Walker Art Gallery, Liverpool

34 Kenneth McConkey, *Impressionism in Britain*, exhibition catalogue, Barbican Art Gallery, London, 1995.
35 Caroline Fox and Francis Greenacre, *Painting in Newlyn 1880–1930*, exhibition catalogue, Barbican Art Gallery, London, 1985.
36 *Sickert Paintings*, exhibition catalogue, Royal Academy of Arts, London, 1992.

THE ROYAL ACADEMY IN THE AGE OF QUEEN VICTORIA

MaryAnne Stevens

In June 1837, William IV, brother of the flamboyant Prince Regent (later King George IV) died. He was succeeded to the throne by the eighteen-year-old Victoria, who was to reign for the next 64 years. Two months earlier, on 28 April, the Royal Academy of Arts had left its accommodation in Somerset House and moved into the east wing of the newly completed National Gallery, situated on the north side of Trafalgar Square. Until 1868 the Academy was to share this building with the government-funded national collection of paintings created as recently as 1824.[1]

Following its creation, through an Instrument of Foundation signed by King George III on 10 December 1768, by 34[2] leading painters, sculptors and architects, the Royal Academy of Arts, under the presidency of the portrait painter Sir Joshua Reynolds and the treasurership of the architect Sir William Chambers, had quickly established itself as an institution of national significance.[3] It organised from 1769 a self-financing Annual Exhibition of works by living artists selected by a jury constituted from its own Members. It founded and ran the first school in the United Kingdom for the professional training of painters, sculptors and architects. And, by 1771 it was financially independent of crown and state.

With its move into Somerset House in 1780, the Royal Academy commanded the art scene in the United Kingdom. It plucked talented youth such as William Blake, John Constable and Samuel Palmer for training in its Schools. It elected as President after the resignation of Sir Joshua Reynolds in 1790 such distinguished practitioners as Benjamin West (1790–1805, 1806–20), James Wyatt (1805–6) and Sir Thomas Lawrence (1820–30), and admitted to its ranks as Academicians such painters as Henry Raeburn, William Beechey and J. M. W. Turner, sculptors such as John Flaxman and Richard Westmacott, and architects including Sir John Soane, Sir Charles Barry and C. R. Cockerell. Furthermore, its opinion was invited on all issues pertaining to the visual arts, from advice on sculptural memorials in St Paul's Cathedral to the inquiry into the appropriateness of the purchase by the State of the Parthenon marbles from Lord Elgin in 1816 and the rebuilding and decoration of the Palace of Westminster after its destruction by fire in 1834.

1 The National Gallery was formed as the nation's collection of Old Masters through the purchase by the State of the Sir John Angerstein Collection in 1823 on condition that Sir George Beaumont, a major collector, patron and donor to the Royal Academy of the Michelangelo Tondo, should leave his distinguished collection of Old Masters and the British School to the new institution. It opened on 10 May 1824 at 100 Pall Mall, the home of the late Sir John Angerstein, before moving to Trafalgar Square in 1837. The new building, designed by Sir William Wilkins RA, accommodated the National Gallery in its west wing and the Royal Academy in its east wing which provided five top-lit galleries on the first floor used for the Annual Exhibition in the summer and for the Royal Academy Schools in the winter. The ground floor accommodated sculpture and cast galleries, the Library and the Keeper's quarters.
2 Two names were appended shortly thereafter, William Hoare and Johann Zoffany.
3 For a comprehensive history of the Royal Academy, see S. Hutchison, *The History of the Royal Academy of Arts 1768–1986*, second edition, London, 1986.

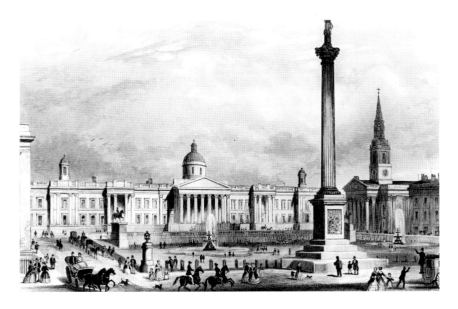

Fig. 1
T. H. Shepherd (1793–1864)
Trafalgar Square c. 1850s
Engraving, 22.6 x 15.3 cm
National Gallery, London

Thus as the Royal Academy stepped into its new accommodation on Trafalgar Square (fig. 1), it was poised to enter an era of assured growth, prosperity and influence. To be sure, shadows were cast across its Membership with the deaths in that very year of the distinguished landscape painter John Constable and of the architect of the Bank of England and Professor of Architecture in the Royal Academy Schools, Sir John Soane. Furthermore, in the report published in 1836 by the 1835 Parliamentary Select Committee on the Arts and their connection with Manufactures, the Royal Academy Schools had been severely criticised.[4] Yet vitality existed among the surviving Members of the generation which dominated the opening decades of the 19th century in such persons as J. M. W. Turner and Francis Chantrey. Furthermore, younger, recently elected Members were coming to prominence, including the future President, Sir Charles Lock Eastlake (cat. 3), the genre painters William Powell Frith (cat. 48), Richard Redgrave (cat. 47), C. R. Leslie and Frederick Pickersgill (cat. 18), the history and animalier painter, Edwin Landseer (cat. 13), and the sculptor John Gibson. Equally, as the institution moved into the early years of the 1840s, its Schools included such future luminaries as the artists and subsequent founders of the Pre-Raphaelite Brotherhood Dante Gabriel Rossetti, John Everett Millais and William Holman Hunt, the landscape painter and author of nonsense verse, Edward Lear, and architects such as E. M. Barry and Richard Norman Shaw. Finally, the Annual Exhibition remained pre-eminent, despite the relatively recent proliferation of other exhibiting bodies such as the British Institution (founded 1805) and the two watercolour societies (established 1804 and 1832).

By the end of the century, despite the noteworthy presidencies of Sir Charles Lock Eastlake (1850–65) (cat. 3) and Frederic Lord Leighton (1878–96) (cat. 5, 9), this pole position had been significantly eroded. Artists did not regard election to Membership as a necessary passport to artistic, financial or social success. The Annual Exhibition's monopoly of contemporary British art had been effectively challenged. The Royal

4 See H. Valentine, q.v.

Academy Schools were faced with very creditable rivals. In addition, the institution had been the subject of continual government inquiry and demands for reform as well as being the butt of constant criticism.

The history of the Royal Academy from 1837 to 1901 can be read in terms of internal factors such as the changing pattern of its Membership, the implications of its relocation to Burlington House on Piccadilly in 1868 and its willingness to accept calls for reform. It can also be considered in relation to external factors such as the maturing of the British industrial economy, the growth in electoral enfranchisement after the Reform Bill of 1832 and the expansion of the role of the State, the rise and consolidation of major urban centres outside London and the expansion of a wealthy, culturally improving middle class.

The Membership of the Royal Academy in 1837, then under the presidency of the portrait painter Sir Martin Archer Shee, stood at 40 full Royal Academicians and up to twenty Associate Members. By the end of the century, the number of full Academicians was unchanged except for the addition of two Academician Engravers in 1853. The limit on the number of Associates was theoretically removed in 1866, but in practice membership increased only slowly thereafter. In 1879 a minimum number of 30 Associates was established and in 1942 a ceiling was set at 40. This response was both to the rise in the number of professional artists during the 19th century and to external pressure to make the institution a more representative body.

The character of the Membership also shifted over the century. Despite the high minded intentions of Sir Joshua Reynolds during his inaugural presidency of the Royal Academy to establish a British School of History Painting – or morally uplifting art made on a grand scale – through the pattern of Membership, the character of the Annual Exhibition and the training given in the Schools, the programme had foundered.[5] By the 1830s, the art which was both practised by Academicians and favoured for the Annual Exhibition by the Jury, or Selection Committee of Royal Academicians, with a few notable exceptions, was essentially dominated by portraiture, landscape and most particularly genre painting. G. D. Leslie, in *The Inner Life of the Royal Academy*, defined genre painting in its broadest historical, literary and moral sense within the context of the Academy as:

> ...those [pictures] representing scenes from domestic or moral life, humorous pictures of various sorts, those in which strong dramatic situations or scenes of sentiment or love are depicted, and pictures with subjects taken from history or from the great dramatists or novelists. In such pictures great care was usually taken in representing the backgrounds, costumes, and accessories with archaeological accuracy; the canvases were generally of moderate dimensions, and the figures introduced in them were always smaller than life.[6]

It was this range of subjects depicted on relatively small scale canvases suited to the domestic interiors of the middle class which were pursued by many Academicians who came to the fore in the 1840s: Redgrave's morally

5 Paula Gillett correctly observes that, from relatively early in the history of the Royal Academy a critical gap had opened up between the teaching in the Schools, with its emphasis upon history painting, and landscape and genre painting apparently demanded by patrons and the exhibition-going public. See P. Gillett, *The Victorian Painter's World*, Gloucester, 1990, pp. 44 ff.

6 London 1914, quoted in B. Denvir, *The Late Victorians: Art, Design and Society 1859–1910*, London, 1986, p. 34.

informed *The Outcast* (cat. 47), Pickersgill's literary-inspired works (cat. 18) and Frith's celebration of scenes from everyday life (cat. 48). This preference for less than heroic scaled works was justified by Academicians as a manifestation of their understanding of the artist's role in early Victorian society as the mouthpiece for the shared ideals and aesthetic expectations of contemporary society.[7]

By the 1870s, as G. D. Leslie also identified, the artist had increasingly shifted his allegiance away from a commitment to the portrayal of society's moral programmes to embrace a concern for art for its own sake. Pioneered in the 1860s by artists who refused resolutely to have any involvement with the Royal Academy – Dante Gabriel Rossetti and James McNeil Whistler – the move to distance art from the everyday, the moral, the historical or the literary was adopted by Members such as Sir Lawrence Alma-Tadema (cat. 7), Sir Edward Poynter (cat. 10), Frederic Leighton (cat. 5, 9) and even John Everett Millais (cat. 51, 54) in the succeeding decade. It was then carried into the new century by the American Member, Edwin Austin Abbey (cat. 28), and by J. W. Waterhouse (cat. 34), Edward Gregory (cat. 30) and Frank Cowper (cat. 27). Sculpture also experienced a similar shift, although rather than contemporary subjects it was the classical ideal inherited from the 18th century which persisted in the carved work of Francis Chantrey, John Gibson and Patrick MacDowell before ceding to the modelled and bronze cast 'New Sculpture' heralded by Leighton's *Athlete Wrestling with a Python* (exhibited Royal Academy 1877) and developed by such Members as Alfred Gilbert (cat. 37, 41), Hamo Thornycroft (cat. 39), Thomas Brock and George Frampton. As with painting, the subject of sculpture was secondary to the modelling, the quality of casting and the subtle tonalities achieved through patination.

Adherence to the principles of art for art's sake precipitated another change in the character of the Membership, namely the shift away from genre painting in the late 1880s and '90s by such Members as Frank Holl, Luke Fildes and Hubert von Herkomer (cat. 60) – despite their publicly acclaimed success within this category – to portrait painting. In part this reflected the growing demand from a generation of newly successful and highly influential entrepreneurs to record themselves for posterity, both for their own private delectation and for the public domain of newly constructed municipal halls and art galleries. It also reflected an economic reality within the art market. The shift in taste towards art for art's sake brought with it a diversification in the pattern of cultural purchases by the art-buying public. The ethos of art for art's sake, with its call for the work of art (painting or sculpture) to be displayed within the total 'aesthetic' environment of beautifully designed decorative arts objects, fuelled the emerging Arts and Crafts Movement. Faced with this new taste, those artists such as Fildes and Herkomer, whose position as gentlemen of considerable social standing had been maintained through the popularity of genre painting, had no option but to adopt the relatively more secure genre of portraiture.[8] Likewise, after the turn of the century the Royal Academy found itself electing relatively more portrait painters into its ranks as it too reflected this shift in public taste.

7 See Gillett, op. cit., chapter 1, 'Gentlemen of the Brush'. Gillett considers the shift from genre painting to art for art's sake with its implications for the role of the artist.
8 Ibid., chapter 4, 'Herkomer, Fildes, and Holl: From Social Realism to Respectability'.

The changing character of the Membership during the Victorian era was reflected in the composition and critical appraisal of, and the popular response to the Annual Exhibitions, renamed the 'Summer Exhibitions' in 1870.[9] Prior to a consideration of these issues, however, it is necessary briefly to rehearse the history of the Royal Academy's locations during the period. The move to the National Gallery in Trafalgar Square in 1837 (fig. 1) gave the Royal Academy improved exhibition and teaching facilities. The galleries on the east side of the main entrance provided sufficient space for the average number of exhibited works to rise from 1278 hung in the Somerset House galleries in 1830 to an average of between 1400 and 1500 in the period from 1837 to 1868. Furthermore, these galleries housed the Royal Academy Schools in the winter, whose curriculum, in adherence to principles laid down by Reynolds in his Discourses of 1769 to 1790, could be enhanced by direct access to the National Gallery's collection in the west wing of the building, a facility guaranteed by the fact that several senior Members of the Royal Academy held notable positions within the National Gallery itself throughout the 19th century. The President Sir Martin Archer Shee was a Trustee, Sir Charles Lock Eastlake and Thomas Uwins were both Keepers in succession, and Eastlake, William Boxall and Edward Poynter were all Directors.[10] However, while the Royal Academy was having to respond to pressure from a fast growing number of professionally trained artists demanding inclusion in the Annual Exhibition, the National Gallery likewise was having to find more gallery space to accommodate its own burgeoning national collection. Discussions towards a resolution stretched over some twenty years from 1848. These alternated between suggestions to remove the National Gallery to Kensington Gore (1853) or to a site behind Burlington House on Piccadilly (1859), and to move the Royal Academy also to Burlington House with either a Piccadilly or a Burlington Gardens entrance façade (1859 and 1865 respectively), or to South Kensington close to what is now the Victoria and Albert Museum (1866). When this latter proposal was rejected by the then President, Sir Francis Grant, on the grounds that the site was too 'suburban', the Royal Academy was finally awarded the existing Burlington House opening onto Piccadilly, and half of the house's garden lying to the north, upon which the institution would have to build at its own expense a suite of grand exhibition galleries and a range of purpose-built teaching studios. In addition, it would have to raise the third storey of the building as a range of galleries to house its permanent collection of works of art by living and deceased Members (the Diploma Collection).

While the Royal Academy's Library, whose foundation was coincidental with that of the Royal Academy itself, and the collection of Diploma Works moved into the new premises at Burlington House between 1876 and 1878, the new suite of main exhibition galleries was ready for use by the Annual Exhibition of 1869. Designed by Sir Sidney Smirke RA according to 'beaux-arts' principles of axial planning, these top-lit galleries effectively doubled the hanging space previously available in Trafalgar Square.[11] Such an exten-

9 The Annual Exhibition of Work by Living Artists was renamed to distinguish it from the Winter Loan Exhibitions which had been inaugurated in January 1870.
10 Eastlake was Keeper 1843–7, and was succeeded in that post by Thomas Uwins; Eastlake became Director in 1850, succeeded on his death in 1865 by Boxall; Poynter was appointed Director in 1894.
11 For a detailed account of the innovative design of these galleries, see G. Waterfield, ed., Palaces of Art: Art Galleries in Britain 1790–1990, exhibition catalogue, Dulwich Picture Gallery, London, and National Gallery of Scotland, Edinburgh, 1991.

sion of a public facility brought with it specific developments in terms of its use and public access, which in turn had an impact upon the finances of the institution. In respect of the use of the new galleries for the annual Summer Exhibition, the increase in scale permitted the number of works hung to increase from c. 1500 to c. 2000 per exhibition; they also encouraged a slightly more spacious hang and, concomitantly, invited a significant increase in the number of entries submitted to the Jury for selection. Between 1869 and 1896, the number of works submitted rose from 4500 to 12,408.[12] Exacerbated by the continuing adherence by Royal Academicians, despite moves to instigate reform in 1883 and 1887, that the number of works which each could hang by right be reduced from eight to six and four respectively, the likelihood of rejection by the Selection Committee inevitably increased, lamented in cartoon and poem alike:

> 'The toil of months, experience of years,
> Before the dreaded Council now appears:–
> It's left their view almost as soon as in it.–
> They damn them at the rate of three a minute.–
> Scarce time for even faults to be detected,
> The cross is chalked: – 'tis flung aside 'REJECTED'.
>
> ...
>
> Shame! that thye, Artists, should such pain have given
> To those who struggle as themselves have striven.'[13]

With the Royal Academy Schools now housed in purpose-built studios to the north of the building, the main galleries, however, risked lying empty throughout the winter season. In January 1870, this was rectified by the mounting of the first Winter Loan Exhibition of Old Master works. Exhibitions on this theme had been initiated by the British Institution in 1806, with the intention, in the absence of a permanent National Gallery, of providing access to the public, connoisseurs, practising artists and students to major works by the Old Masters normally hung in great private houses throughout the United Kingdom (fig. 2). In 1867, the British Institution's lease had expired, and its activities ceased. Concerned by the demise of so significant a cultural institution, and after considerable public debate, it was proposed that the Royal Academy accommodate the exhibition. The Academy chose to combine the exhibition with a memorial exhibition of works by recently deceased Academicians. Thus, in 1870, Leonardo da Vinci's *Virgin of the Rocks* (National Gallery, London) and Sebastiano del Piombo's (then attributed to Giorgione) *Judgment of Solomon* (Kingston Lacy, Dorset) hung in galleries adjacent to those displaying works by the late C. R. Leslie and W. Clarkson Stanfield. Although initially considered to be a temporary solution pending the availability of space within the National Gallery,[14] the Winter Loan Exhibitions remained at Burlington House, thus instituting a new responsibility, namely the mounting of major loan exhibitions, which continues to this day.[15]

The provision of the new galleries at Burlington House also had a direct impact on the finances of the Royal Academy. Funded primarily

12 For all statistics given after 1860, see RA Annual Report, Royal Academy of Arts Library.
13 Anon. (probably J. E. Soden), *A Rap at the R.A.*, London, 1875, p. 21.
14 See *The Times*, 22 November 1869.
15 For further information on the decision to adopt the Winter Loan Exhibition and the procedures surrounding its selection, transportation and installation, see the Getty Archive, Santa Monica; a copy exists in the Archive, Royal Academy of Arts Library.

Fig. 2
James and F. P. Stephanoff
(c. 1787–1874 and c. 1788–1860)
The British Institution in 1816 1817
Pen and watercolour, 20 x 29.4 cm
Victoria and Albert Museum, London

through the sale of entry tickets and catalogues to the annual Summer
Exhibition, the Royal Academy experienced a notable growth in income
over the period 1869–1900. While it had netted an average income of
£10,000 per annum between 1850 and 1869, the first Summer Exhibition to
be held at Burlington House recorded a 50% rise in income, with net
receipts from 315,000 visitors standing at £15,000. By 1879, the number
of visitors had risen to an unprecedented 391,190, a staggering 115,000
catalogues had been sold and the net receipts from the exhibition had risen
to £20,814. For the subsequent twenty years, the average attendance stood
at 355,000 per year. The Winter Loan and Memorial Exhibitions never
achieved this same level of popular attendance or financial success: the
first Winter Exhibition of 1870 achieved a gross profit of £3000 (in contrast
to the Summer Exhibition of the same year which netted £17,000), and
the majority of the Memorial Exhibitions were equally more restrained,
although that held for Sir Edwin Landseer RA in 1874 drew an attendance
of 105,000 visitors and sold 30,000 catalogues. With returns of these
magnitudes, the Royal Academy remained solvent throughout the period
of Queen Victoria's reign, despite having had to pay out of its own reserves
the sum of £115,000 for the construction of the new galleries, the Schools
and the adaptations to the third floor of Burlington House between 1868
and 1878.[16] It was only in 1908 that the institution registered a deficit for
the first time in its 140 years of existence.

The success of the Annual Exhibitions of works by living artists was
due to a number of interrelated factors. Despite the establishment of the
National Gallery in 1822, the primacy of the Old Masters which had been
largely accepted without criticism since the 18th century gradually ceded to
contemporary British art during the succeeding century. This new taste was
not only demonstrated in the creation of major private collections by newly
wealthy industrialists such as the army clothier John Sheepshanks[17] and the

16 The Main Galleries and Schools cost £81,000 and the alterations to Burlington House cost £34,000,
 giving a total cost of £115,000. The Royal Academy used £40,000 left to the institution by the sculptor
 John Gibson towards this total cost, leaving a net cost of £75,000 to be found from the Royal
 Academy's core reserves.
17 Sheepshanks left his collection of British art to the South Kensington Museum (later the Victoria and
 Albert Museum); see J Treuherz, q.v.

inventor of the steel pen nib Joseph Gillott but also, after c. 1870, in the pattern of purchases made by the newly established provincial art galleries in major industrial cities such as Birmingham, Liverpool, Manchester and Newcastle as well as in cities of the British Empire such as Sydney and Melbourne.[18] Joseph Gillott's collection, for example, consisted of 525 pictures, of which 305 were of the British School, their selection reflecting his close friendships with many distinguished contemporary artists who were also Royal Academicians, including Turner, Etty and Landseer. When auctioned at Christie's in London in 1872, it was described as 'the noble collection of pictures [which] has enjoyed so world-wide fame, and has long been regarded by connoisseurs – and justly so – as a complete epitome of the English School...'[19] For the newly established provincial art galleries, the rise in the strong sense of national identity from mid-century, coupled with the desire to achieve value for money, led them to acquire the relatively less expensive, and more readily available contemporary art ranging from Turner, Constable and Maclise to Waterhouse, Leighton, Herkomer and Marcus Stone. Bought off the walls of the Royal Academy, through the fast growing world of commercial art dealers, and from provincial exhibitions which regularly included art which had been recently shown on the walls of Burlington House, these works were by artists who had most generally found favour at, and almost exclusively established their names and reputations through, the Royal Academy's Annual Exhibition.[20] The central role of the Annual Exhibition as the arbiter of artistic excellence in contemporary art was confirmed beyond doubt by the bequest of Sir Francis Chantrey RA on his death in 1847. This charged the President and Council of the Royal Academy to purchase 'Works of Fine Art of the highest merit in painting and sculpture that can be obtained [provided that they had been] entirely executed within the shores of Great Britain' in order to establish a gallery of modern British art.[21] Although only activated after the death of his widow in 1875, the bequest from 1877 was used by the Royal Academicians to buy works out of the Summer Exhibition which were normally highly popular with the public and almost exclusively by their fellow Members: genre scenes by William Powell Frith, Marcus Stone, Luke Fildes and William Frederick Yeames; classical subjects by Leighton and Alma-Tadema (cat. 31, 32); portraits by Ouless and George Frederick Watts (cat. 9), as well as works by Sargent, Henry Scott Tuke and the sculptor Hamo Thornycroft (cat. 39). The Royal Academy was thus using its own Members' work and perception of excellence as the touchstone for establishing the canon of the nation's collection of British Art which was initially displayed at the South Kensington Museum and ultimately, after 1897, at the Tate Gallery, Millbank.

The 19th century saw close relationships established between the artist and the collector, the artist and the art market and the artist and the viewing public. This was manifested not only in the crowds who poured into the Annual Exhibition but also in the viewing public's enthusiasm for

18 Herbert von Herkomer, for example, advised on the purchase of works from the Summer Exhibition which formed the basis of the National Gallery of Victoria, Melbourne, Australia.

19 The sale took place in three portions at Christie's, London on 19 and 20 April, 26 and 27 April, and 3 and 4 May 1872. Introduction to the sale catalogue, quoted in George Bedford, *Art Sales*, 1888, vol. I, pp. 184 ff.

20 See G. Waterfield, 'Art Galleries and the Public: A Survey of three Centuries', in *Art Treasures of England*, exhibition catalogue, Royal Academy of Arts, London, 1998, pp. 13–59.

21 Sir Francis Chantrey's Will, 31 December 1840, quoted in S. Hutchison, op. cit., p. 107.

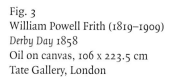

Fig. 3
William Powell Frith (1819–1909)
Derby Day 1858
Oil on canvas, 106 x 223.5 cm
Tate Gallery, London

specific works: barriers had to be erected in front of Frith's *Derby Day* (fig. 3) and *The Railway Station* (Royal Holloway College, University of London) when they were exhibited at the Annual Exhibitions of 1858 and 1862 respectively, as was also the case when Elizabeth Lady Butler exhibited her *Calling the Roll after an Engagement, Crimea (The Roll Call)* (fig. 4) in 1874. This relationship was reinforced by several institutions or practices. Engravings of works exhibited in the Annual Exhibition spread access to such art to a wider audience. This was particularly potent after the founding of the Art-Union of London in 1841 which for the cost of a guinea gave subscribers the chance to win a painting in a lottery and the guarantee of an engraving after a famous painting by an English artist. Secondly, the development of the commercial art galleries from the later 1840s brought dealers into association with the Annual Exhibition. Frith's *Derby Day* illustrates both of these factors: not only was the painting commissioned and purchased for £1500 by a private individual, Jacob Bell, prior to being shown at the Annual Royal Academy Exhibition in 1858 but the artist also sold the engraving rights to the work to his dealer Ernest Gambart, for £1500.[22] These sums were not insignificant, and confirmed the rising economic status of the successful artist, epitomised in the finances of most Royal Academicians in the 19th century. Such financial returns permitted the artist to advance his social standing from craftsman to gentleman, a move which was sealed in many cases by the acquisition of purpose-built 'artists houses', such as those commissioned from Richard Norman Shaw by such Academicians as G. F. Watts, Luke Fildes, Marcus Stone (fig. 5). The engagement of the artist with his public was further supported after 1870 by the institution of studio viewing days held

Fig. 4
Elizabeth Thompson Butler (1846-1933)
Calling the Roll after an Engagement, Crimea (The Roll Call) 1874
Oil on canvas, 92.7 x 183.3 cm
Royal Collection, by permission of Her Majesty the Queen

22 See P. Gillett, op. cit., pp. 85–6.

prior to the Summer Exhibition ('Show Sunday', open studio Saturdays and Sundays)[23] and by the growing world of art critics and the art press. By the 1880s, for example, it was possible for *The Times* to give a detailed preview of what each prominent Royal Academician was proposing to show at the forthcoming Summer Exhibition. After listing the productions of Leighton, Burne-Jones, Alma-Tadema, Poynter, Parsons, Boughton, Hamo Thornycroft and Gilbert, among others, the author declares: 'A week or two hence the public will be able to judge for themselves [the quality of the exhibition]'.[24]

The apparently dominant position of the Royal Academy in the 19th century had to be defended in the face of persistent investigation from the government, mounting criticism from other artists and the cultivated visitor, and growing competition from alternative professional bodies, exhibition organisations and teaching institutions. Already, within the first two decades of the 19th century, the Royal Academy had been brought to task by William Hazlitt for its failure either to establish a triumphant British School of History Painting or to educate and expand a public taste capable of supporting contemporary art through connoisseurship or patronage.[25] In 1836, the Select Committee had found wanting the Schools. In 1834, 1839 and 1844, there were calls from Parliament that the institution should be publicly accountable. In all three instances, the Royal Academy appealed to the most powerful politicians of the day, Sir Robert Peel and Lord Melbourne, and the principle of the institution as a private, non-state funded organisation and hence free from public scrutiny was reaffirmed: 'I had the greatest satisfaction in ... considering the independence and free action of the institution to be essential instruments of its success, I shall always be disposed to claim for it protection from needless or vexatious interference.'[26] In anticipation of the eventual resolution of the pressure on space in the National Gallery building at the end of the 1850s, a Royal Commission was set up in 1863 to 'inquire into the present position of the Royal Academy in relation to the Fine Arts, and into the circumstances and conditions under which it occupies a portion of the National Gallery, and to suggest such measures as may be required to render it more useful in promoting Art and in improving and developing public taste'.[27] While acknowledging that the institution was 'of great service to the country, in assisting to keep up and to cultivate a taste for Art',[28] the Commission was severe in its recommendations covering the representative nature of the Membership, the organisation of the Annual Exhibition and the teaching in the Royal Academy Schools. Most importantly, the Commission recognised the need for the Royal Academy to acquire new and more spacious accommodation, and recommended that, in return for

23 Ibid., pp. 193–6.
24 *The Times*, 1 April 1886.
25 See P. Funnell, 'William Hazlitt, Prince Hoare, and the Institutionalisation of the British Art World', in B. Allen, ed., *Towards a Modern Art World (Studies in British Art I)*, London and New Haven, CT, 1995, pp. 145–56.
26 Sir Robert Peel, quoted in RA General Assembly Minutes, vol. IV, p. 318.
27 *Report of the Commissioners appointed to inquire into the present position of the Royal Academy...and the Minutes of Evidence*, London, 1863.
28 Ibid., p. v.

financial support from the State and a reconstruction of its Membership on 'a wider and more liberal basis'[29] the Royal Academy stood to become 'a valuable permanent Council of advice and reference in all matters relating to the Fine Arts, public monuments, and buildings'.[30] The Academy's determination to retain its independence from the government meant that it both reaffirmed its willingness, initially made to Disraeli in 1859,[31] to finance out of its own funds its new accommodation and chose to distance itself from the immediate implementation of the Commission's recommendations.

A culture of cautious reform within the Royal Academy had nonetheless been in existence for several decades before 1863. The Schools, for example, had undergone some reorganisation following the Select Committee of 1835. Furthermore, the call for published accounts was eventually met with the publication of the first Annual Report in 1860. But reform had wider implications; it addressed issues concerning the institution's ability to represent the artistic community and its willingness to make the Fine Arts more accessible. Representation of the artistic community directly involved the number and character of the Membership of the Royal Academy. Since its foundation in 1768 it had remained numerically small, inclined to 'nepotistic' practices and resolutely determined to guard its Members' privileges regarding the numbers of works and their placement in the Annual Exhibition. In 1866, a decision was taken to increase substantially the number of Associate Royal Academicians but no specific action took place until 1876 when five new Associate Members were elected.[32] In 1868, the Academy introduced the class of Foreign Member known as Honorary Academicians, and the following year proceeded to elect six European artists into this category.[33] In order to make the Selection Committee of the Annual Exhibition more representative, the Academy in 1871 increased its numbers to twelve (subsequently reduced to ten in 1878) and determined that it must always include at least five painters, an architect, a sculptor and an engraver. However, the Academy failed to reflect the growth in the number and quality of female artists, demonstrated as much in the establishment of the Female School of Art in 1842, the institution of the Society of Female Artists in 1856, the admission of the first female student into the Royal Academy Schools in 1860 and into the Slade School of Art from its inception in 1871. In 1879 Elizabeth Lady Butler missed election to Associate Membership by two votes, the place being won by Herkomer. It was not until the election of Annie Swynnerton to Associate Membership in 1922 that this inequality was haltingly, and belatedly corrected.

The need to fulfil its remit to expand the taste for the Fine Arts produced a number of responses from the Royal Academy. As early as 1862, the Academy instituted three 'late night' openings per week during the run of the Annual Exhibition at a 50% reduction in the price both of entry and of the catalogue 'for the admission of the working classes'. Following the removal to Burlington House and the introduction by the government of an annual August Bank Holiday in 1871, the last week of the Annual Exhibition

29 Ibid., p. viii.
30 Ibid., p. xii.
31 RA Council Minutes, vol. XI, p. 280.
32 Eyre Crowe, Edwin Long, John Wright Oakes, George Adolphus Storey (all painters), and Frederick William Woodington (sculptor).
33 Louis Gallait (Belgian); Claude Guillaume, Louis Pierre Henriquel-Dupont, Ernest Meissonier, Jean Léon Gérôme and Eugène Emmanuel Viollet-le-Duc (French). Subsequent Honorary Academicians to be elected before 1901 included Adolf Menzel (1896) and Jules Breton (1899).

not only included all late nights at half price but also involved prolonging the closure of the exhibition by one day, also at half price, in order to incorporate the Bank Holiday. The impact on visitor numbers was appreciable: in 1881, 8290 visitors came on the August Bank Holiday Monday. To assist this broader audience, the Royal Academy instituted Press Viewing days in 1871 (fig. 6). Descriptive catalogues were also published from 1875, a selection of paintings and sculpture were illustrated in *Royal Academy Pictures* from 1888 and there was a considerable growth in the critical coverage in the press, from a small group of writer-critics such as Thackeray, Ruskin, W. M. Rossetti, F. T. Palgrave and P. G. Hamerton, to the emergence of professional art critics such as D. S. MacColl, Roger Fry and George Bernard Shaw and regular coverage in the daily press.

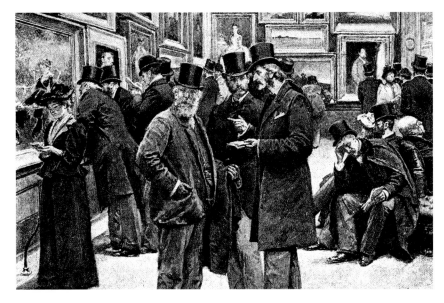

Fig. 6
Wal Paget (1863–1935)
'Press Day at the Royal Academy'
Magazine of Art, March 1892
Royal Academy of Arts

That the Royal Academy had consistently been an object of attack from the government, critics and excluded artists in one respect testifies to its generally perceived position as arbiter of excellence in the Fine Arts. Despite veiled criticism from John Ruskin in *The Times* of 1851 that 'I believe that there are so few pictures at the Academy whose reputation would not be grievously diminished by a deliberate inventory of their errors',[34] the general perception of the Royal Academy, its Members and its Annual Exhibitions in mid-century was best summarised by a contributor to *The Art Journal* in 1856 who saw the art world, epitomised by the Royal Academy, through a haze of patriotic cultural euphoria:

> Looking at the histories of the various schools of painting since the revival of Art, it may be affirmed, without fear of contradiction, that not one presents a case of rapid improvement parallel to our own. It occupied the Italians three centuries from the thirteenth to the fifteenth to develop their school, and another century firmly to establish it. Fifty years have sufficed to place England on a level with the best Art-epoch of the continent.[35]

During the ensuing four decades, however, critics were the prescient seers of the erosion of the Royal Academy's artistic monopoly. In 1878, from a position informed by developments in both contemporary French and British avant-garde art, the American author and art critic Henry James commented somewhat negatively that, 'I suspect that there is little doubt that the exhibition of 1878 is decidedly weak. It is not an exhibition from which it would be agreeable to the indigenous mind to think that a Frenchman, a German or even an Italian, should derive his ultimate impression of contemporary English art'.[36] Fifteen years later, Arthur

34 Letter addressed to the Editor and dated 26 May 1851, published in *The Times*, 30 May 1851.
35 Quoted in B. Denvir, op. cit., p. 4.
36 Unsigned notes. Originally published in *The Nation*, 6 June 1878; reprinted in H. James, *The Painter's Eye: Notes and Essays on the Pictorial Arts*, ed. J. L. Sweeney, University of Wisconsin Press, 1989, p. 167.

Tomson, in *The Studio*, concluded that the Royal Academy Annual Exhibition had replaced its responsibility to enlarge public taste in the Fine Arts with outright commercialism which favoured 'the [art] object painted in such a manner that the imagination of the spectator should never be troubled'. Tomson concludes that this approach demonstrates that 'surely the charge of commercialism is proven by the most cursory visit to Burlington House' and that 'therefore, no wonder that the collection at Burlington House is not very notable and is not in any way representative of the art of this country'.[37]

Tomson had come to this less than complimentary view of the Royal Academy through comparison with the art exhibited contemporaneously at other venues in London: 'Compare the walls with those of the Grafton Gallery, the New Gallery, or the New English Art Club'.[38] Had he been writing ten years earlier, Tomson would have substituted the New Gallery for the Grosvenor Gallery, the former established in 1887 and effectively inheriting the latter's mantle on its demise in 1890. Indeed, by the close of the 19th century, the Royal Academy's monopoly on the exhibition of contemporary British art at its Annual Exhibition had been seriously eroded. This was in part due to the dramatic increase in the number of professional artists during the century whose clamour for exhibition space had brought into existence a plethora of societies, from the British Institution founded in 1805, the two watercolour societies founded 1804 and 1832, and the Royal Society of British Artists established in 1823, to the appearance of specialist, media-determined societies at the end of the century such as the Royal Society of Painter-Engravers (1880) and the Pastel Society (1898).[39] The monopoly was also challenged by the creation and expansion of commercial art galleries in London following the opening of the London branch of T. Agnew and Son in 1860 which increasingly provided attractive alternative venues for artists to reach the public. Equally important was the obduracy among the majority of the Royal Academicians in incorporating into its Membership or reflecting in its selection of works for the Annual Exhibition changes in both subject matter and technique which newer generations of artists, in part under the influence of contemporary developments in French art, chose to foster. This younger generation of artists was to find alternative exhibition space on the walls of the Grosvenor Gallery, founded by Sir Coutts Lindsay in 1877 (fig. 7),[40] at the New English Art Club, founded in 1886, and at the International Society, established in 1896 with James McNeil Whistler as its first president. To be sure, the Royal Academy intermittently registered its awareness of external competition: the then President of the Royal Academy, Sir Francis Grant, and Frederic Leighton, chose to buy off the Grosvenor Gallery as a potential rival to the Royal Academy's Summer Exhibition by showing at the former's inaugural exhibition in 1877, and Leighton, in 1890, succeeded in having a founder member of the New English Art Club, George Clausen (fig. 8), elected to

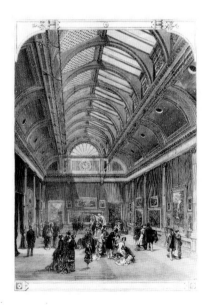

Fig. 7
'The Grosvenor Gallery of Fine Art, New Bond Street'
Illustrated London News, 5 May 1877
Wood engraving
The Illustrated London News Picture Library

37 Arthur Tomson, *The Studio*, June 1893, reprinted in B. Denvir, op. cit., p. 239.
38 *Idem.*
39 For the British Institution, see Joanna Pomeroy, 'Creating a National Collection: The National Gallery's Origins in the British Institution', *Apollo*, August 1998. For later institutions, see Julie F. Codell, 'Artists' Professional Societies: Production, Consumption, and Aesthetics', in B. Allen, op. cit., pp. 169–87.
40 For the Grosvenor Gallery, see S. P. Casteras and C. Denney, ed., *The Grosvenor Gallery: A Palace of Art in Victorian England*, Yale Center for British Art, New Haven, CT, 1996, and Christopher Newall, *The Grosvenor Gallery Exhibitions: Change and Continuity in the Victorian Art World*, Cambridge, 1995. For the New English Art Club, see *Impressionism in Britain*, exhibition catalogue, Barbican Art Gallery, London, 1995.

Associate Membership. Other 'radicals' such as Stanhope Forbes and Frank Bramley were elected in 1892 and 1894 respectively, the latter year also seeing the elections of John Singer Sargent and the symbolist sculptor George Frampton. Millais presided over the election in 1898 of another 'radical', Henry Herbert La Thangue.

Frederic Leighton died in 1896. Sir John Everett Millais, who succeeded him as President of the Royal Academy died six months later. Queen Victoria died in 1901. The Royal Academy had weathered a century of change, its financial independence intact, its freedom of action unshackled by the State, its role within British art still the subject of intense and continual debate. In 1837, the Royal Academy could justly claim leadership of a relatively unified British art world. In 1907, Walter Crane in his *Artist's Reminiscences*, saw this world as fragmented, dominated by cliques and by small groups of artists in which the Royal Academy seemingly had little place.[41] The situation was in fact less bleak for the institution than Crane suggested. Rather, the expansion both quantitatively and qualitatively in the provision of professional art training, and the proliferation of alternative exhibiting bodies served to place the Royal Academy within a broader artistic culture within which it could more readily engage in shaping the visual arts in the new century:

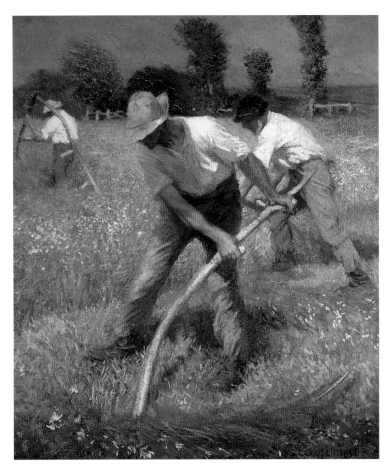

Fig. 8
George Clausen (1852–1944)
The Mowers 1891
Oil on canvas, 97.2 x 26.2 cm
Usher Gallery, Lincoln

Have the critics who take the line that all the ills of art can be laid at the doors of the Royal Academy, ever reflected what would be the result of the following experiment? Let us suppose the galleries at Burlington House extended, and an infusion made each year of all the modern paintings in the New English Art Club and the International, would the artistic temperature of the Academy be raised by a fraction of a degree? Are not many of the salient exhibitors the same in all three exhibitions? Dare any society open its doors without a water-colour or two by Sargent? Can it be maintained that when Mark Fisher has a picture in the New English Art Club he is considered on the side of the angels, and that canvases by the same able hand are works of damnation when they are hung on the north side of Piccadilly? Can the New English Art Club claim to express an aesthetic creed altogether higher than, and differing from that of the Academy...? No critic who was not purely partisan would say so.[42]

41 Walter Crane, *An Artist's Reminiscences*, London, 1907, p. 297.
42 Walter Sickert, 'The Royal Academy', *The English Review*, August 1912, reprinted in *A Free House! The Writings of Walter Richard Sickert*, ed. O. Sitwell, London, 1947, p. 74.

THE ROYAL ACADEMY SCHOOLS IN THE VICTORIAN PERIOD

Helen Valentine

'Wherever Art institutions are set up or exhibitions opened' the advice and assistance of the Royal Academy is sought 'and thus the authority of that body, like the restless and ravenous feelers of a huge polypus, is extended, and clutches its prey in all directions'[1]. Such was the perception of J. P. Davis in 1858, a painter, and certainly no friend to the Academy, and it was a view echoed, less virulently, in the art press from the 1850s. For most of the 19th century the Academy was undoubtedly the most influential art institution, and its élite body of Members was consulted on every major project concerning matters of taste, was employed at the Government Schools of Design, held important posts in national art institutions, and maintained a strong presence in the commercial art world with its Annual Exhibitions. That a privately funded, autonomous institution could maintain such power was partly due to lack of government sponsorship of the arts, but also to the authority it derived from the Royal Academy Schools. The Academy's involvement in, and commitment to, teaching gave it a seriousness and purpose beyond the selling of art. Many highly successful artists trained in the Schools, and in 1860 the Academy's Annual Report stated that three-quarters of the current Membership had studied in the Schools including John Everett Millais, Edwin Landseer, Daniel Maclise and William Powell Frith.

Despite (or perhaps because of) its influence, the Academy and its Schools did not escape criticism. The most serious attack came in a report from the 1835 Select Committee on the Arts and their Connection with Manufactures. The Academy was under public scrutiny because of the proposed move from a royal palace, Somerset House, to a building erected at public expense, the new National Gallery. This gave the Radicals in parliament such as William Ewart (1798–1869), member for Liverpool, and a man responsible for founding public libraries throughout the country, the justification to look more closely at the Academy's affairs. The report, delivered in 1836, found fault with certain aspects of the teaching in the Schools and in particular criticised the emphasis on drawing from life and the omission of any practical training in technique or composition. It was also noted that elected Professors often failed to deliver their lectures over considerable periods.

The President, Sir Martin Archer Shee, was unrestrained in his response, feeling that the Academy had been subjected to 'a rigid scrutiny', and that the report itself was 'a farrago of folly, vanity, and egotism' which contained 'misrepresentations so palpably absurd – so ludicrously malignant'.[2] The report had little or no effect on the running of the Royal Academy Schools, but led instead to the government establishing its own Schools of Design in 1837. These were not created, however, in direct

1 J. P. Davis, *The Royal Academy and the National Gallery*, London, 1858, p. 12.
2 Sir Martin Archer Shee, *A Letter to Lord John Russell on the Alleged Claim of the Public to be admitted Gratis to the Exhibition of the Royal Academy*, London, 1837, p. 27.

competition with the Academy but were aimed at raising standards in design of manufactured goods and thus laid much emphasis on the teaching of ornamental design.

Discussions over future accommodation of the Academy once again prompted the government to act by setting up a Royal Commission in 1863 to 'inquire into the present position of the Royal Academy in relation to the fine arts'. This Commission, although far more sympathetic to the Academy than the 1835 Select Committee, again criticised its teaching methods. It was felt that a more thorough, broader syllabus should be overseen by instructors of different departments, who would be guided by a general Director of the Schools rather than by the current part-time Keeper, and that this position should be open to all artists, not just Academicians. It was further suggested that a public Annual Exhibition of students' work should be held and that the subject of chemistry, as applicable to art, should be taught. Of all these recommendations only the latter was taken up with the appointment of a Professor of Chemistry in 1871.

Any further interference from the government was stalled by the move of the Academy out of the National Gallery to new purpose-built premises at Burlington House. Over the gardens of the original house the Academy built the Schools, at its own expense, with top-lit north-facing studios, and above these, an impressive suite of galleries together with a lecture room. The students greatly benefited from this extra space and could now for the first time work throughout the year with only a two-month vacation in the summer.

The teaching methods in the Schools were relatively untouched by the move to Burlington House, and in fact had changed little since the first student entered the Academy in 1769. The length of study for a student was originally six years, but this had increased to ten in 1800. However, throughout the 19th century it was slowly reduced again to seven years in 1853, six in 1881, and finally to five in 1889. The decision was also made in 1881 to divide the study into two terms of three years, and to have an Upper and Lower School of Painting and Modelling. A Keeper, elected from the Royal Academicians, was in overall charge of the Schools and undertook the teaching in the Antique and Painting Schools.

Entry to the Schools was open to anyone with a demonstrable talent for drawing or modelling. Applicants submitted a finished drawing, about two feet high, of an undraped Antique statue, or, if the drawing was of a torso, it had to be accompanied by drawings of a head and hand or foot. Sculptors had to send a model or relief of a similar subject. Most students prepared for entry to the Royal Academy at another art school. Many artists from the 1840s attended Henry Sass's School of Art in Bloomsbury which, from 1842, was run by Francis Stephen Carey, or J. M. Leigh's Academy which, after 1860, became Heatherley's Art School. The number of art schools increased steadily throughout the 19th century and by 1895 Tessa Mackensie's guide to London art schools listed 35 in London alone.[3] Not all these were preparatory schools for the Academy and some, such as the Slade School, founded in 1871, were direct rivals. The Academy Schools, however, continued to hold their position as the most prestigious place of study until the end of the century.

3 Tessa Mackensie, ed., Art Schools of London: A Description of the Principal Fine Art Schools in the London District, London, 1896.

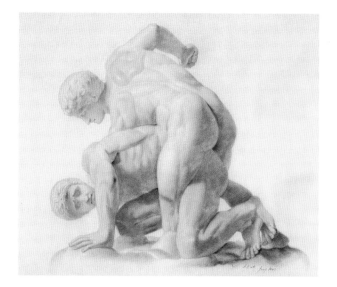

Fig. 1
Sir Edwin Landseer RA (1802–73)
Fist from cast of the Laocoon c. 1816–17
Chalk on brown paper, 38 x 36 cm
Royal Academy of Arts

Fig. 2
Sir John Everett Millais RA (1829–96)
The Wrestlers 1842
Pencil on white paper, 49 x 63.2 cm
Royal Academy of Arts

Fig. 3
William Carter (1863–1939)
Male Standing Nude 1882
Chalk on pencil on white paper,
72.4 x 39.4 cm
Royal Academy of Arts

If an applicant's drawing was approved by the Keeper, he or she was admitted as a 'Probationer', which meant he or she was given three months to prepare a set of drawings or models in the Academy, including a skeleton and an anatomical figure. If these were accepted by the Council (the ruling body of the Academy) as showing sufficient promise, the student was formally enrolled in the Antique School, where he could draw from an impressive collection of plaster casts, many of which had been presented to the Academy by the Prince Regent in 1816. The casts were nearly all taken from Greek and Roman statues, busts and architectural fragments, although there were a few casts after Renaissance sculptors such as Michelangelo and Donatello. Students were required to produce a series of finished drawings and attend classes on perspective, as well as other lectures given by the various professors, before they could proceed to the Life School. The Academy clung to this progression from the Antique to Life as students were supposed to strive for the ideal, in the Albertian sense, and improve on any imperfections the model might have. Although there was a growing emphasis on realism in the 19th century, and increased aesthetic appreciation in the individuality of models, this did not change the methods of teaching. There was, however, a noticeable change in the style of drawing from the life and Antique. Whereas previous generations had drawn in chalk on tinted paper with white chalk highlights and a background of various tones (fig. 1), students of the 1840s and '50s worked up drawings 'with the stump[4] or point to a high finish' and they were executed on white paper with 'the outline sharply defined with…a distinct edge, the white paper forming the background throughout'[5] (fig. 2). By the 1880s white paper was still commonly used but there was less concern with broad modelling with the use of the stump and more attention given to a detailed representation of the surface (fig. 3).

Teaching in the Life School was undertaken solely by Royal Academician 'Visitors'. Royal Academicians were elected as Visitors and served in rotation for nine months of the year. From 1868 Associate Members of the

4 A stump was a tightly rolled piece of leather or paper which was used to spread chalk or pencil for areas of shading, and was particularly effective in creating volume.
5 G. D. Leslie, *The Inner Life of the Royal Academy*, London, 1914, p. 10.

Academy were also eligible to teach as Visitors. Each Visitor attended for a month, setting the models and examining and instructing the performances of the students. Opinions as to the efficacy of the system were divided, and much evidence on this was collected by the 1863 Commission. Some believed that the stimulation of different eminent artists far outweighed the benefits of a sustained, consistent programme of tuition. Many Academicians including C. W. Cope, Richard Westmacott and Richard Redgrave proposed various reforms, such as having permanent teachers or masters, and although discussed in the Council Meetings and General Assemblies, decisions were constantly deferred. Redgrave concluded after three years on Council that it 'has been three years of battle; for while changes were rife in Art, the Academy hung on to the old constitution and officers'.[6] Even in 1901 Alfred Gilbert concluded that 'the periodical visits of Members is useless, bewildering and expensive' and that the 'entire absence of anything like Elementary teaching, incurs necessary loss of time, both to the student and Visitor'.[7]

One problem with the Visitor system was the variable quality of the teaching; some Members took their responsibilities very seriously and put great effort into their classes while others were less diligent. Visitors had to set the model who would pose for two hours, excluding rests. The model would keep the same pose for three or four nights and students would draw lots for their places. There were both male and female models and often on the last night of a Visitor's month treats were set. Constable, for example, in 1831 set two male models in poses mimicking Michelangelo's *Last Judgement* and on another occasion set up a female model as Eve and had great boughs of trees brought from Hampstead Heath, at his own expense, to create a garden of Eden.[8] Daniel Maclise also related that there were sometimes 'a group of Graces, now, a composition of two or three gladiators...sometimes a Manikin in armour contrasted with the flesh; sometimes a child with a woman'.[9]

From the middle of the 19th century there was a growing unease and a religious and moral questioning of the use of female nude models, both from inside and outside the artistic profession. In England, unlike France and Italy, the nude was not a common subject for exhibited paintings, and thus the need for nude models was debated, particularly for the state funded Government Schools of Design, which were after all set up to train artists to design manufactured goods. In 1860 Lord Haddo moved in the House of Commons that these schools should not be funded if they employed a living female model. Although the motion was defeated, the subject continued to be discussed and the Academy was not untouched by this debate. Edwin Landseer raised the possibility of the models at the Academy being partially draped. Council however felt that 'any partial concealment for considerations of decency would tend to attract attention to what might otherwise pass unnoticed', but they could recommend that Visitors 'dissuade students from bestowing unnecessary attention on unimportant parts, especially when decency suggests their being passed over'.[10]

6 F. M. Redgrave, *Richard Redgrave, a Memoir*, London, 1891, p. 331.
7 Alfred Gilbert, 'Visitor's Report from Modelling Life School', 7 January–2 March 1901, RA Archives no. 1323.
8 P. Leslie, ed., *The Letters of Constable to C. R. Leslie*, London, 1931, pp. 22, 163.
9 A. Gilchrist, *Life of William Etty*, London, 1855 vol. II, p. 58.
10 RA Council Minutes, 1861, p. 205; quoted in Alison Smith, *The Victorian Nude: Sexuality, Morality and Art*, Manchester and New York, 1996, p. 33.

THE MODEL "BRITISH MATRON."

Mr. H-rel-e, R.A. (as the M.B. Matron). "Oh dear! Oh dear! Who could ha' sat for that?"

Fig. 4
The Model 'British Matron'
Cartoon by Linley Sambourne
Punch, 24 October 1885
Punch Library and Archive

In 1873 the Academy expressed concern that the rules governing the Life Room were not being respected and ordered that a copy of the relevant law should be pinned up outside the room, which stated that 'none but Members of the Academy or Students of the School shall be admitted when the female model is sitting, nor shall any student under twenty years of age (unless he be married) be allowed to study from that model'.[11]

The argument that no respectable women should model in the nude, and that no woman should be encouraged or persuaded to do so, was fuelled by J. C. Horsley in 1885. In October of that year he gave a speech to the Church Congress where he asked 'where is the justification in God's sight for those who induce women so to ignore their natural modesty, and quench their sense of true shame, as to expose their nakedness before men and thus destroy all that is pure and lovely in their womanhood?'[12] Horsley's speech was used as part of a wider campaign aimed at preventing any representations of the female nude being exhibited. The supporters of this proposal were however in the minority and the tradition of the nude and its connection to the most elevated works of art were upheld, and Horsley was ridiculed in the press for his views and dubbed 'Clothes Horsley'. A cartoon published in *Punch* (fig. 4), depicted Horsley dressed as a British Matron[13] looking at the *Venus de' Medici* and asking, 'Who could ha' sat for *that*?', thus pointing out the absurdity of an argument which would not only exclude nudes from contemporary painting but would also apply to earlier works of art, including the masterpieces of the Ancients.

Students were allowed to paint from the living draped model in the Painting School from 1847 at the instigation of the Keeper, George Jones. Originally the Painting School was set up in 1815 to copy paintings. Throughout the 19th century the Academy collected copies of Old Master paintings for this School, such as a copy attributed to Anton Raphael Mengs after Raphael's *Madonna di Foligno* which was purchased in 1859 at a sale of Lord Northwick's pictures. In addition pictures were borrowed from private collectors and from the Dulwich Picture Gallery. Of the many paintings loaned from Dulwich, works by Van Dyck remained the most popular during the 19th century and works by Rembrandt, Velazquez and Murillo were increasingly requested as opposed to history paintings and classical landscapes, which were not asked for after the 1860s.

In addition to their attendance in the Antique, Life and Painting Schools, students were expected to attend lectures given by the Professors of Painting, Sculpture (established 1810), Architecture (for architectural students), Perspective, Anatomy and Chemistry (established 1871). The most important annual event for students was the prize-giving ceremony on 10 December, the Academy's birthday. Medals and awards were given for various categories including a gold medal for a historical painting, silver medals for painting a figure from life or copying an oil painting, and premiums for drawing from a cast. The ceremony was described during Lord Leighton's presidency as 'a most brilliant affair' when 'Lord Leighton delivered one of his eloquent discourses' and that 'the applause was long and loud as the young ladies, in pretty evening dresses, received their

11 RA Annual Report, 1873, p. 24.
12 J. C. Horsley, *Art Schools and Art Practice in their Relation to a Moral and Religious Life*, Derby and London, n.d. [1885], p. 2.
13 This was a reference to an earlier letter in The Times from 'A British Matron' complaining about paintings of nudes exhibited at the Royal Academy and the Grosvenor Gallery which was in fact written by Horsley himself.

Fig. 5
'The 10th of December – Prize Day'
Magazine of Art, 1888, p. 61
Royal Academy of Arts

medals with smiles and blushes'[14] (fig. 5). Once the Academy had moved to Burlington House the largest gallery, Gallery III, was transformed for the event and many Members were in attendance as well as the students and their families. The successful students' work was put up in the galleries for the visitors to study after the prize-giving.

The most prestigious prize was the travelling scholarship, which originally provided for a student to reside abroad for three years. This was reduced to two years in 1854 and one year in 1881 as the importance of the scholarship waned as travelling became easier and there was less priority given to the study of the Old Masters. In 1892 Philip Hermogenes Calderon, Keeper at the Academy, explained that the original intention was 'to spend a year studying in some recognised Art Centre...the works of great masters' but that now a 'new interpretation has lately come into vogue' and that the students 'now consider themselves at liberty to spend their time in any place and in any manner most agreeable to themselves – beginning their travels by a visit to Southern Spain and Morocco, chiefly in search of subjects, and finishing their year by a more or less rapid tour through Italy and Switzerland'.[15]

There was another more fundamental change in the Schools in 1860 when the Academy unwittingly accepted Anne Laura Herford as the first female student.[16] She had submitted her drawings for acceptance as a Probationer signed only with her initials and surname. As there was no law against admitting women as students she was accepted. This was not an isolated act of rebellion as throughout the 1850s pressure had been put on the Academy to admit female students. Herford attended evening classes, including drawing from the undraped model at the home of Elizabeth Florence Fox, who ran these classes from 1848 until her marriage in 1859. It was from here that female artists including Barbara Bodichon and Anna Mary Howitt set up the Society of Female Artists in 1856 and campaigned for admission to the Academy Schools. In 1859 a memorial was sent to all

14 G. D. Leslie, op. cit., p. 54.
15 RA Annual Report, 1892, p. 32.
16 Herford's career was brief as she became a nurse in 1870 following an outbreak of cholera, and died shortly afterwards from too great an administration of chloroform given to relieve neuralgia.

Royal Academicians and was also published in the *Athenæum* requesting that the Schools be open to women as 'no less than one hundred and twenty ladies have exhibited their works in the Royal Academy alone, during the last three years, and the profession must be considered as fairly open to women'.[17]

Following Herford's success four other female artists were admitted in 1861 and another six the following year. None however was accepted from 1864 to 1867 on the grounds of lack of space, but once the Academy moved to Burlington House admissions increased to about twelve a year. The next obstacle was to persuade the Academy to allow female students to draw from the undraped life model as admission to the Schools for women was only for the Antique and Painting Schools. Gertrude Massey studying in the 1880s complained of the problems of being denied access to the nude as 'we were supposed to accept the conventional point of view that women had no legs. They had heads, arms and feet, apparently linked together by clothes'.[18] It was possible to arrange to study from the life elsewhere. Lady Elizabeth Butler, the famous painter of battle scenes and military life, entered the Academy Schools in 1866 but recalled that she had to join 'a class in Bolsover Street for the study of the 'undraped' female model and worked very hard there on alternate days'.[19] It was not always easy, however, to find life classes outside the Academy. Sir Hubert von Herkomer ran his own art school in Bushey, Hertfordshire, from 1884 which purported to give the same privileges to male and female students unless the female students were married. Gertrude Massey 'went to see him in his studio, but he refused point blank even to glance at my work and told me bluntly to go home and make puddings'.[20]

Women students strove to redress the inequality in the provision of training and facilities at the Academy and petitioned the Members for their own life class throughout the 1870s and 1880s. The petitions became increasingly forthright in their demands. In 1878 they merely requested to draw from the semi-draped model without which they could not 'hope to rise above mediocrity, at any rate, in the highest branch of our Art'.[21] By 1883 the female students pointed out that they were serious artists who 'rely on the profession we have chosen as our future means of livelihood, and that therefore, a class which is considered so essential to the training and success of male students must be equally so to us'.[22] The petition in 1891 was to study from the nude female model and the partially draped male model as the 'lack of this training places women at a very great disadvantage'.[23] Finally in 1893 it was resolved to allow female students to draw from a male model undraped except around the loins. The exact manner of draping was only agreed in 1894 and was to consist of 'ordinary bathing drawers, and a cloth of light material 9 ft long by 3 ft wide, which shall be wound round the loins over the drawers, passed between the legs and

17 *Athenæum*, 30 April 1859.
18 Gertrude Massey, *Kings, Commoners and Me*, London, 1934, p. 3; quoted in C. Yeldham, *Women Artists in Nineteenth-Century France and England*, New York and London, 1984, pp. 34–5.
19 Elizabeth Butler, *An Autobiography*, London, 1922, p. 46; quoted in F. Borzello, *The Artist's Model*, 1982, p. 28.
20 G. Massey, op. cit., p. 13; quoted in C. Yeldham, op. cit., p. 38.
21 Petition of female students to be allowed to draw from semi-draped model, 4 April 1878, RA Archives RAC/5/8.
22 Petition from female students for partially draped model, 4 December 1883, RA Archives RAC/5/18.
23 Petition from female students to study from nude woman model and partially draped male, 10 December 1891, RA Archives RAC/5/33.

tucked in over the waistband' and to prevent any accidents 'a thin leather strap shall be fastened round the loins in order to insure the cloth shall keep its place'.[24]

The contemporary perception of the female students in the 1880s was varied. An article on the Schools in 1887 by M. H. Spielmann describes the women as 'all pinafore-aproned and neat' and that they 'may be seen exchanging confidences...or more practically eating sandwiches under cover of the 'Dancing Faun' during the eleven o'clock 'long rest' which the male students often pass at a billiard-saloon hard by'[25] (fig. 6). The article claimed that there was 'no love lost between them' and that 'the men regard the girls as interlopers and intruders, who claim men's rights when men have an advantage – such as the opportunity of studying from the nude' but that 'the girls take a feminine pleasure, generally speaking, in snubbing the men, regarding them evidently as selfish, noisy, and above all, ineligible specimens of their sex'.[26] W. P. Frith also comments that the women almost equalled the men and from whom 'they constantly carry off prizes'.[27] However, the statistical evidence shows that between 1880 and 1901 there were 308 male students and 110 female students of which 41% of male students won prizes as to 28% of the female.

Despite these tensions, the 1880s and '90s saw students developing their own social life in the form of clubs, mixed teams of hockey and tennis as well as dances, fancy-dress balls and dramatic productions. In 1895 the Royal Academy Dramatic Club produced an elaborate production titled *Pallettaria*, an 'original musical Anachronism' performed at St George's Hall, Langham Place with music by E. A. Lambert (fig. 7).

The arrival of female students obviously changed the atmosphere in the Schools but as a whole the Academy was not responsive to the new demands from the students. By the 1880s many students were attracted to the Paris ateliers and to the new approaches to painting in France while the Schools still continued with their traditional methods of teaching. This meant that as the Royal Academy Schools entered the 20th century they failed to maintain their position as the most prestigious place of study.

Fig. 6
'Passing the Long Rest'
Magazine of Art, 1888, p. 60
Royal Academy of Arts

Fig. 7
Programme cover of *Pallettaria* June 1895
23 x 29.3 cm
Royal Academy of Arts

24 RA Annual Report, 1894, p. 18.
25 M. H. Spielmann, 'Glimpses of Artist Life: The Royal Academy Schools', *Magazine of Art*, 1888, p. 57.
26 M. H. Spielmann, op. cit., p. 60.
27 W. P. Frith, *My Autobiography and Reminiscences*, London, second edition, 1887, p. 323.

VICTORIAN PAINTING TECHNIQUE: A CRAFT REINVENTED?

Helen Glanville

In the 19th century every painting was executed onto a support which was either rigid or flexible, such as a wooden panel or a canvas (fig. 1). To prevent the support absorbing the paint medium it was brushed over with a layer of animal glue or size which made it less absorbent. On top of this was applied the ground layer which provided a suitable surface onto which the artist could then apply his paint. In the 19th century the ground was often made up of several layers (fig. 5) and was, more often than not, white to provide a reflectant surface for the paint. Onto this the artist would draw or transfer his preliminary drawing, with the help of a drawn in grid. This was sometimes sealed with a coat of oil or varnish (fig. 3) but this practice was unsound as it could lead to severe cracking in the paint layers above. Once any preliminary drawing was completed the artist would be ready to paint in his composition.

All paint is made up of pigment (coloured particles) and medium (a liquid substance which either dries or solidifies to form a film which binds the coloured particles). To make a mixture flow and handle more easily the artist would have to add a diluent, such as spirit of turpentine for an oil-based medium. If the paint contained a lot of medium and little pigment or a transparent pigment such as a lake (fig. 3), then the paint is referred to as a glaze, because, like glass, it allows what is beneath to show through. Colours which are glazed can be deepened without being muddied. Often, in 19th-century paintings, the surface would receive a final transparent coating, a varnish, which would saturate, or enrich, the colours as well as acting as a protective layer.

By the time of Queen Victoria's accession to the throne in 1837, painters generally recognised that much of the traditional knowledge of artists' materials, pigments and other technical aspects pertaining to their craft had been lost and that modern works had a much shorter life expectancy than the universally admired Old Masters. Unlike the present age, durability and excellence of materials and technique were seen as almost a moral obligation, leading to experimentation and technological advances in painting materials. Artists had originally learned their craft as apprentices in their master's workshop, spending many years learning to prepare panels or canvases and to mix pigments ready for use. During the 17th century, however, apprentices began to establish themselves as artists' colourmen, supplying painters with the materials which previously they would have prepared for them in the studio. Thus began a rapid decline in the painter's knowledge of his craft, so that by the 18th century many painters felt they had lost control over both the quality and purity of materials they used, and the nature of the materials available to them. It was only during the 19th century, with the birth of chemistry as an analytical and systematic science, that artists were able to enlist the help of chemists to investigate the nature of the materials they were using, as well as to benefit from the introduction of a large range of new pigments which were the

spin-off of the discovery of new chemical elements such as cadmium and strontium. This meant that the artist, who until then had had a very poor choice of green pigments and no purples, suddenly found he had emerald green, viridian, as well as numerous new mixed greens from all the new yellow and blue pigments being manufactured, and a wide range of purple hues due to the discovery of aniline dyes. There was great excitement about new pigments flooding onto the market, but also considerable frustration as their manufacture was in its infancy and the pigments were frequently unstable. The naming of pigments was also haphazard, so that the artist never knew whether in buying Naples Yellow he was buying a lead-based pigment or one containing cadmium or chrome, or indeed if he was buying the same pigment as the previous month. In addition there was the possibility of adulteration with cheaper foreign matter by unscrupulous, profit-seeking colour merchants.

George Field was the first chemist to put his science to the direct use of artists. In the first half of the 19th century he started to manufacture chemically pure pigments and began to supply many leading artists. The publication of Field's *Chromatography or a Treatise on Colours and Pigments* (1835) was an indispensable guide to any artist seriously concerned with the nature and use of his materials; and John Constable, J. M. W. Turner and William Mulready were among the artists who subscribed to its publication. The fact that a much enlarged edition appeared six years later is an indication of its worth to the artistic community. This was the first serious collaboration between artists and scientists. In the latter part of the century Frederic, Lord Leighton and Sir Arthur Herbert Church, Professor of Chemistry at the Royal Academy (1879–1911), corresponded almost weekly on matters such as the behaviour or compatibility of pigments and media,[1] and in 1880 Holman Hunt gave an impassioned lecture at the Royal Society of Arts begging for a closer involvement of chemists in matters artistic.[2] The practical aspects of painting were not taught in the Royal Academy Schools, or indeed in any other art school. It had become a complex subject and Thomas Phillips, Professor of Painting at the Royal Academy, referring to manuals and other theoretical instruction on painting, preferred to quote from Shakespeare that 'if to do were as easy as to know that'd were good to do, chapels had been churches and poor men's cottages princes' palaces'.[3] The importance, however, attached to artists' understanding of the materials they used, was reflected in the appointment in 1871 of the first Professor of Chemistry to teach the chemistry of paint to students at the Royal Academy Schools.

Many artists of the preceding generations measured their work against the work of the Old Masters, and in particular the masters of the Venetian School such as Titian and Veronese (fig. 2). They thought that the wonderfully deep and rich colours were the result of some secret ingredient or process and much energy was devoted to trying to discover the 'Venetian Secret'. Recipes for this 'secret' circulated and resulted in artists using peculiar concoctions of materials containing, more often than not, the tarry substance, bitumen. Like all tar, bitumen never dries and turns from a rich golden brown to an opaque gritty black. These artists thought they had lost the knowledge of a material, while in fact they had lost a skill. The glowing

1 Correspondence in Royal Academy Archives.
2 *Journal of the Royal Society of Arts*, 23 April 1880, pp. 485–99.
3 Thomas Phillips, *Lectures on the History and Principles of Painting*, London, 1833, title page.

shadows of Venetian paintings were achieved through good craftsmanship. Many thin translucent layers applied one over another, and with each one being left to dry thoroughly, resulted in wonderfully rich saturated colours. The Victorians sought a quick, immediate solution in the thick application of a single material, and thick layers dry unevenly resulting in unsightly cracks.

The Academicians Sir Charles Lock Eastlake and Richard Redgrave were among the most eminent figures of the Victorian art world. They were both immensely scholarly and dedicated their lives not only to their own work but were involved in running the most important art institutions of the day. In different ways they also helped improve the technical knowledge of their contemporaries and were determined to understand why much of their predecessors' work was deteriorating so drastically.

Eastlake was President of the Royal Academy from 1850 to 1865, counsellor to Prince Albert on all matters artistic, and the first Director of the National Gallery where he was responsible for the acquisition of 139 of the Gallery's finest Old Master paintings. In 1847 he published *Materials for a History of Oil Painting* which remains unrivalled in its erudition, and was profoundly influential upon fellow painters and Academicians. It contained both original treatises on painting technique from the 16th and 17th centuries, and also his own observations on the way certain effects were achieved by the Old Masters. Some of the methods described were followed exactly by artists such as William Dyce and Richard Redgrave. For example, in the red drapery of *Omnia Vanitas* (cat. 11) William Dyce uses a transparent pure lake glaze bound in varnish over a less rich glaze containing opaque vermilion which is applied over very freely sketched-in folds as Eastlake had accurately observed in Titian's technique in *The Vendramin Family* in the National Gallery (although he incorrectly surmised that the richness of the glaze was due to Titian's use of varnish rather than oil as the medium). His own use of a resinous varnish in the lower layer of the red drapery in *Hagar and Ishmael* (cat. 12) has led to cracking in the upper layers (fig. 3). Redgrave painted the imploring kneeling figure of the sister in *The Outcast* (fig. 4, cat. 47) with luminous transparent brown shadows over a brilliant white ground and with scumbled opaque modelling for the drapery – a method described by Eastlake in his essay on Rubens's technique.

Two years later another influential book appeared, Mrs Mary Merrifield's *Original Treatises dating from the XIIth to the XVIIIth Centuries, on the Arts of Painting...* (1849). Knowledge of original texts was still in its infancy and it was the translations of these texts which provided artists with the first concrete information about pigments and oils, the preparation of canvases and other details which previously would have been learned in a workshop if the apprentice system had not fallen into decline.

Eastlake's other major contribution to the improved longevity of his fellow artists' works was the introduction of copal as a painting medium. Copal is a hard fossil resin which dissolves in oil at extremely high temperatures, and gives a very tough glossy film. Eastlake, having observed the remarkable condition of Venetian paintings, set about, with a typically Victorian spirit of enquiry, to test their solubility and melting points. He established that the substance used by Venetian painters showed all the physical properties of a fossil resin and, with the help of chemists, he explored various ancient recipes updating and improving them for

Fig. 4
Kneeling figure from Richard Redgrave's *The Outcast* (cat. 47)
This figure is based on that of the Magdalen in Rubens's *Descent from the Cross* (Antwerp Cathedral), but unlike many artists inspired by Rubens, Redgrave also emulates Rubens's technique by placing thick opaque highlights over thin transparent and warm shadows.

contemporary use. By the end of the century copal mediums, their actual nature often masked by brand names such as Bell's Medium, or Siccatif de Haarlem, were widely used.

Richard Redgrave is known as a genre painter and as co-author with his brother Samuel of *A Century of British Painters* (1866). Less known, however, are his contributions to the care and conservation of paintings. In his position as Inspector General for Art at the South Kensington Museums (now the Victoria and Albert Museum), he had particular responsibility for the British pictures. He regularly checked them for ongoing deterioration, and in the 1860s photographed cracks as they appeared and grew larger. Almost a century would pass before major museums and galleries would take up this practice again. Redgrave was also concerned with the effects of the high levels of London pollution on paintings. In 1859 he set up a Government Commission to consider these effects and enlisted the help and expertise of such great 19th-century scientists as Michael Faraday and John Tyndall. Test plates were painted out with lead white in a variety of media, and set out for a period of two years in particular galleries and institutions as well as in a country toilet. The results were illuminating, 'the most injured' being 'that from the National Gallery, Charing Cross' and the next 'from a country privy'.[4]

Artists sought the luminosity of reflectant white grounds such as were used by the Old Masters and were particularly concerned therefore with the problem of the darkening of paint containing lead, especially lead white grounds, used in the preparation of canvases or panels. The Victorians realised that 'sulphuretted hydrogen', or hydrogen sulphide, discoloured the lead present in so many painting materials, such as grounds, transforming the white carbonate and hydroxide of lead into the black sulphide of lead. Redgrave suggested backing canvases with a second primed canvas to limit the effects of air pollution. Edwin Long was obviously influenced by Redgrave's advice as he used a double canvas, supplied by the colour merchant Roberson, for his painting *Nouzhatoul-âouadat* (cat. 66). Other artists, including Frith and Redgrave (cat. 48, 47) applied an additional priming layer of brilliant zinc white which remained unaffected by London's sulphurous air (fig. 5). The problem of pollution became so bad that artists were advised not to leave their paintings unvarnished because of the 'greasy, corroding dirt' of London's air. Goodall, however, failed to heed this advice. A sample from his painting *The Song of the Nubian Slave* (fig. 6, cat. 64) shows that the picture was painted in a medium containing a high proportion of wax which would have remained tacky, and that an even layer of dirt became wedded to the paint surface presumably while the painting was left unvarnished in his studio.

The other significant factor influencing technological advances in the 19th century was the enormous upsurge in the amateur market. By the 1840s pigskin bladders (fig. 7) were replaced firstly with a glass and then a metal syringe, as can be seen in the paint box presented to Queen Victoria (fig. 8). This was soon displaced by the extruded metal tube as a container for ready made-up oil paint as is still used today. Squeezing paint out of a tube rather than out of a bladder made painting a much faster and less messy business for amateur and professional painters alike.

Fig. 8
Queen Victoria's oil paint box.
Mahogany inlaid with tortoishell and ivory with metal syringes inscribed for specific colours. 52.7 x 38 x 15.2 cm
Royal Academy of Arts
Metal syringes manufactured to contain ready made-up oil paint superseded bladders, and were in turn replaced by extruded metal tubes.

Fig. 7
Pigskin bladders
For centuries, made up oil-paint was kept in pig-skin bladders which would be pierced by the artist and the paint squeezed out when required.

4 *Report of the Commission appointed to consider the subject of lighting picture galleries by gas presented to the Lords of the Committee of Privy Council on Education.*

It was the intellectual and scientific stature of the personalities involved that encouraged such technological advances in a domain which to us may seem rather secondary – painting materials. But the Victorian age fervently believed that enjoying and practising art, and in particular painting, were essential for the well-being not only of the individual, but of society as a whole. As George Field, the chemist and artists' colourman, wrote in the preface to his book *Chromatography*, art 'refines the taste, enhances the powers and improves the disposition and morals of a people – and whatever improves the morals, promotes the happiness of man, individual and social'.[5]

Fig. 1 General structure of a
19th-century English canvas painting

Varnish – often made of the same material as the medium used to bind the paint. This makes its removal, if it is discoloured, a hazardous operation

Paint Layers
pigments –
binding media – various varnishes and resins were added to oil by artists to try and achieve the same appearance as Old Master paintings

Under Drawing – some artists transferred preliminary drawings by first squaring up the canvas

Sealing Layer – oil or varnish

Ground Layers – these were usually white or pale toned in emulation of 15th- and 16th-century Old Master paintings. A correctly prepared and applied ground is essential for the durability of a painting

Size Layer – size (animal glue) was often applied cold as a jelly by artist colourmen for economic reasons, rather than the traditional hot method which penetrates the canvas much better

Woven Support – industrial manufacture of canvas and the incorrect preparation of canvases lead to poor durability of 19th-century paintings

1 brown glaze. The elemental analysis of this layer seems to indicate Dyce's use of a new pigment, Cappagh brown, which first appeared in pigment catalogues in 1846

2 blue paint layers making up the sky. French synthetic ultramarine discovered in 1827 is the blue pigment, which was much cheaper than natural ultramarine, which came from the semi-precious stone lapis-lazuli

3 pure lead white found beneath the layer of sky

4 top layer of ground. Pure lead white ground with the occasional particle of plant black which would have given it a cooler tone, lead white having a yellowish cast

Fig. 2
Pinhead sample from the brown foliage of William Dyce's *Omnia Vanitas* (cat. 11) in ordinary reflected light, x 500
16th-century Venetian painting exerted an enormous influence on Victorian painters. Dyce's technique reflects the state of contemporary knowledge of these painters. The foliage was painted brown in emulation of the discoloured green found in 16th-century Italian painting. It is only known now, however, that this brown was originally green and has subsequently discoloured.

5 G. Field, *Chromatography or a Treatise on Colours and Pigments*, London, 1835, p. ix.

Juxtaposition of transparent (lake) and semi-transparent (lake and vermilion) layers, described by Eastlake in his essay on Venetian technique, and also employed by Dyce. The blue used in the sky, synthetic ultramarine, is at present the earliest example of the use of this pigment, first synthesized in 1827.

1 red lake and vermilion
2 red lake
3 red lake and vermilion
4 this oil layer is applied onto a varnish layer which could be the cause of the cracking
5 the priming is sealed with a varnish layer
6 priming layer is off-white, containing particles of ochre and black

Fig. 3
Pinhead sample take from edge of a drying crack in the red drapery in Sir Charles Lock Eastlake's *Hagar and Ishmael* (cat. 12) in ordinary reflected light, x 500

The triple priming layer is clearly visible. The brilliant zinc white top layer corresponds exactly to that advocated by A. H. Church, the Royal Academy's Professor of Chemistry (1879–1911), in his publication *The Chemistry of Painting* (1890). The zinc white provided the painting with a brilliant white underlayer, which Frith used to the full to give luminosity to the composition, using very thin layers of paint on top.

1 zinc white
2 the middle layer contains a mixture of lead white and whiting
3 the lowest layer is whiting applied in a glue medium

Fig. 5
Pinhead sample of ground layers from W. P. Frith's *The Sleeping Model* (cat. 48) in ordinary reflected light, x 100

The milky fluorescence of the cross-section sample in ultra-violet light indicates that Goodall mixed wax with his oil medium. The solubility of this wax in 'weak' solvents, such as white spirit, can cause problems during varnish removal. The painting would have had a slightly soft, tacky surface on completion and in this case was not varnished until some time later.

1 thin layer of soot beneath the varnish
2 sky painted with cobalt blue and emerald green. The presence of the latter indicates that Goodall, unlike some of his contemporaries, was not worried by the 'turning green' of cobalt blue with age but wanted a greenish tinge to his sky
3 ground is a single layer of lead white and chalk

Fig. 6
Pinhead sample from top edge of Frederick Goodall's *The Song of the Nubian Slave* (cat. 64) in ordinary reflected light, x 500

CATALOGUE

Presidents of the Royal Academy of Arts during the Reign of Queen Victoria (1837–1901)

Under the Instrument of Foundation signed by King George III in 1768, the Royal Academy of Arts is answerable to none save the sovereign, it is governed by the President and Council, the latter appointed by the General Assembly of all Academicians and the former elected annually by the same body.

The Royal Academy saw five Presidents during Queen Victoria's reign (cat. 2). All five jealously guarded the independence of the institution from government intervention, held positions of national significance – from Trusteeships and Directorships of the National Gallery to the headship of the leading training institutions for artists and designers – and fought doggedly to defend the Royal Academy's domination of the art world.

When the Royal Academy moved in 1837 from Somerset House on the Strand to the east wing of the newly completed National Gallery in Trafalgar Square, its presidency was in the hands of Sir Martin Archer Shee (1769–1850). A student at the Royal Academy Schools, Shee was a more talented portrait painter than he was poet. A contemporary of J. M. W. Turner, he was elected Associate in 1798, Royal Academician in 1800, and President in 1830 in succession to Sir Thomas Lawrence. During his twenty-year tenure, Shee steered the Royal Academy through troubled times which saw demands from Parliament for greater transparency in its finances, its handling of the Annual Exhibition and its conduct of its Schools, and for wider and more effective representation of the artistic community. Shee successfully fought off any intrusion by government, parliament or the wider public into the affairs of the Royal Academy, guarding its financial and organisational autonomy and yet maintaining its position as an institution of national importance. Shee served as a Trustee of the National Gallery.

Already suffering from ill-health in 1845, Shee died in August 1850 and was succeeded by Sir Charles Lock Eastlake (1793–1865) (cat. 3). Like Shee, Eastlake had been a student at the Royal Academy Schools, being elected an Associate in 1827 and full Academician in 1830. Eastlake was a highly educated and well travelled artist who early established a reputation as a painter of history paintings (cat. 12), landscapes and portraits.

Long sojourns in Italy ensured a thorough knowledge of the Renaissance masters, which he drew upon as Trustee, Keeper and eventually first Director of the National Gallery (1855–65), and as author of treatises on art history, aesthetics and, most importantly, the painting techniques of the Renaissance artists, *Materials for a History of Oil Painting* (2 vols, 1847–69). He also brought this knowledge and experience to bear upon the mounting debate concerning the preservation of Old Master paintings in the face of rising air pollution and the durability of the recently introduced chemical-based paints. As an eminent Academician and knowledgeable connoisseur he was appointed first secretary to the Fine Arts Commission established to advise on the decoration of the new Palace of Westminster (Houses of Parliament),and as President of the Royal Academy, he acted as a commissioner of the Great Exhibition held in Hyde Park, London in 1851.

The presidential succession on Eastlake's death in 1865 was not seamless: Sir Edwin Landseer had been elected but declined the honour due to ill-health; the General Assembly met again on 1 February 1866, and Francis Grant (1803–78) won the position. Grant (cat. 4) enjoyed considerable financial security, owned a hunting estate in Leicestershire and married into the aristocracy. He combined his hunting interests and his social position to establish a reputation as a painter of sporting subjects and society portraits. Probably a more astute politician than a distinguished artist, Grant successfully thwarted Queen Victoria's wish that the Royal Academy relocate from the National Gallery to the South Kensington site, and thus successfully delivered as its new home Burlington House on Piccadilly. Furthermore, he rejected government offers of subsidy to underwrite the cost of the move, arguing that the Royal Academy should retain its financial and institutional independence by paying out of its own reserves the erection of the new exhibition galleries and the Schools on the garden of the erstwhile town house, and the addition of a third floor of Diploma Galleries onto Burlington House itself. He also mediated certain significant institutional reforms including the introduction of Honorary Members in

1868, the augmentation of the number of Associate Members in 1866 and the institution of Winter Loan Exhibitions from January 1870.

Frederic Leighton (later Frederic Lord Leighton Bt) (1830–96) was unquestionably the most talented artistically and politically of all of the Presidents to hold office during Queen Victoria's reign. Leighton (cat. 5, 9) had been trained in Italy, Frankfurt/Main and Paris before dramatically establishing his reputation at the Royal Academy Annual Exhibition of 1858 with his painting, *Cimabue's Celebrated Madonna is carried in Procession through the Streets of Florence* (Royal Collection) which was immediately bought by the Queen. Leighton was a leading exponent both of High Victorian Classicism, creating large scale celebrations of classical subjects such as *The Syracusan Bride* (private collection) and *Daphnephoria* (Lady Lever Art Gallery, Port Sunlight) as well as religious works and portraits, and of the 'New Sculpture', which he pioneered in his modelled and bronze-cast sculptures, *Athlete Wrestling with a Python* (Royal Academy 1877) and *The Sluggard* (Royal Academy 1886). As President, he was unstinting in his defence of the preeminence of the Royal Academy, seeking to neutralise such alternative exhibition venues as the Grosvenor Gallery (1877) and the New English Art Club (1886), remorselessly ensuring that major artists should continue to exhibit their best work at the Summer Exhibitions, cajoling such recalcitrant Members as G. F. Watts (cat. 8) to remain committed Academicians, enticing such distinguished artists as Edward Burne-Jones to accept Associate Membership in 1885, and vigorously supporting the election of younger, innovative artists. On his death in 1896 he was accorded a state funeral and burial in St Paul's Cathedral.

John Everett Millais's youthful involvement with the Pre-Raphaelite Brotherhood, a group of artists determined to overturn the Royal Academy's adherence to the primacy of the High Renaissance, would not appear to have ensured his election to the Presidency of the Royal Academy some forty years later. However, Millais (1829–96) (cat. 6, 51, 54) had been involved with the institution since his admission to its Schools in 1840 and his precocious, and much heralded, debut at the Annual Exhibition of 1846. After brief involvement with D. G. Rossetti, William Holman Hunt and Ford Maddox Brown from 1848 as the Pre-Raphaelite Brotherhood, which earned him considerable critical acclaim from John Ruskin, Millais accepted election as Associate in 1853 and as Full Academician ten years later. The austere, intense realism of his Pre-Raphaelite work gave way to a looser, more painterly technique applied to genre scenes, landscapes and portraits which proved to be highly popular. His tenure as President in succession to Leighton lasted a mere six months; he died on 13 August 1896.

The position of President for the closing five years of Queen Victoria's reign was held by Edward Poynter (1836–1919) (cat. 10). Trained at the Royal Academy Schools and in Paris, Poynter first exhibited at the Royal Academy in 1861. A fellow exponent of High Victorian Classicism together with Leighton and Alma-Tadema (cat. 7), Poynter was elected Associate Member in 1869, full Member in 1876 and President in 1896. Apart from the Royal Academy, he also had a distinguished national career, both in art education and in the field of museum administration. He was appointed the first professor of the Slade School of Art (established by University College, London in 1871) and later Director of the National Art Training School (now the Royal College of Art, London). He also held the positions of Director of the National Gallery (from 1894) and Director for Art of the South Kensington Museum (now the Victoria and Albert Museum, London).

Cat. 1
Charles West Cope RA
The Council of the Royal Academy selecting Pictures for Exhibition 1876
Oil on canvas, 142.5 x 216.2 cm
Presented by G. Moore, 1876

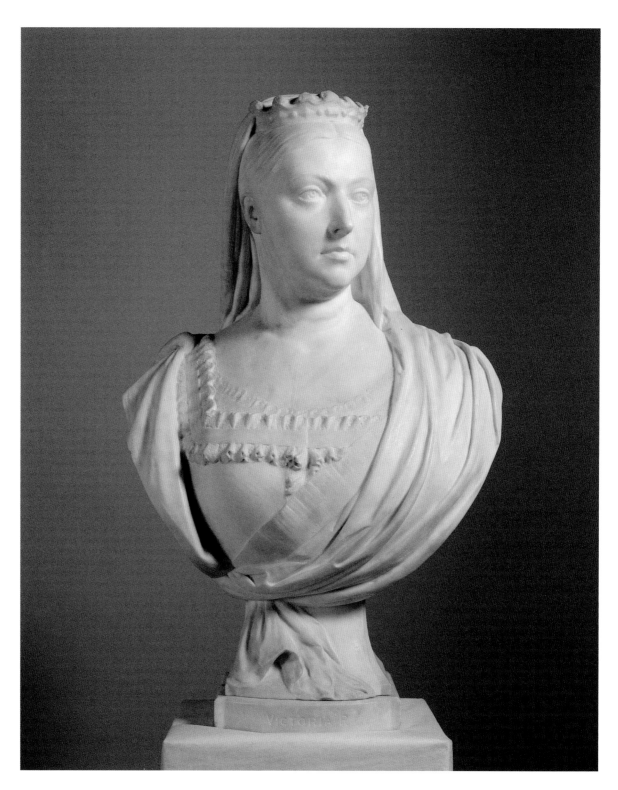

Cat. 2
Princess Louise, Duchess of Argyll
Queen Victoria 1876
Marble, 83.8 x 58.5 x 36 cm
Presented by Princess Louise, 1877

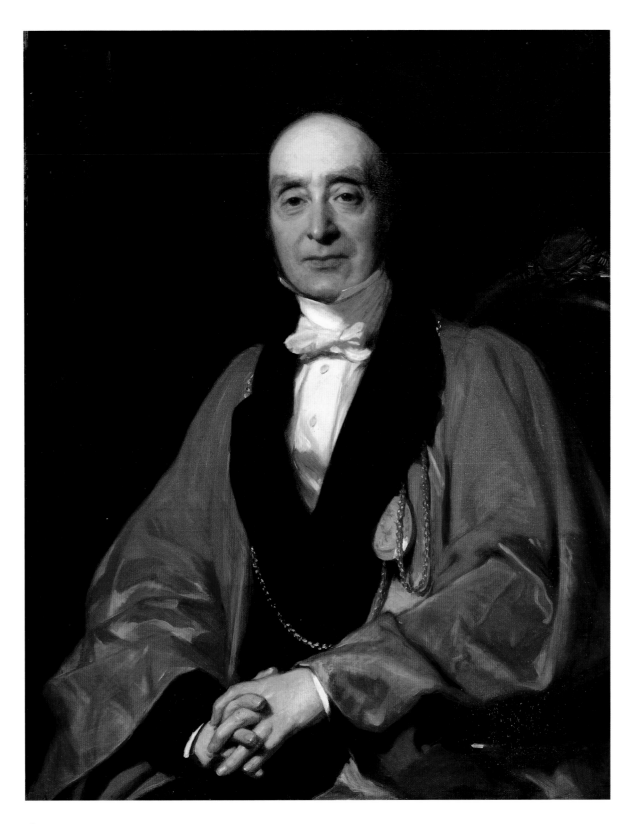

Cat. 3
John Prescott Knight RA
Sir Charles Lock Eastlake PRA c. 1857
Oil on canvas, 90 x 70 cm
Presented by the artist, 1857

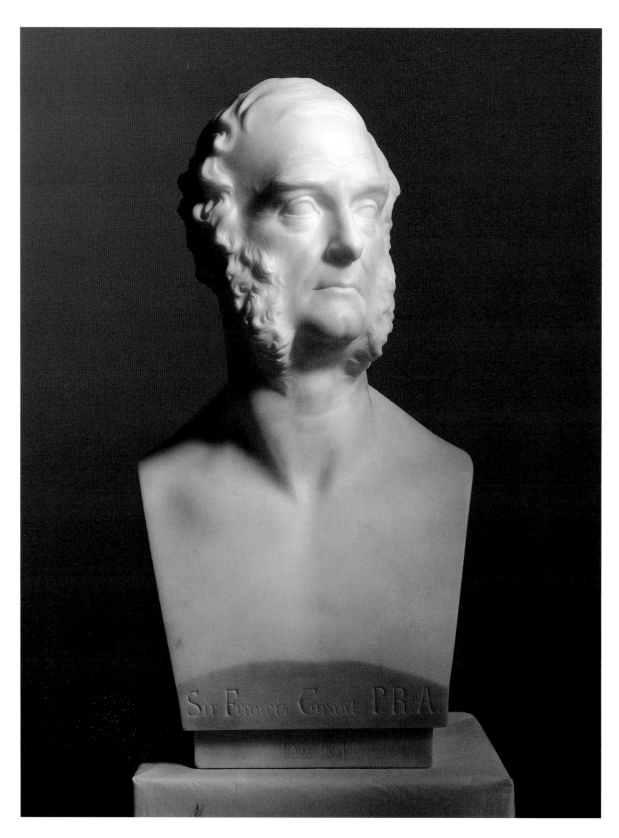

Cat. 4
Mary Grant
Sir Francis Grant PRA 1866
Marble, 66 x 35 x 30 cm
Presented by Mary Grant, 1876

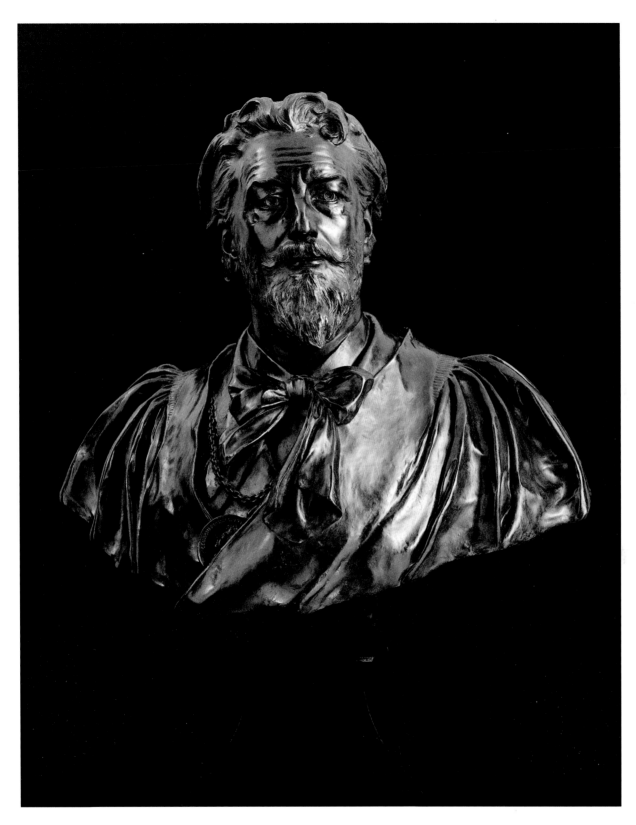

Cat. 5
Sir Thomas Brock RA
Frederic, Lord Leighton 1892
Bronze, 83 x 78 x 38 cm
Diploma Work accepted 1893

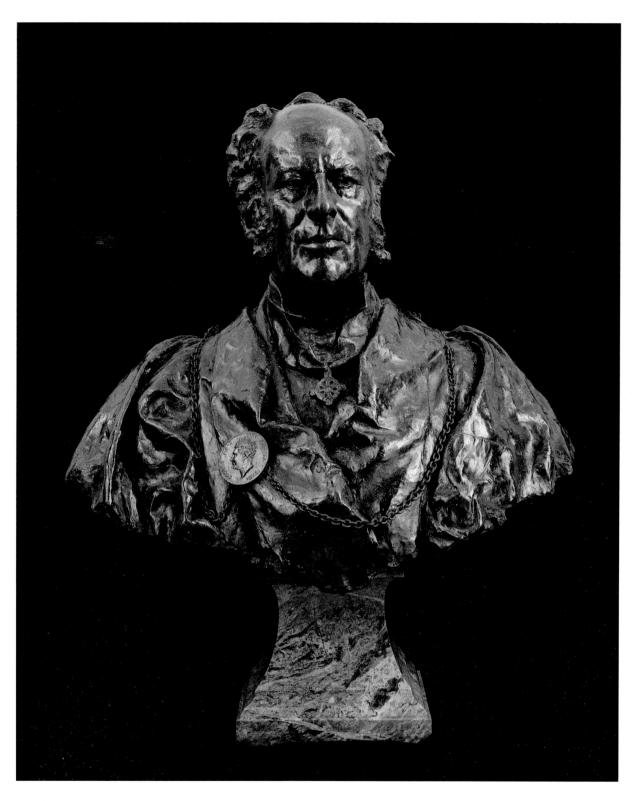

Cat. 6
Edward Onslow Ford RA
Sir John Everett Millais, Bt, PRA c. 1882
Bronze, 82 x 51 x 31 cm
Presented by the sculptor, 1896

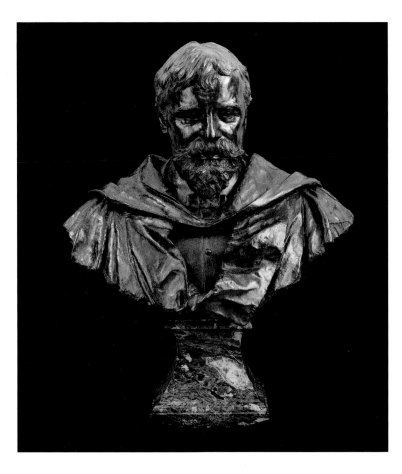

Cat. 7
Edward Onslow Ford RA
Sir Lawrence Alma-Tadema 1895
Bronze, 77 x 67 x 44 cm
Diploma Work accepted 1895

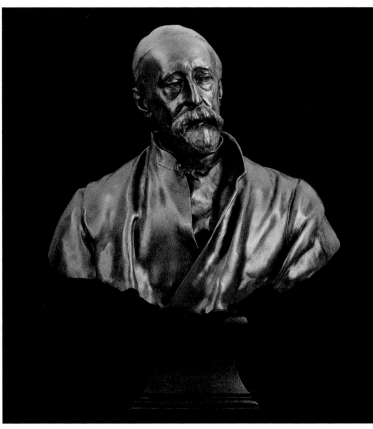

Cat. 8
Sir Alfred Gilbert RA
George Frederic Watts 1888
Bronze, 78.5 x 61.5 x 38 cm
Cast from the plaster presented by the
NACF, 1936

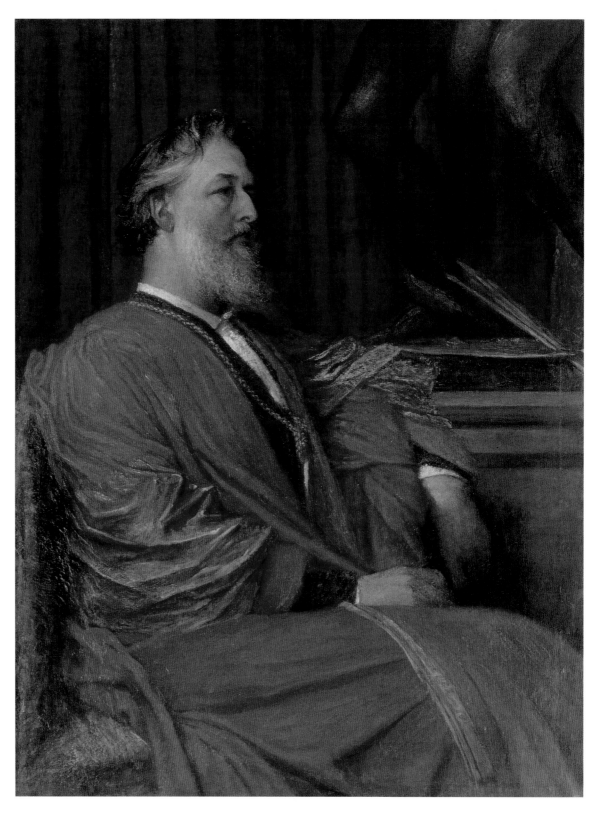

Cat. 9
George Frederic Watts RA
Frederic, Lord Leighton, PRA 1890
Oil on canvas, 111.2 x 85 cm
Presented by George Frederic Watts RA

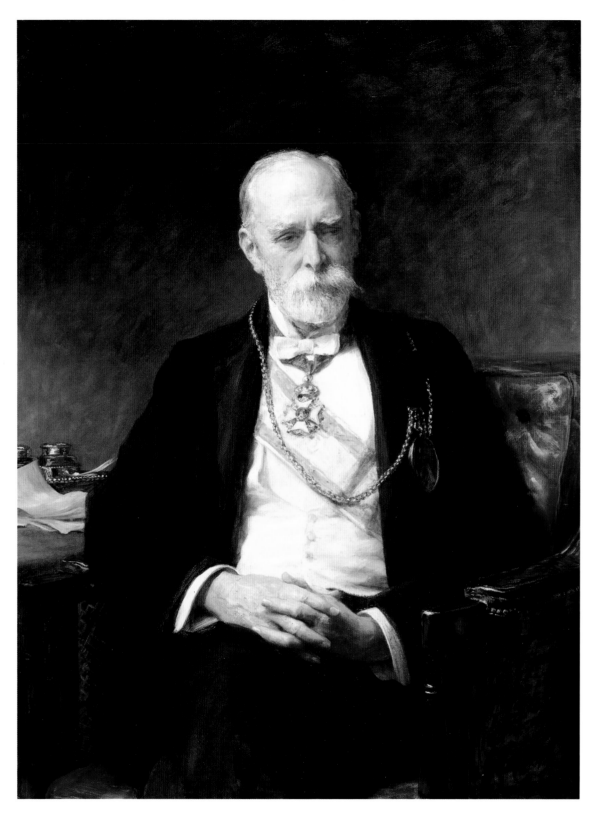

Cat. 10
Sir Arthur Stockdale Cope RA
Sir Edward Poynter., Bt. PRA 1911
Oil on canvas, 110.5 x 85.1 cm
Diploma Work accepted 1911

Historical Genre

Eastlake's *Hagar and Ishmael* (cat. 12) and William Dyce's *Omnia Vanitas* (cat. 11) both show the influence of the German Nazarene School in their classically arranged compositions, uncluttered backgrounds, clear colours and adoption of the slightly archaic manner of the early Renaissance masters. Shannon, however, in *Vanity and Sanctity* (cat. 25) with its strange allusions, is, as a contemporary critic noted, 'full of ghosts. There is the ghost of Sacred and Profane love, the ghost of several late Titians and Giorgiones ... [and] yet there is no plagiarism for all these memories are fused in a very agreeable manner'.[1] The format of Cowper's exquisite *Vanity* (cat. 27), despite being entirely secular, derives from representations of the Virgin and Child by painters of the Venetian School. Vanity holds her traditional attribute of a mirror, and an opal, signifying shifting passions, adorns her forehead. In contrast to Vanity's downcast eyes, which encourage the viewer only to admire, the women represented in Abbey's *A Lute Player* (cat. 28) and Gregory's *Après?* (cat. 30) directly challenge the spectator. Both women are gorgeously attired but only in Gregory's picture is a narrative hinted at with the spilt wine, the overturned stool and the provocative title.

Shakespeare's works remained a popular source of subject matter for Victorian artists, but more often than not comic moments were chosen, such as Elmore's *Two Gentlemen of Verona* (cat. 17), which was exhibited with the accompanying lines from Act III, scene I of that play, in which the Duke of Milan talks of the love of Valentine and Silvia, and recalls:

'This love of theirs myself have often seen,
Haply, when they have judg'd me fast asleep'

Elmore's knowledge of Italian Renaissance paintings strongly influenced the design of the richly coloured costumes in this work. Hart's scene of *An Early Reading of Shakespeare* (cat. 16) does not relate to a real historical event, but recreates the atmosphere of an earlier age. From the 1830s there was a growing interest in the early history of England, particularly the Middle Ages which were perceived as the golden age of 'Merrie' England. Although some artists, such as Marcus Stone, chose the more recent past of the 18th century (cat. 24) or Regency period in which to set depictions of elegant ladies and courting couples, others, such as Dicksee in *Startled* (cat. 29), cast their subjects back to a much earlier period in English history. Here Dicksee gives the familiar scene of female bathers startled by male intruders a specific historical reference by including a Viking long-boat. The figures are lit by the setting sun which casts a great luminosity throughout the entire picture. It was however more common for artists, especially those belonging to the so-called 'St John's Wood Clique', to choose quotidian incidents, rather than momentous events from what was seen as the most romantic era of English history, that of the Tudors and Stuarts. In 1866 Calderon and W. F. Yeames RA rented Hever Castle for the summer and this is where Calderon's *Whither?* (cat. 15) was painted. The subject is typical of his work in that it poses an open-ended question for the viewer to engage with. This type of painting is often referred to as a 'problem picture'. Pickersgill's *The Bribe* (cat. 18, detail left) is more unequivocal as to its story but still leaves us wondering as to what lies beyond the door. The English Civil War was a particularly rich source of inspiration for Seymour Lucas and Crofts (cat. 21, 22), although neither represents specific historical incidents, unlike Egg's *The Night before Naseby* (cat. 20) which depicts Cromwell praying in his tent on the night before his great victory at the Battle of Naseby in 1645. Gow's exquisitely painted *A Mountain Pass* (cat. 23), Prinsep's *La Révolution* (cat. 26), and the dramatic *Jacobites 1745* (cat. 19) all refer to important historical events in a romanticised way. Many artists, including Charles Landseer in his painting *The Dying Warrior* (cat. 14), were inspired by the historical novels of Sir Walter Scott. Landseer's source for this latter painting was Scott's *Castle Dangerous*, his particular concern being to focus on the dying man's affecting relationship with the priest who recites the last rites. Edwin Landseer typically makes an animal the main protagonist of such feelings in *The Faithful Hound* (cat. 13 where an enormous bloodhound howls a mournful lament for his dead master as the last rays of sun fade from the scene.

[1] *The Times*, 2 May 1921.

Cat. 11
William Dyce RA
Omnia Vanitas 1848
Oil on canvas, 62.7 x 75 cm
Diploma Work accepted 1848

Cat. 12
Sir Charles Lock Eastlake RA
Hagar and Ishmael 1830
Oil on panel, 58.4 x 50.8 cm
Diploma Work accepted 1830

Cat. 13
Sir Edwin Landseer RA
The Faithful Hound c. 1830
Oil on canvas, 66 x 88.9 cm
Diploma Work accepted 1831

Cat. 14
Charles Landseer RA
The Dying Warrior c. 1843
Oil on canvas, 78.7 x 99 cm
Diploma Work accepted 1845

Cat. 15
Philip Hermogenes Calderon RA
Whither? 1867
Oil on canvas, 86.5 x 111.5 cm
Diploma Work accepted 1867

Cat. 16
Solomon Alexander Hart RA
An Early Reading of Shakespeare 1838
Oil on canvas, 69.8 x 90.2 cm
Diploma Work accepted 1840

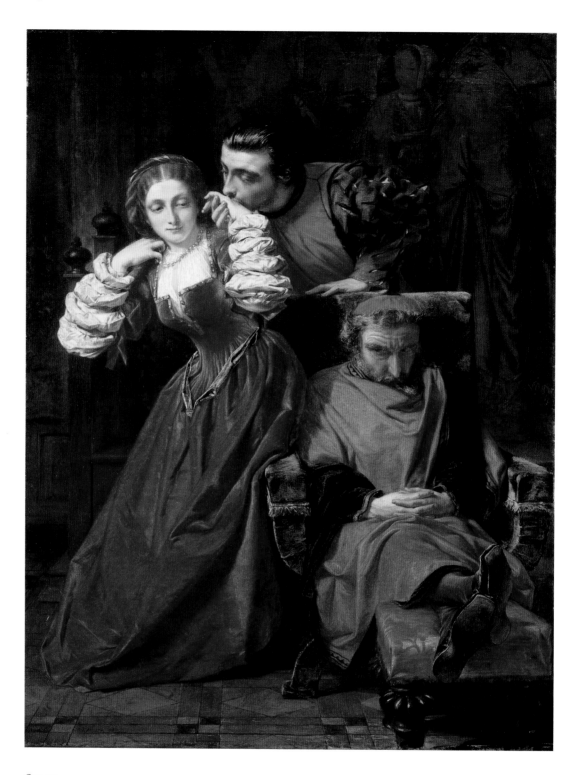

Cat. 17
Alfred Elmore RA
Two Gentlemen of Verona 1857
Oil on canvas, 68.6 x 52.1 cm
Diploma Work accepted 1857

Cat. 18
Frederick Richard Pickersgill RA
The Bribe 1857
Oil on panel, 75 x 55.9 cm
Diploma Work accepted 1857

Cat. 19
John Pettie RA
Jacobites 1745 1874
Oil on canvas, 88.9 x 124.5 cm
Diploma Work accepted 1874

Cat.20
Augustus Leopold Egg RA
The Night before Naseby 1859
Oil on canvas, 101.6 x 127 cm
Diploma Work accepted 1863

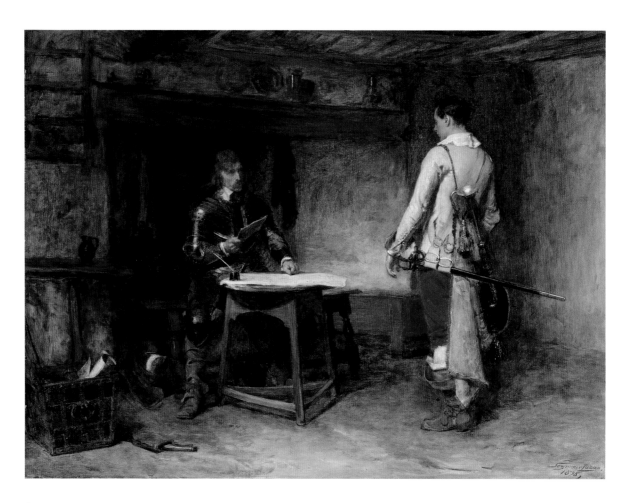

Cat. 21
John Seymour Lucas RA
News from the Front 1898
Oil on canvas, 72.5 x 96.5 cm
Diploma Work accepted 1899

Cat. 22
Ernest Crofts RA
To the Rescue 1896
Oil on canvas, 90.2 x 64.8 cm
Diploma Work accepted 1897

Cat. 23
Andrew Carrick Gow RA
A Mountain Pass, 1895
Oil on canvas, 61 x 45.7 cm
Diploma Work accepted 1895

Cat. 24
Marcus Stone RA
Good Friends 1887
Oil on panel, 49.5 x 21.6 cm
Diploma Work accepted 1887

Cat. 25
Charles Shannon RA
Vanity and Sanctity 1921
Oil on canvas, 105.4 x 109.2 cm
Diploma Work accepted 1921

Cat. 26
Valentine Cameron Prinsep RA
La Révolution 1896
Oil on canvas, 160 x 110.5 cm
Diploma Work accepted 1896

83

Cat. 27
Frank Cadogan Cowper RA
Vanity 1907
Oil on panel, 54.6 x 36.8 cm
Diploma Work accepted 1936

Cat. 28
Edwin Austin Abbey RA
A Lute Player 1899
Oil on canvas, 76.9 x 51.2 cm
Diploma Work accepted 1900

Cat. 29
Sir Frank Dicksee PRA
Startled 1892
Oil on canvas, 97.8 x 67.3 cm
Diploma Work accepted 1892

Cat. 30
Edward John Gregory RA
'Après?' 1899
Oil on canvas, 127 x 90.2 cm
Diploma Work accepted 1900

Mythological and Classical Subjects

Compared with the preceding century, the Victorian period saw an explosion of new sources from which artists took their subject matter, including medieval history, the romantic poetry of Shelley and Tennyson, and the experience of life in the modern, bustling metropolis. Classical myths and the Ancient World continued, however, to be an important resource and in fact there was a noticeable revival of interest in such subjects in the last quarter of the century when leading artists such as Frederic Leighton exhibited paintings of classical myths on a grand scale. Richmond greatly admired Leighton's work, and, like him, exhibited several large classical setpieces, such as *Orpheus returning from the Shades* (cat. 35). This painting was inspired by Shelley's *Orpheus Fragments* (1820) and when shown at the Royal Academy was accompanied by the following lines from that poem:

> 'So Orpheus, seized and torn
> By the sharp fangs of an insatiate grief,
> Maenad-like waved his lyre in the high air
> And wildly shrieked, "Where she is it is dark"'

The swirling drapery echoes the contorted figure of Orpheus whose head is flung back in despair.

In preparation for his paintings, Leighton often made small models which he used as compositional aids. When draped in wet muslin these allowed him to experiment with the effects of drapery. *Cymon* (cat. 40) was used in this way for the painting *Cymon and Iphigenia* (Art Gallery of New South Wales), and depicts the simple shepherd Cymon transfixed by the beauty of the sleeping Iphigenia. In the model (cat. 38) for *The Garden of the Hesperides* (Treuherz Fig. 1), Leighton works out a complex grouping of the three daughters of the god of Evening (i.e. Hesperus, who guarded the apples given to earth by Hera), moulding it into a pyramidal shape. *The Sluggard* (cat. 42) by Leighton is a smaller version of a life-size sculpture inspired by the sight of one of his models, Giuseppe Valona, stretching after a sitting. It is given a classical reference however in the full-size version by the inclusion of the Victor's laurel wreath at his feet. The naturalistic modelling and attention to surface detail in this work are qualities which characterise a style known as 'New Sculpture', in contrast to the smoother forms of more idealised neo-classical sculpture exemplified by the work of John Gibson.

Leighton greatly admired the work of Alfred Gilbert, a leading exponent of the 'New Sculpture'. *Eros* (cat. 41) is a model for the main figure of the Shaftesbury memorial fountain which was unveiled in Piccadilly Circus in 1893. Full of vitality and movement, it features a figure poised lightly on the toes of one foot. Thornycroft's representation of the Greek archer *Teucer* (cat. 39) also depicts a figure shooting an arrow. The critic Edmund Gosse remarked at the time that although it has 'something almost archaic about its rigidity' it remains 'the most courageously realistic work that Mr. Thornycroft has produced'.[1]

Artists such as Alma-Tadema and Poynter were more inspired by the daily lives of people in ancient times rather than the antics of its gods and heroes. With much learned and meticulous archaeological accuracy, they aimed at nothing short of reconstructing the physical reality of the Ancient Greek or Roman world. Alma-Tadema's *Way to the Temple* (cat. 32, detail left) represents a priestess selling bronze statues, while behind her is revealed a Dionysiac procession. *Improvisatore* (cat. 31) is Alma-Tadema's only nocturnal picture and shows a singer with his lyre chanting over a grave in a moonlit grove. *The Fortune Teller* (cat. 33) by Poynter uses the setting of a Roman bath to display his mastery of the female nude and his ability to depict the rich effect of a marbled interior.

Other artists chose to represent more universal myths such as *St George* (cat. 36) by Solomon, a wonderful swirling composition with rich colours inspired by the Venetian School, and *A Mermaid* (cat. 34) by Waterhouse. The latter represents a beautiful mermaid, dreamily combing out her long hair with her lips parted, perhaps in song. There is no hint here of the Siren, luring sailors to their deaths, but a feeling rather of gentle melancholy as she sits alone in an isolated inlet.

[1] *Magazine of Art*, 1881, p. 331.

Cat. 31
Sir Lawrence Alma-Tadema RA
Improvisatore 1872
Oil on panel, 64.7 x 44.4 cm
Purchased by the Royal Academy of Arts, 1944 (Stott Fund)

Cat. 32
Sir Lawrence Alma-Tadema RA
The Way to the Temple 1882
Oil on canvas, 101.5 x 52 cm
Diploma Work accepted 1882

91

Cat. 33
Sir Edward Poynter, Bt, PRA
The Fortune Teller 1877
Oil on canvas, 62.2 x 74.9 cm
Diploma Work accepted 1877

Cat. 34
John William Waterhouse RA
A Mermaid 1900
Oil on canvas, 96.5 x 66.6 cm
Diploma Work accepted 1901

Cat. 35
Sir William Blake Richmond RA
Orpheus returning from the Shades 1885
Oil on canvas, 185.5 x 115.5 cm
Diploma Work accepted 1900

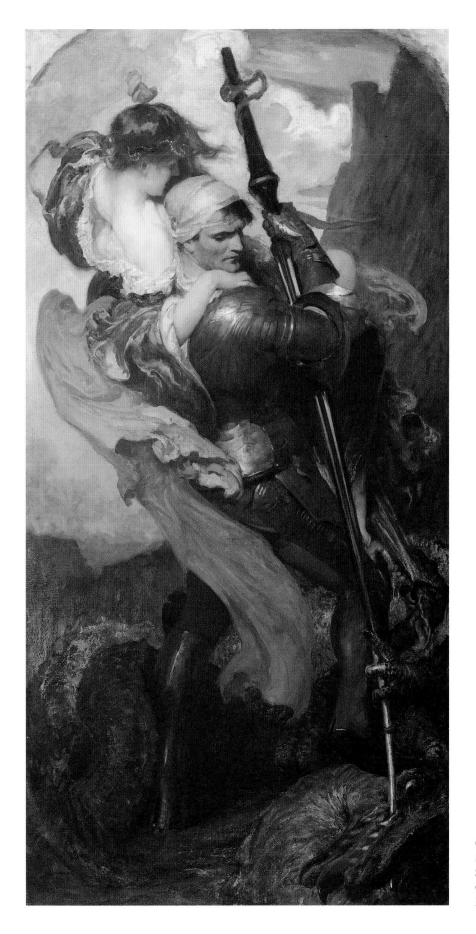

Cat. 36
Solomon Joseph Solomon RA
St George c. 1906
Oil on canvas, 212.1 x 105.4 cm
Diploma Work accepted 1906

Cat. 37
Sir Alfred Gilbert RA
Sketch Model for Figure on Jubilee Monument to Queen Victoria, Winchester 1887
Bronze, 30.5 x 14.7 x 85 cm
Cast from the plaster presented by the NACF, 1936

Cat. 38
Frederic, Lord Leighton PRA
The Garden of the Hesperides c. 1891
Bronze, 18 x 35 x 21 cm
Cast from the plaster presented by the artist's sisters, Mrs Orr and Mrs Matthews, 1896

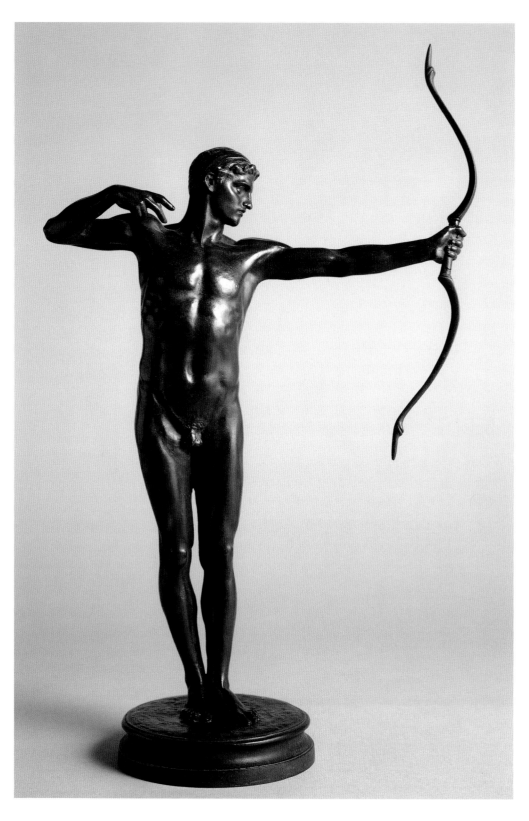

Cat. 39
Sir Hamo Thornycroft RA
Teucer 1881
Bronze, 44 x 30 x 9 cm
Presented by Elfrida Manning, daughter of Sir Hamo Thorny-
croft, 1987

Cat. 40
Frederic, Lord Leighton PRA
Cymon c. 1882-3
Bronze, 55 x 17.7 x 17 cm
Cast from the plaster presented by the artist's sisters,
Mrs Orr and Mrs Matthews, 1896

Cat. 41
Sir Alfred Gilbert RA
Sketch Model for Eros 1891
Bronze, 62 x 27 x 68 cm
Cast from the original model, 1926

Cat. 42
Frederic, Lord Leighton PRA
The Sluggard 1885
Bronze, 35 x 31.5 x 16 cm
Cast from the plaster presented by the
artist's sisters, Mrs Orr and Mrs
Matthews, 1896

Modern Genre

Alma-Tadema's family was immensely important to him and in *A Family Group* (cat. 58) he depicts his wife Laura on the right with her two sisters and brother and, reflected in a mirror at the back, an image of himself in a straw hat. The painting was given by Alma-Tadema to his wife on their silver wedding anniversary. A portrait of his fifteen-year old-daughter, *Miss Anna Alma-Tadema* (cat. 56) also contains portraits of the artist and his wife in the oval panels on the door. The painting presents a subtle harmony of silvery and greyish-green tones with the oyster-coloured sash and the gleaming seashells. Alma-Tadema kept this portrait throughout his life but frequently exhibited it in important exhibitions. In contrast Clausen's exquisite portraits of himself and his wife (cat. 57, 55) are on a much more intimate, domestic scale.

Millais's *Souvenir of Velazquez* (cat. 54), a tribute to the great Spanish master who was becoming increasingly popular in England in the 1860s, is painted with vigorous, highly-assured brushstrokes. His portrait of his grandson in *Bubbles* (cat. 51) was purchased with the copyright by the *Illustrated London News*. The latter sold it on to the soap manufacturers A. and F. Pears, who, much to Millais's fury, published a reproduction of it with a bar of their soap added, in which debased form it became by far the most widely circulated of all Millais's works. The boy in Millais's painting is innocently at play whereas the children in Sant's *The Schoolmaster's Daughter* (cat. 53) are shown mimicking, and therefore indirectly commenting upon, the adult world. Horsley used his own home in Cranbrook, Kent, newly altered by the celebrated architect Richard Norman Shaw RA, as the setting for *A Pleasant Corner* (cat. 49). A pretty girl is settled in an inglenook by the fire and an allusion is made to the season by the snowdrops on the window. Horsley probably used a local girl to model, but many Victorian artists complained of the difficulty of obtaining good models. Frith was asked to get the permission of the orange-seller's priest before she would consent to sit for *The Sleeping Model* (cat. 48). His difficulties did not end there as he wished to capture the model's pretty smile, as we see on the painted canvas in the picture, but she kept falling asleep. There is an irony in this anecdote that was almost certainly lost on the artist, since he was clearly not concerned to depict the reality of his model's exhausting life as a street seller.

In the early decades of the 19th century David Wilkie's paintings, often of Scottish peasant subjects, were very popular and his work continued to be influential, as can be seen in Knight's *The Parting Blessing*, Allan's *The Shepherd's Grace* and Faed's *'Ere Care Begins* (cat. 46, 45, 52). They all depict the simple and honest rural life in implicit contrast to the unpleasantness of life in England's rapidly growing industrial cities. Knight's painting also imitates Wilkie's work with its rich brown tones and its box-like interior.

Maclise's *The Woodranger* (cat. 44, detail left) owes much to 17th-century Flemish sporting pictures and has the exuberance of Rubens's work. Painted in strong, vibrant colours it is a demonstration of bravura technique. Cope's *The Night Alarm* (cat. 59) is equally arresting, but more through its use of dramatic lighting and narrative. In complete contrast nothing is uncertain in Marks's *Science is Measurement* (cat. 50) where a skeleton of a stork is measured, calibrated and recorded.

There were some Victorian artists who also attempted to depict the life of the hungry, homeless and oppressed. Redgrave painted various such subjects from the 1840s, including *The Outcast* (cat. 47), which represents a fallen woman with her illegitimate child being evicted from her home by her stern father despite the pleadings of the family. On the floor is a purse of money and an incriminating letter and the print on the wall appears to depict Abraham casting out Hagar and her illegitimate child Ishmael (cf. Eastlake's painting of this subject, cat. 12). The scene is made more pathetic by the snowy wastes outside the door and the innocent child's hand raised in echo of the hand of the pleading sister. Herkomer was of a later generation and one of the so-called social-realist painters who were not afraid to portray the unglamorous, even shocking consequences of poverty and economic oppression. His *On Strike* (cat. 60), a forceful painting of life-size dimensions, succeeds in engendering sympathy for the families of striking workers while monumentalising the dignity of the latter's determined struggle against exploitation.

Cat. 43
Sir John Watson Gordon RA
Auld Lang Syne 1851
Oil on canvas, 125.7 x 105.4 cm
Diploma Work accepted 1851

Cat. 44
Daniel Maclise RA
The Woodranger c. 1838
Oil on canvas, 213.5 x 91.5 cm
Diploma Work accepted 1840

Cat. 45
Sir William Allan RA
The Shepherd's Grace 1835
Oil on panel, 49 x 71 cm
Diploma Work accepted 1835

Cat. 46
John Prescott Knight RA
The Parting Blessing 1841
Oil on panel, 63.5 x 82.5 cm
Diploma Work accepted 1844

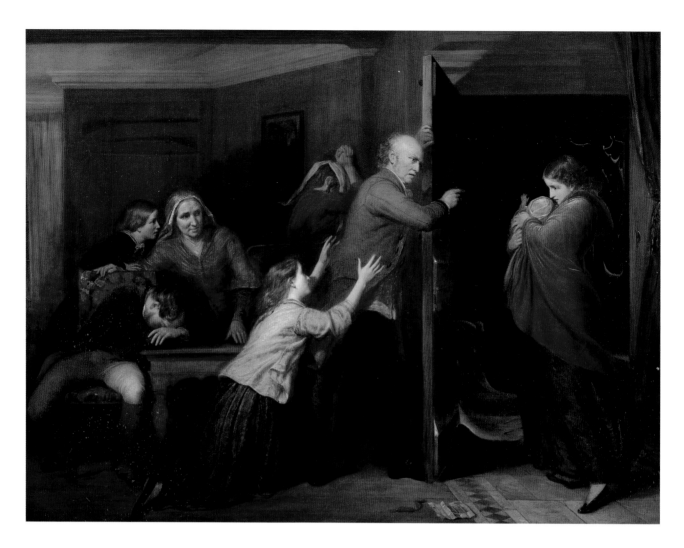

Cat. 47
Richard Redgrave RA
The Outcast 1851
Oil on canvas, 78.7 x 104.2 cm
Diploma Work accepted 1851

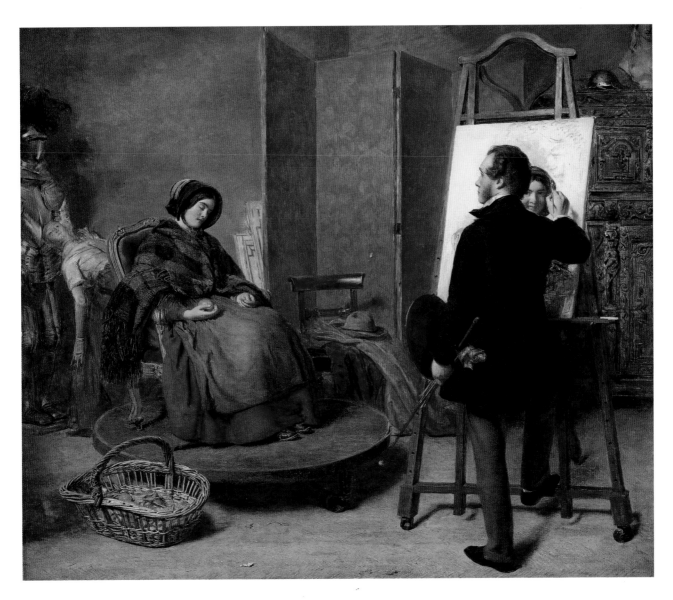

Cat. 48
William Powell Frith RA
The Sleeping Model 1853
Oil on canvas, 63.5 x 71.8 cm
Diploma Work accepted 1853

Cat. 49
John Callcott Horsley RA
A Pleasant Corner 1865
Oil on canvas, 76.2 x 55.9 cm
Diploma Work accepted 1865

Cat. 50
Henry Stacy Marks RA
Science is Measurement 1879
Oil on canvas, 91.5 x 61 cm
Diploma Work accepted 1879

Cat. 51
Sir John Everett Millais, Bt, PRA
Bubbles 1886
Oil on canvas, 107.5 x 77.5 cm
Reproduced by kind permission of Unilever PLC

Cat. 52
Thomas Faed RA
'Ere Care Begins 1865
Oil on canvas, 58.4 x 73.7 cm
Diploma Work accepted 1865

Cat. 53
James Sant RA
The Schoolmaster's Daughter c. 1870
Oil on canvas, 85.1 x 110.5 cm
Diploma Work accepted 1870

Cat. 54
Sir John Everett Millais, Bt, PRA
A Souvenir of Velazquez 1868
Oil on canvas, 102.7 x 82.4 cm
Diploma Work accepted 1868

Cat. 55
Sir George Clausen RA
Agnes Mary Webster 1882
Oil on canvas, 31.1 x 21.3 cm
Presented by A. C. Clausen,
son of the artist, 1964

Cat. 56
Sir Lawrence Alma-Tadema RA
Miss Anna Alma-Tadema 1883
Oil on canvas, 113 x 78.5 cm
Purchased by the Royal Academy, 1944 (Stott Fund)

Cat. 57
Sir George Clausen RA
Portrait of the Artist 1882
Oil on canvas, 31.1 x 21.3 cm
Presented by A. C. Clausen, son of the artist, 1964

Cat. 58
Sir Lawrence Alma-Tadema RA
A Family Group 1896
Oil on canvas, 30.5 x 27.9 cm
Purchased by the Royal Academy of Arts, 1944 (Stott Fund)

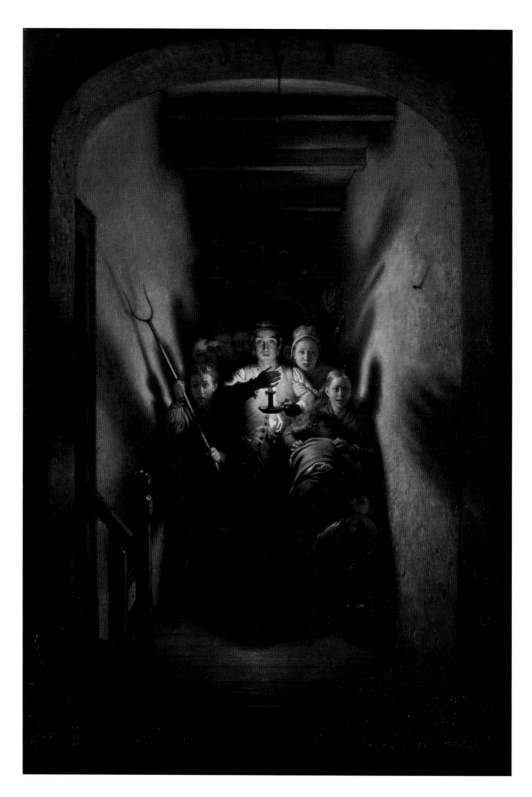

Cat. 59
Charles West Cope RA
The Night Alarm: The Advance 1871
Oil on panel, 147.3 x 97.8 cm
Diploma Work accepted 1876

Cat. 60
Sir Hubert von Herkomer RA
On Strike 1891
Oil on canvas, 228 x 126.4 cm
Diploma Work accepted 1891

Towards the Exotic

The 'exotic' was initially a Romantic concept. It provided the artist and writer with an escape, from both the austere programme of Neo-classicism and the dour demands of reality, into an imaginary world located in the little-explored landscapes and cultures of southern Spain, North Africa and the Levant. Samuel Coleridge could summon up the scintillating domain of Kubla Khan, and Jean-Dominique-Auguste Ingres could depict a bevy of nudes in a Turkish bath with neither poet nor painter having recourse to physical dislocation. By the mid-19th century, however, the demand of Positivism for objective truth called for artists to cast aside such romantic illusions. Instead, they felt beholden to seek out and record these regions in sketch and through photographs in order to give their finished visual representations the note of authenticity. Given the hardship of travel in these regions, Spain was the first country to be regularly visited by artists. David Roberts, J. F. Lewis and John Phillip (cat. 62) travelled there in the 1830s, and Edwin Long, as a student of the latter, accompanied his master there, for the first of many trips, in 1857. Although the culture and religion of Spain were not as remote or unknown to these British artists as were those of the Orient, namely North Africa and the Levant, the Islamic heritage in architecture and music, and the intensity of the southern light and colour presented the country – in contradistinction initially to Italy and Greece – in an essentially anti-classical guise.

David Roberts, J. F. Lewis and Edwin Long extended their direct involvement with the exotic by undertaking journeys to Egypt and the Levant. Roberts's interests in the archaeology, architecture, landscapes and local customs of the area led him to undertake an extensive eleven-month trip to Cairo, up the River Nile to Nubia and thence through Sinai, Syria, Palestine and Lebanon from 1838–9. The journey not only provided a rich accumulation of subjects for paintings of archaeological remains populated with figures in contemporary ethnic costume, such as The Gateway to the Great Temple at Baalbec (cat. 61), but also for a set of lithographs published in six volumes from 1842 to 1849 entitled The Holy Land, Syria, Idumea, Arabia, Egypt and Nubia. David Roberts provided Frederick Goodall with letters of introduction for his unique visit to Egypt. Arriving directly from England, he stayed in Cairo from Autumn 1858 to April 1859, travelling to Gizah and Suez. An established artist of genre and biblical scenes who had already been elected an Associate Academician in 1852, Goodall had journeyed with the specific intention of gaining firsthand experience of life in Egypt in order to give authenticity to his subsequent work, including the oriental genre scene, The Song of the Nubian Slave (cat. 64). The desire accurately to record everyday life in Egypt led J. F. Lewis to settle in the old quarter in Cairo in 1841 after four years of travel through Italy, Greece and the Levant. He was to remain there for ten years, living as an Egyptian pasha and accumulating a vast repertoire of images and objects. He drew upon these after his return to England in 1851, first for meticulously wrought watercolours and then, from 1859, for equally detailed oil paintings. Lewis's Diploma Work, The Door of a Cafe in Cairo (cat. 63, detail left) is redolent with authentic detail, from the costume and still life objects in the foreground to the intimation of a crowded Cairo streetscape in the background.

Although Briton Riviere never travelled to exotic regions, the pressure to create realist subjects led him meticulously to construct appropriate habitats for his genre paintings of animals, as in The King Drinks (cat. 65) and for his biblical scenes, such as Daniel in the Lion's Den (1872, Walker Art Gallery, Liverpool). In the former, the king of the beasts is suitably set within a rocky, desolate landscape whose details could have been gleaned from David Roberts's views of the desert of Sinai as recorded in his six volumes of lithographs (see above). The urge to give authentic voice to religious as well as genre scenes also spurred Edwin Long to travel through Egypt and Syria in 1874, and to return to Cairo the following year. These trips afforded the factual details necessary for such paintings as the critically acclaimed Babylonian Marriage Market (Royal Holloway College, University of London) which Long exhibited at the Royal Academy and which gained him election as an Associate Academician. It also provided the raw material for a more personal account of the Orient, Nouzhatoul-âoudat (cat. 66). Translated into English, the title means 'The Delight of the House', which gives the painting both a sentimental and a vicarious religious resonance.

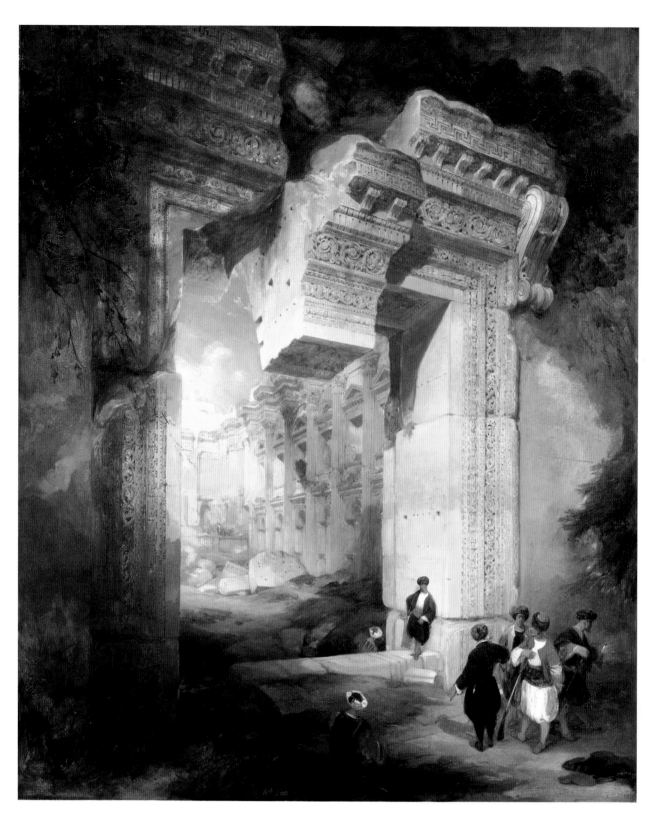

Cat. 61
David Roberts RA
The Gateway of the Great Temple at Baalbec 1841
Oil on panel, 75 x 62.2 cm
Diploma Work accepted 1841

Cat.62
John Phillip RA
Prayer 1859
Oil on canvas, 73.7 x 58.4 cm
Diploma Work accepted 1859

Cat. 63
John Frederick Lewis RA
The Door of a Cafe in Cairo 1865
Oil on panel, 76.2 x 53.3 cm
Diploma Work accepted 1865

Cat. 64
Frederick Goodall RA
The Song of the Nubian Slave 1863
Oil on canvas, 68.6 x 91.5 cm
Diploma Work accepted 1863

Cat. 65
Briton Riviere RA
The King Drinks 1881
Oil on canvas, 61 x 91.5 cm
Diploma Work accepted 1881

Cat. 66
Edwin Long RA
Nouzhatoul-âouadat 1881
Oil on canvas, 72.4 x 58.4 cm
Diploma Work accepted 1882

Landscape Painting

The development of landscape painting in Britain from the 18th century was determined by the shifting definition accorded to the term, 'truth to Nature'. Initially defined by the idealised nature represented in the classical landscapes of French 17th-century artists, notably Claude Lorraine and Nicholas Poussin, 'truth to Nature' became subject to the aesthetic variants of the sublime and the picturesque. These two categories both gave modes of access to the celebration of native British landscape, which paralleled a rise in nationalist sentiment at the end of the 18th century, and focused the attention of artist and poet alike on the truths inherent in the particulars, as opposed to the generalities of Nature herself. In art this transformed landscape painting from the generalised views of Richard Wilson and Alexander Cozens to the specificity recorded by John Robert Cozens, Thomas Girtin, J. M. W. Turner and John Constable, and in literature from the panoramic vision of James Thomson and Alexander Pope to the observation of detailed natural elements and personal emotional responses found in the work of William Wordsworth, Samuel Coleridge and John Clare.

Sir Joshua Reynolds's confirmation of the superiority of history painting relegated landscape painting to a secondary category which delayed not only the acceptance of the more specific landscapes of Constable on the walls of the Royal Academy's Annual Exhibition but also the introduction of study from nature into the Royal Academy Schools curriculum until the 1840s. It therefore is of no surprise, during most of the 19th century, that neither was landscape as a prominent genre represented in the Annual Exhibitions nor that landscape painters figured in numerical strength as Royal Academicians.

The landscape painters who succeeded the heroic generation of Turner and Constable not only had to contend with the towering achievement of this older generation but also with the new realities and meanings contained within the idea of landscape painting itself. By the mid-19th century, the United Kingdom had experienced rapid, and continuing, urbanisation which encroached upon the countryside and industrialisation that had continued to scar the landscape. Landscape painting came increasingly to provide a visual balm with which to salve this two-fold blight: landscape paintings could evoke a rural idyll, as in Vicat Cole's *Autumn Morning* (cat. 67 detail left), or celebrate the ritual routine of unchanging rural practices, as in Leader's *The Sandpit, Burrow's Cross* (cat. 70) and in Graham's *Homewards* (cat. 69, or the familiar character of the seasons, as in Farquharson's *'When snow the pasture sheets'* (cat. 68). Equally, marine subjects no longer celebrated naval battles or Man pitted against the fury of Nature, but rather, as in the works by Moore (cat. 71) and Hemy (cat. 72), the enormity of unsullied sea and sky. Within this shared programme, however, there were differences in approaches to the meaning of truth to Nature. While Vicat Cole, with his meticulous notation of the detailed plant growth, the arching trees and the distant view seen through the suffused light of the morning sun reflects John Ruskin's aesthetic programme which called for the artist to observe and record the vast specificity of Nature in order to reveal the 'infinite goodness and wonder of God's creation', the more allusive landscapes of Leader and Graham sought out the atmospheric and expressive aspects of Nature and recorded them through broader technique.

Cat. 67
George Vicat Cole RA
Autumn Morning 1891
Oil on canvas, 81.5 x 132 cm
Diploma Work accepted 1891

Cat. 68
Joseph Farquharson RA
'When snow the pasture sheets' 1915
Oil on canvas, 55.9 x 91.5 cm
Diploma Work accepted 1915

Cat. 69
Peter Graham RA
Homewards c. 1882
Oil on canvas, 73.7 x 110.7 cm
Diploma Work accepted 1882

Cat. 70
Benjamin Williams Leader RA
The Sandpit, Burrow's Cross 1898
Oil on canvas, 61 x 101.6 cm
Diploma Work accepted 1899

Cat. 71
Henry Moore RA
Summer Breeze in the Channel c. 1893
Oil on canvas, 60.3 x 101 cm
Diploma Work accepted 1893

Cat. 72
Charles Napier Hemy RA
A Plymouth Hooker 1910
Oil on panel, 38.1 x 69.9 cm
Diploma Work accepted 1910

Cat. 73
George Henry Boughton RA
Memories 1896
Oil on canvas, 54.6 x 80 cm
Diploma Work accepted 1896

Cat. 74
James Clarke Hook RA
Gathering Limpets 1886
Oil on canvas, 50.8 x 85.1 cm
Diploma Work accepted 1886

Cat. 75
Sir William Quiller Orchardson RA
On the North Foreland 1890
Oil on canvas, 91.5 x 76.2 cm
Diploma Work accepted 1890

Cat. 76
Robert Walker Macbeth RA
The Lass that a Sailor Loves c. 1903
Oil on canvas, 67.3 x 90.2 cm
Diploma Work accepted 1903

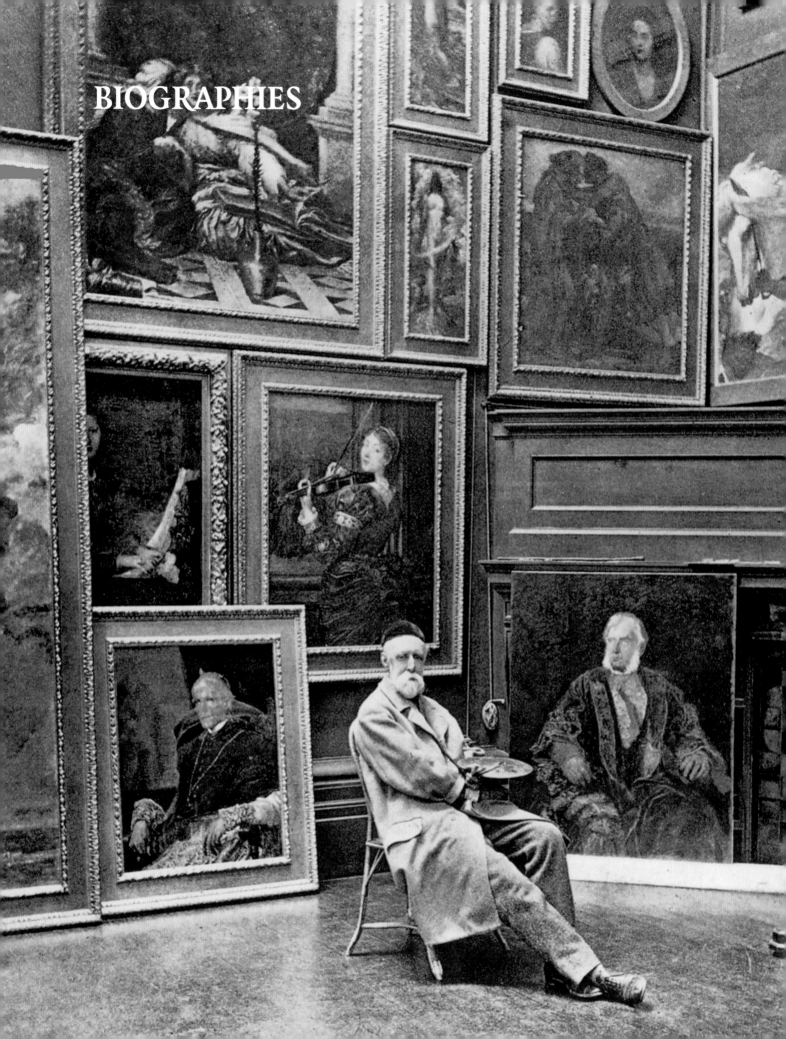

BIOGRAPHIES

Biographies by Rebecca Virag
Photographic research by Patricia Eaton

Edwin Austin Abbey 1852–1911
Born in Philadelphia, at the age of fourteen Abbey began drawing lessons with Isaac L. Williams, a portrait and landscape painter, and attended night classes at the Pennsylvania Academy of the Fine Arts in 1868–71. He moved to New York and worked as an illustrator for *Harper's Magazine* and in 1878 was sent to England to research illustrations for *Selections from the Poetry of Robert Herrick* (1882). Abbey settled in England and divided his time between London and Gloucestershire.

In 1880 he travelled to Holland with G. H. Boughton (q.v.), and recorded this trip in *Sketching Rambles in Holland* (1885). Abbey illustrated many volumes including Goldsmith's *She Stoops to Conquer* (1887), Shakespeare's *Comedies* (1896) and two volumes of poetry, *Old Songs* (1889), which won a first class medal at the Paris Exposition in 1889. It was not until 1889 that Abbey began to paint seriously in oil, taking subjects usually from the Middle Ages and the 18th century. He was elected ARA 1896 and RA 1898.

Abbey's major oeuvre was the creation of murals, including *The Quest and Achievement of the Holy Grail* (1890–1901), a series for the Boston Public Library. It was during this time that Abbey had a huge studio built at Fairford, Gloucestershire. He also led a team of younger artists in the painting of the murals for the Houses of Parliament in 1908–10. The 'Picture of the Year' in 1896 was Abbey's *Richard Duke of Gloucester and the Lady Anne* (Yale University Art Gallery). In 1907 Abbey was offered a knighthood which he declined due to his American citizenship.

Sir William Allan 1782–1850
Born in Edinburgh, Allan trained at the

Trustees' Academy in Edinburgh with David Wilkie and also briefly at the RA Schools. In 1805 Allan left for Russia and on his arrival met Sir Alexander Crichton, a physician to the Imperial family, who obtained for Allan unlimited access to all areas of the Russian Empire. Allan visited Tartary, Circassia and the South, and made studies of the life and landscape which were later developed into paintings, many of which he exhibited at the RA. He returned to Edinburgh in 1814, following the defeat of Napoleon in Russia.

These paintings found little favour in Scotland, although Sir Walter Scott helped greatly in finding Allan patrons and buyers. Allan's friendship with Scott stimulated his interest in subjects from Scotland's medieval past. With works such as *Knox Admonishing Mary Queen of Scots* (1823) he did much to revive the taste for history painting in Scotland. Further travel in the near East produced new orientalist subjects including *Peter the Great Teaching his Subjects Shipbuilding* (1845), purchased by the Grand Duke Nicholas of Russia.

Allan was elected ARA 1825, RA 1835 and was elected President of the RSA in 1838. He was knighted in 1842. Allan also painted historical battle scenes, and died still at work on the huge canvas of *The Battle of Bannockburn* (1850).

Sir Lawrence Alma-Tadema 1836–1912
Born in Dronryp, Holland Alma-Tadema entered the Antwerp Academy in 1852 where Luis de Taye, Professor of Archaeology, much influenced his work. In 1863 he visited Florence, Rome, Naples and Pompeii while on his honeymoon. On this and subsequent visits he made measured drawings of the ruins, examined excavated artefacts in the Naples Museum and collected photographs and information about classical antiquities and architecture. He lived in Brussels 1865–9, exhibiting there and in London, Paris and Amsterdam. In 1870, he settled in London and was naturalised three years later. His paintings of domestic scenes of the classical past were a novelty in England at this time. Alma-Tadema was renowned for the archaeological correctness of the objects he featured in his paintings, often using photographs to achieve the specificity that gave his work its 'historical' status.

He exhibited at the RA from 1869 and also at the OWS, the Grosvenor Gallery and the New Gallery. He was elected ARA 1876, RA 1879 and was knighted in 1899. He was awarded the Royal Gold Medal by the RIBA in 1906 for his promotion of architecture in painting. He numbered all his works with roman numerals, his last work being Opus CCCCVIII. He is buried in St Paul's Cathedral.

'G. F. Watts', (previous page) Photograph by J. P. Mayall, published in F. G. Stephens *Artists at Home*, London, 1884

George Henry Boughton
1833–1905

Boughton was born in a village near Norwich but the family migrated to America when he was one year old. Boughton first trained for a mercantile career. He taught himself the rudiments of draughts manship and was so talented that in 1856 he was sent to England. He spent his time there sketching in the Lake District, Scotland and Ireland. In 1860 he travelled to Paris where he became a pupil of Couture and Edouard Frère before deciding to settle in London.

He exhibited at the RA in 1863, showing *Early Puritans of New England*, a painting that combines romance with New England history. Works of a similar subject appeared throughout his career, such as *God speed! Pilgrims setting out for Canterbury...* (1874).

In 1880, Boughton commenced a sketching tour of Holland with fellow American E. A. Abbey (q.v.) which led to the publication of his book *Sketching Rambles in Holland* (1885) and many paintings of Dutch historical genre subjects. Although Boughton was often very specific about date, place and costume in the titles of his work and undertook archaeological research, his work was above all imaginative and idealised.

In addition to submitting short stories to *Harper's Magazine* and *Pall Mall Magazine*, Boughton was also an illustrator for the Grolier Club in New York. Boughton was elected ARA 1879 and RA 1896.

Sir Thomas Brock
1847–1922

Brock was born in Worcester and trained in the Government School of Design. In 1866 he moved to London to work in the studio of the sculptor, John Henry Foley RA. Brock entered the RA Schools in 1867 and in 1869 he won the gold medal for his *Hercules Strangling Antaeus*. Brock developed a close friendship with Leighton

(q.v.) and Brock's *Hercules* influenced Leighton's most celebrated sculpture, *Athlete Wrestling with a Python*, which Leighton modelled in Brock's studio.

After Foley's death in 1874, Brock was commissioned to complete the works which Foley had left unfinished, including the colossal statue of the Prince Consort for the *Albert Memorial* at Kensington. His greatest public monument was the memorial to Queen Victoria, which stands in front of Buckingham Palace. This work was to take Brock twenty years to complete and after its unveiling in 1911, he was honoured with the KCB by King George V. Brock also completed a huge bronze equestrian statue of *Edward the Black Prince* (1902) in full armour for the new square in Leeds city centre.

Brock's busts were generally believed to be among the best of his work and include a bust of Longfellow (1884) for the Poet's Corner in Westminster Abbey. After Leighton's death, Brock was chosen to create the memorial to him in St Paul's Cathedral and it is with this work that Brock can be seen as a principal exponent of the 'New Sculpture'. He was elected ARA 1883 and RA 1891.

Philip Hermogenes Calderon
1833–1898

Born in Poitiers, the son of a Spanish priest and a French mother, Calderon entered J. M. Leigh's Art School before studying in Paris in 1851 at the atelier of François Edouard Picot. There he met Henry Stacy Marks (q.v.), a future fellow member of the St John's Wood Clique.

Calderon first exhibited at the RA in 1853 with *By the Waters of Babylon*. He produced other work with biblical themes but his oeuvre consisted principally of historical genre scenes marked by their attention to historical detail and accuracy, as was characteristic of the work of the St John's Wood Clique. Among Calderon's fellows in the 'Clique' were the artists Marks, Seymour Lucas (q.v.) and G. D. Leslie RA.

There is an element of humour in much of Calderon's work such as the comic romantic farce represented in *Moonlight Serenade* (1872) and the wry humour of a presentation of a five-year-old girl in *Her Most High, Noble and Puissant Grace* (1867). This painting was the only British painting to receive a gold medal at the Exposition Universelle of 1867 in Paris. Calderon was elected ARA 1864 and RA 1867. He was Keeper of the RA 1887–98.

Sir George Clausen
1852–1944

Clausen was born in London to a Scottish mother and a father of Danish origin. He initially followed his father's trade as an interior decorator but in 1867 attended evening classes at the National Art School. He was taught by Edwin Long (q.v.) who persuaded him to devote himself entirely to painting.

In 1875 Clausen travelled to Holland and Belgium where he developed an interest in Dutch naturalism and he exhibited subjects such as *High Mass at a Fishing Village on the Zuyder Zee* until 1883. Around this time, he was influenced by Jules Bastien-Lepage and his style of outdoor realism. In 1882, he went to Quimperlé, France to paint French rustic scenes and in 1883 briefly attended the Académie Julien in Paris. In 1886, Clausen and other painters formed the New English Art Club which championed French *plein-air* painting.

In the 1890s, Clausen developed a more fluid style to convey a sense of figure movement and worked with a more luminous palette. He was elected ARA 1895, RA 1908 and was appointed Professor of Painting at the RA 1903–6. His lectures to students were very popular and were published immediately. In addition to his small intimate oils and watercolours of rural scenes, Clausen began to produce large scale mural-like work in a grand manner for exhibition at the RA. Aged 75 years, Clausen executed a mural for the House of Commons and was knighted in 1927.

George Vicat Cole 1833–1893

Born in Portsmouth and given the middle name 'Vicat' as a tribute to his mother's family. Cole was trained by his father, George Cole, a landscape and animal painter and 1849–54 accompanied his father on sketching tours to the river scenery of the Wye, the Moselle and the Dart. He never received any formal artistic education, which he was to regret in later life due to the weakness of his figure drawing. At the age of 16, Cole exhibited his first work, a landscape in oils, at the BI.

In 1857–9 Cole settled in Albury in Surrey, an idyllic village near Guildford which provided Cole with ideal landscape subject matter. He used a hut as a mobile studio to sketch the countryside. Such detailed scrutiny of nature produced a series of harvest paintings including *Surrey Cornfield* (1861). These subjects were symbolic of national unity and plenty and such idyllic scenes were very popular with urban Londoners. Cole's direct and scientific observance of nature shows awareness of the practice of the Pre-Raphaelites.

Cole began exhibiting at the RA in 1859 and was elected ARA 1870 and RA 1880, being the first 'pure' landscape painter to gain full membership of the RA since 1851. At the end of his life he also painted the River Thames and its surrounding landscape.

Sir Arthur Stockdale Cope 1857–1940

Born in London and educated in Norwich and Wiesbaden, Cope was the son of Charles West Cope (q.v.). He studied at Carey's Art School and then in 1874 at the RA Schools. Cope began to exhibit at the RA from 1876 and also at the Paris Salon where he received a gold medal and the Rosa Bonheur prize.

Cope was chiefly a portraitist, enjoying an extremely successful society practice although he occasionally painted landscapes. Cope's work was imaginative and detailed, picking on accessories which would convey the essence of the sitter and often in an innovative way. His portrait of the artist, *John Pettie R.A.*, shows Pettie at his easel with paint brushes and palette. Pettie's easel is turned towards him, thus suggesting that he is either painting Cope, who is painting him, or painting us, the spectators.

Cope was commissioned to paint many Royal portraits, including George V and Edward VIII. One of his most memorable works is *Some Sea Officers of the Great War* (1921), which features 22 officers, seated and standing in the Admiralty Board Room. Cope ran his own art school in South Kensington in the 1900s. Cope died at his home near Launceston, Cornwall.

Charles West Cope 1811–1890

Born in Leeds to a father who was a watercolourist, and who named his son after his friend the painter, Benjamin West. Cope was a student at Sass's Academy and then in 1828 was admitted to the RA Schools alongside the painter Daniel Maclise (q.v.). In 1831 Cope went to Paris, and in 1833–5 he travelled around Italy and the Netherlands. In 1836 Cope exhibited a sentimental domestic genre painting, *Mother and Child*, at the BI which was the precursor to many other small paintings of maternal or domestic subjects undertaken throughout his career.

Cope was successful in the competition to decorate the Houses of Parliament and in 1842 was commissioned to paint several frescoes. It consumed his artistic talents until the end of his life, and made his name and reputation as a painter of high art. Cope painted *Edward III Conferring the Order of the Garter on the Black Prince* for the South Gallery which was finished in 1848 and also executed eight frescoes for the Peers' corridor illustrating the virtues and heroism of figures from the Civil War.

Cope was elected ARA 1843 and RA in 1848, the same year that he produced the vast canvas, *Cardinal Wolsey Arriving at the Gate of Leicester Abbey*, for Prince Albert. In addition to his work for the Houses of Parliament, Cope also exhibited scenes from Shakespeare, Milton and Scott, as well as biblical subjects.

Frank Cadogan Cowper 1877–1958

Son of the writer, Frank Cowper, he was born at Wicken, Northamptonshire. He studied art at the St John's Wood Art School and the RA Schools 1897–1902 and spent six months working in the studio of E. A. Abbey RA (q.v.). Cowper's attention to the detail of patterned fabrics, decoration and jewellery which governed much of his work demonstrated a debt to the methods of the Pre-Raphaelites.

St. Agnes in Prison, Receiving from Heaven the Shining White Garment (1905) was bought by the Chantrey Bequest. Cowper's rather profane painting, *The Devil Among the Nuns* (1907) depicting the Devil disguised as a troubadour singing a song of love to nuns at their evening meal, nonetheless contributed to his election as ARA in 1907. He was not elected RA until 1934.

In 1910 Cowper was one of six artists commissioned to paint frescoes for the Eastern Corridor in the Houses of Parliament. He worked alongside John Byam Shaw, with whom Cowper shared many stylistic similarities, including the way in which they both signed their work on what were painted to appear as small cartellino pinned to the canvas. Cowper returned to the Houses of Parliament in 1912 to paint further decorative panels.

In the 1920s, Cowper produced many society portraits. Cowper was also a skilled watercolourist and contributed illustrations to *The Idler* and *The Graphic*. He continued to exhibit until 1957 and died in Cirencester aged 81 years.

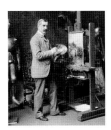

Ernest Crofts
1847–1911

Born in Leeds, Crofts became the pupil in London of the painter, Alfred Barron Clay, from whom he acquired a taste for history painting. In 1868 Crofts studied in Düsseldorf with Emil Hünten who specialised in battle paintings. During the Franco-Prussian war Crofts visited a number of battlefields and his experiences were depicted in his first picture exhibited at the RA in 1874, *A Retreat: Episode of the French–German War*. Crofts remained in Germany until the late 1870s when he returned to England, eventually settling in St John's Wood in the 1890s.

Crofts also painted scenes from the English Civil War and the Napoleonic Wars, often highlighting particular incidents of battle or focusing on individuals rather than producing the sweeping battle panoramas of the early 19th century. His paintings were meticulous in their historical accuracy and his studio was filled with a vast array of original helmets, uniforms and weapons including a small cannon and a marching drum. He used mannequins dressed in period costume as models. Crofts was praised for his lively scenes but he and other English battle painters were attacked by M. H. Spielmann in 1897 for refusing to portray realistically the gore and horrors of war.

Crofts was elected ARA 1878, RA 1896 and was made Keeper of the RA Schools in 1898.

Sir Frank Dicksee 1853–1928

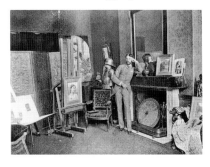

Dicksee was born in London into an artistic family. His father, Thomas Francis Dicksee, and his uncle, brother and sister all exhibited at the RA. Dicksee was taught by his father before entering the RA Schools in 1871. In the 1870s and '80s, Dicksee worked as an illustrator for contemporary periodicals such as *Cassell's Magazine* and *The Graphic*, as well as illustrating books such as Longfellow's *Evangeline* (1882).

Dicksee was an early member of the Langham Sketching Club where the rules dictated that members must instantaneously invent a composition suggested to them by a set subject. Dicksee's first RA success of 1877, *Harmony*, was bought for the Chantrey Bequest, and developed from an idea first executed at the Langham Club. One of Dicksee's best known works, *Chivalry* (1885), reveals in the depiction of the evening glow of the sunset, the dramatic lighting and rich colouring typical of his work. Dicksee had been much influenced by the work of the Venetian School on a visit to Italy in 1882. In addition to historical and literary subjects, Dicksee also produced scenes of social drama, such as *The Crisis* (1891) and *The Confession* (1896).

Dicksee was elected ARA 1881, RA 1891, and was President of the RA 1924–8. He was a fierce opponent of modernism and continued to paint romantic subjects often set in medieval times. He was knighted in 1925.

William Dyce
1806–1864

Born in Aberdeen, the son of Dr William Dyce, a lecturer in medicine. In 1825, after a brief period as a student of design at the RSA in Edinburgh, Dyce left for London and then Rome where he studied at the British Academy. He met painters of the Nazarene School, Overbeck and Cornelius, through Baron Bunsen, a leading figure of Rome's social circle who also shared Dyce's interest in old Latin church music. Dyce was an accomplished musician and student of ecclesiology, and in 1843 prepared a revised *Order of Daily Service* for the High Anglican Church.

Dyce believed implicitly in art as a vehicle for moral and religious improvement and from 1830 produced a series of paintings on the life of Christ based on the styles of the Italian Old Masters and the work of the Nazarenes. In 1837 Dyce was appointed superintendent of the newly-opened Government School of Design in London and in 1838 successfully entered the competition to decorate the Houses of Parliament. He published technical details on the art of fresco painting in *Notes on Frescos in Italy* (1845–6) and executed *The Baptism of King Ethelbert* in 1846 in the House of Lords and seven allegorical works on the Arthurian theme for the Queen's Robing Room, which were much acclaimed although he died leaving the work unfinished. He was elected ARA 1844 and RA 1848.

Sir Charles Lock
Eastlake
1793–1865

Born in Plymouth where his father was lawyer to the Admiralty. In 1809 he became a pupil of Benjamin Robert Haydon and also entered the RA Schools, and in 1814 travelled to Paris to copy the paintings collected by Napoleon in the Louvre. Eastlake painted one of the last portraits of Napoleon before his death when the HMS Bellerophon landed at Portsmouth on its way to St Helena.

In 1816 Eastlake travelled to Italy, and then to Greece in 1818 with the architect Charles Barry, and lived in Rome from 1818 to 1830 where he was involved in the establishment of the *Academy for Young English Artists*. His major painting of 1828, *Italian Scene in the Anno Santo, Pilgrims Arriving...*, was a romanticised view of peasant life in Italy. Later works often featured brigands and banditti wearing picturesque and colourful national costume. Eastlake was elected ARA 1827 and RA 1830.

Eastlake was involved in arts administration throughout much of his career, as secretary of the Royal Commission for the Decoration of the Houses of Parliament in 1844, as the first Director of the National Gallery in 1843, and as President of the RA, 1850–65. His purchases of the so-called Italian Primitives, such as Piero della Francesca for the

National Gallery, brought him much praise. Eastlake was also a recognised art scholar, translating Goethe's *Theory of Colours* (1840) and editing Kugler's *Handbook of the History of Painting* (1841).

Augustus Leopold Egg 1816–1863

Egg was born in London, the son of a rich gunsmith. He studied at Sass's Drawing School and in 1836 entered the RA Schools. Egg's first works were Italian subjects, although he had never visited Italy.

In the late 1830s Egg helped form a sketching club known as 'The Clique' with fellow members, W. P. Frith (q.v.) and Richard Dadd. Egg was a painter of historical genre, and his scenes from the domestic lives of figures from British history were often cheerful and humorous, notably *Queen Elizabeth Discovers she is no longer Young* (1848). More serious work included a series of paintings, *Past and Present*, which took as its subject the perils of adultery in modern life.

Egg was a supporter of the Pre-Raphaelites and shared ideas about colour theory and studio practice with William Holman Hunt. He was also a member of the Guild of Literature and Art, which was founded by Charles Dickens and others to aid struggling artists and men of letters. Several plays were staged by Dickens's company to raise money for the scheme and in which Egg himself performed and designed costumes. Egg was elected ARA 1848, but soon after his election as RA in 1860 was forced to leave England due to failing health. He died in Algiers three years later.

Alfred Elmore 1815–1881

Born in Cloghnakilty, County Cork, Ireland, where Elmore's father was an army surgeon. The family moved to London and as a boy Elmore drew sculptures at the British Museum before entering the

RA Schools in 1832. He exhibited his first major work at the BI, *Christ Crowned With Thorns*, in 1837.

Elmore visited Paris 1833–9 and in 1840 he spent three months at the Munich Academy, studying drawing technique before going to live in Italy for two years. Elmore was elected ARA 1845 and RA 1857.

In addition to painting scenes from Shakespeare, Elmore depicted subjects from some more unusual historical sources, such as Samuel Pepys's Diary and events from the reigns of the kings and queens of France. Elmore's only modern-life subject was *On the Brink* (1865) which moralised against the dangers of gambling for unaccompanied women. Elmore's adeptness in creating unusual light effects, such as those caused by gaslight and firelight, features in many of his paintings.

Elmore is believed to have visited Algiers in the late 1860s and '70s when he produced several orientalist and Algerian subjects. He was influenced by the high classical style of Leighton and Poynter at the end of his career, producing *An Eastern Bath* (1880) as one of his final RA exhibits.

Thomas Faed 1826–1900

Faed was born in Kircudbrightshire, the son of a Scottish engineer. Faed's brother John was also a painter who specialised in Highland landscapes. The two brothers studied at the Trustees' Academy in Edinburgh where they were pupils of Sir William Allan (q.v.). Thomas Faed became an Associate of the RSA in 1849 and exhibited his first major work there, *Scott and his Friends at Abbotsford*, in the same year. In 1851 he began exhibiting in London paintings such as *Cottage Piety*, a cottage interior detailing the humble domestic life of the poor, which was to be the prevalent subject of Faed's work.

Faed's use of humour was comparable to other contemporary Scottish painters such as Erskine Nicol ARA, but a preference for pathos characterised much of his work and contributed to the

success of *The Mitherless Bairn* (1855). Faed was elected ARA 1860 and RA 1864. The titles of his work were often taken from the poetry of Robert Burns, or from Scottish folk tales.

Faed's paintings were frequently engraved and widely disseminated abroad as well as in England. Failing eyesight forced him to abandon his art in 1892 and he died eight years later in St John's Wood, London.

Joseph Farquharson 1846–1935

Farquharson was born in Edinburgh where his father, a keen amateur painter, practised medicine and was laird of a highland clan in Aberdeenshire in the locality of Finzean. Farquharson inherited his title in 1918. He studied at the Trustees' Academy in Edinburgh and attended life classes at the RSA where he also exhibited until the early 1880s. The Scottish landscape artist, Peter Graham (q.v.), was a family friend and influenced Farquharson's landscapes of the 1860s.

In 1874 Farquharson left for Holland where he met Jozef Israels, a painter of the Hague School, who inspired Farquharson to paint several domestic interiors. From 1880, he made several trips to Paris, studying in the atelier of Carolus-Duran and also learning the principles of *plein-air* painting from the Barbizon School painters. *A Joyless Winter Day*, exhibited at the RA in 1883, depicts a bleak snow-covered Scottish moor, where a shepherd and his sheep struggle through a blizzard, and demonstrates Farquharson's ability to capture the scenes of deepest winter. Farquharson was able to observe directly such frozen conditions by using a portable hut with a stove in the Finzean woodlands.

In the mid-1880s and early '90s Farquharson made several trips to Egypt and subsequently exhibited biblical scenes. He continued to paint until his death in 1935, although in later years his subjects were often restricted to his gardens at Finzean.

Edward Onslow Ford 1852–1901

Ford was born in London, but following the early death of his father moved to Antwerp and attended the Antwerp Academy as a student of painting. He studied under Wagmuller, in Munich, who advised him to change from painting to modelling. Ford returned to England in 1874.

Among Ford's public monuments are *General Gordon on a Camel* (1890) which was brought back from Khartoum and placed in the courtyard of Gordon Boy's School, Woking and the *Shelley Memorial* (1892) University College, Oxford. Ford was one of the leading exponents of the 'New Sculpture' Movement which prized individuality as opposed to breadth. Ford's marble version of a turbanned female head of a girl, known as *A Study* (1891), was seen to evoke an elusive, spiritual ideal. His many busts uphold the 'New Sculpture' ideals of individuality, verisimilitude and delicate modelling. Many artists sat for Ford, including Millais (q.v.), Briton Riviere (q.v.) and Herkomer (q.v.). Ford was elected ARA 1888 and RA 1895.

William Powell Frith 1819–1909

Born at Studley Royal in Yorkshire, Frith was encouraged to paint by his father who was an art enthusiast. Frith entered Sass's Drawing School in 1835 and then the RA Schools in 1837. From 1839 he began painting scenes illustrating the work of Sir Walter Scott, Shakespeare, Molière and Goldsmith, and his first RA exhibit in 1840 was a scene from *The Vicar of Wakefield*. Frith, however, was dissatisfied with the modest success of his historical genre paintings, and despite his dislike of modern dress which he considered unpicturesque, turned to subjects from modern life, beginning with a commission from Dickens in 1842 to portray two contemporary characters from his novels. Frith was elected ARA 1845, RA 1852, and the following year the first of his panoramic canvases of modern-life subjects appeared. *Life At the Seaside (Ramsgate Sands)*, set in a popular Victorian seaside resort, was a great success with the public who enjoyed scrutinising the individual incidents among the various groups and classes of people. Similar panoramic groups followed with *Derby Day* (1858) and *The Railway Station* (1862). He also painted modern-life moral subjects in two series, *The Road to Ruin* (1878) and *The Race for Wealth* (1880). A commission from Queen Victoria to paint the marriage of the Prince of Wales occupied Frith until 1865. Frith published his *Autobiography and Reminiscences* in three volumes (1887–8).

Sir Alfred Gilbert 1854–1934

Born in London, Gilbert's parents were both professional musicians. He enrolled at Heatherley's School of Art and then entered the RA Schools in 1874 and also became J. E. Boehm's apprentice. In 1875 Gilbert went to Paris to study at the Ecole des Beaux Arts and also travelled to Italy where his visit to Florence around 1880–1 inspired his first statue in bronze, *Perseus Arming* (1882). In this work Gilbert revived the 'lost wax' process of casting bronze that rid sculpture of unsightly 'seams'.

Gilbert's aim as a sculptor was to suggest colour by the use and manipulation of texture and shadow, and he was at the forefront of the progressive school of British sculpture known as the 'New Sculpture'. He received many public commissions, including the *Memorial to Queen Alexandra* (1928–32) at Marlborough Gate. The *Fawcett Memorial* in Westminster Abbey is one of his best known works, in which he demonstrated an innovative use of oriental alloys, producing many varying coloured patinas. This very Gothic work featured miniature knights, queens, dragons and sirens, all encrusted with semi-precious stones, enamel and ivory. The *Clarence Memorial*, commissioned by the Prince and Princess of Wales. was similar in conception. Gilbert's best known achievement is the *Shaftesbury Memorial* (1886–93), better known as 'Eros', in Piccadilly Circus.

Gilbert's chronic inability to finish commissions led to ruptures with the Royal family and several court cases brought by dissatisfied patrons. The crippling cost of monuments such as 'Eros' led to his bankruptcy in 1901, and impoverished exile in Bruges. He was elected ARA 1887 and RA 1892, although he was forced to resign from the RA in 1908 following the court cases; he rejoined in 1932.

Frederick Goodall 1822–1904

Goodall was born in London into an artistic family, his father was a well-known engraver of J. M. W. Turner's landscapes and his brothers and sisters were also artists. Goodall initially studied engraving in his father's studio but then decided to become a painter. In 1838 Goodall sketched with his father in Normandy, Rouen and Brittany and subsequently exhibited subjects such as *Passing The Cross, Brittany* (1843) where travellers passing by a roadside Calvary bow their heads in deference. In the late 1840s and early '50s Goodall painted a series of nostalgic subjects from British history such as *An Episode in the Happier Days of Charles I*.

Goodall was elected ARA 1852 and RA 1863. In 1858 Goodall made his first trip to the Near East, meeting the Bavarian born artist Carl Haag in Cairo, where the two men shared a studio. In his *Reminiscences* (1902), Goodall explains that he wished to paint biblical subjects; however, most of his works were scenes of contemporary life in Egypt portrayed in biblical terms. Goodall returned to Egypt in 1870 and joined a nomadic Bedouin tribe near Saqqara.

Although English genre subjects continued to appear sporadically along with some portraits in the 1890s, Goodall continued to be fascinated with Egypt and the Nile, and his home in Regents Park, London was filled with Egyptian artefacts and memorabilia.

Sir John Watson Gordon 1788 or 1790–1864
Born in Edinburgh, the son of Captain J. Watson of the Royal Navy. Gordon (born John Watson) studied at the Trustees' Academy in Edinburgh, where David Wilkie and Sir William Allan (q.v.) were also pupils, and also in the studio of his uncle, George Watson PRSA. Encouraged by Henry Raeburn, a family friend, Gordon's style was closely modelled on Raeburn's. On Raeburn's death in 1823, Gordon became Scotland's leading portrait painter. Gordon began his career by painting genre and history subjects, but by 1821 had settled on portraiture. As there were already four portraitists in Edinburgh named 'Watson', he assumed the additional name of 'Gordon' in 1826.

Gordon was intimately connected with the RSA, contributing much to its formation, and became its President in 1850. In the same year Gordon was knighted. Gordon greatly admired the work of Velazquez and was much influenced by his loose and dramatic style of portraiture. Gordon contributed many paintings to the RA exhibitions, and was elected ARA 1841 and RA 1851. Among his sitters were Sir Walter Scott, David Roberts, John Frederick Lewis and the Prince of Wales. He died of a stroke in Edinburgh and his brother founded the Watson Gordon Professorship of Fine Art at Edinburgh University in his memory.

Andrew Carrick Gow 1848–1920
Gow studied at Heatherley's School of Art where he excelled in watercolour and was elected a member of the NWS in 1868.
He exhibited paintings of historical and military subjects, genre and portraits at the RA from 1867. Gow achieved his first real success with the *Relief of Leyden* (1876), which demonstrated his ability in expressing action and drama.

In 1879 Gow exhibited an unusual genre scene, taken from the life of Chopin, *A Musical Story By Chopin*. Gow was elected ARA 1880, and RA 1890 and was Keeper of the RA Schools 1911–20.

Loot, 1797, shown at the RA in 1875, was admired by Ruskin for its meticulous attention to detail and for representing the reality of war without any false sentiment. In 1885, Gow visited Algeria, which resulted in several Algerian subjects painted on the spot such as *Nôtre Dame d'Afrique*, a sensitive marine landscape off the coast of Africa and *Algerian Gossip* (1886), an exotic genre scene. He was commissioned to paint a large picture of Queen Victoria at St Paul's Cathedral on the day of her Diamond Jubilee in 1887.

Peter Graham 1836–1921
Born in Edinburgh, the son of an accountant, Graham was a pupil of Robert Scott Lauder in Edinburgh and was a contemporary of Orchardson and Pettie (q.q.v.). His early work was mainly genre scenes until 1860 when he decided to concentrate more fully on landscape painting. In 1866 Graham moved to London and exhibited *A Spate in the Highlands* at the RA, the success of which he never truly surpassed. The resounding public success of Graham's painting sparked off debate concerning the neglect of landscape painters within the RA.

Graham's next popular success was *A Rainy Day* (1871), which captured perfectly the effects of wet weather in the Highlands. From 1872, Graham showed large paintings of bleak storm-lashed cliffs covered with seabirds, which were created from numerous sketches and studies made from boats moored just off the rocks.

In addition to landscapes and coastal scenes, Graham depicted glimpses of the Scottish Highlands, swathed in mist and heather, often featuring shaggy-coated, long-horned highland cattle. Graham owned a country house in Buckinghamshire where he kept half a dozen Highland cattle, using them as

models for his painting. His canvases often introduced bright patches of purple and violet to vary the tones of grey and dun. Graham was elected ARA 1876 and RA 1882.

Mary Grant 1831–1908
Mary Grant was the niece of Sir Francis Grant PRA. She studied sculpture in Paris and Florence and then in London where she was the pupil of John Henry Foley RA. Her work includes many busts, decorative reliefs and public monuments.

Grant's decorative work included several figures for the West Front and Porch of Lichfield Cathedral and figures for the screen of Winchester Cathedral. She also sculpted a marble reredos for Edinburgh Cathedral. Her portrait busts were considered to be among her best work and her sitters included Countess Dudley, various members of Parliament and Queen Victoria herself. Grant received many commissions from the Queen such as the relief of Dean Stanley for a memorial in the Royal private chapel at Windsor Castle. Her most well-known work is the bronze relief of *Mr Fawcett M.P.* (1886) on the Thames Embankment.

Although a contemporary of 'New Sculptors' such as Alfred Gilbert (q.v.) and Onslow Ford (q.v.), Grant was generally identified with the neo-classical manner school of her master J. H. Foley.

Edward John Gregory 1850–1909
Gregory was born in Southampton where for a short time he worked in the drawing office of the P&O Steamship Company. After meeting Hubert von Herkomer (q.v.), however, he moved to London in 1869 and attended the RCA briefly. He then entered the RA Schools in 1870, but was largely self-taught. Gregory worked as an illustrator for *The Graphic* 1871–5.

Gregory excelled in painting the

elegant modern life of cities, with works such as *Dawn* which portrays a scene in a London ballroom where, as the dawn is breaking, the pianist plays on while a flirtation is taking place nearby. Gregory scored his first major public success with *Boulter's Lock, Sunday Afternoon* (1897). The painting was shown in Paris, St Louis and Toronto, bringing Gregory international fame and was much admired for its accuracy of observation, both of the natural scenery and the types of boats and styles of dresses.

Gregory was a prominent exhibitor at the RI throughout his career and became its President 1898–1909. He was elected ARA 1883 and RA 1898. In 1882, Gregory visited Italy and produced a series of paintings of Venice, which was bought by his chief patron, Charles Galloway, who owned about one third of Gregory's total output. Gregory had a house at Cookham Dean in the 1890s and died in the nearby village of Marlow.

Solomon Alexander Hart 1806–1881

Hart was born in Plymouth, the son of a Jewish goldsmith and engraver. He moved to London in 1820 and started sketching at the British Museum before entering the RA Schools in 1823. In 1830, Hart exhibited *Interior of a Polish Synagogue*, an ambitious work which was well received and brought him many commissions including a companion piece, the *English Roman Catholic Nobility taking the Communion in the time of Queen Elizabeth* (1831). He was elected ARA 1835.

Hart also painted portraits and historical subjects including *Wolsey and Buckingham*, a scene from Shakespeare's *Henry VIII*, which was bought by Lord Northwick, and a large painting illustrating Lady Jane Grey at the place of her execution on Tower Hill, which helped secure his election as RA in 1840. Hart visited Italy 1841–2, and made a series of elaborate drawings of architectural interiors and famous historical sites which were incorporated into pictures of Italian

history such as *The Interior of the Baptistry of St. Mark's at Venice as in 1842*. Hart returned to painting some overtly Jewish subjects, including the large and impressive, *Manasseh ben Israel Pleading with Oliver Cromwell for the Admission of the Jews* (1878). Hart was elected Librarian of the RA in 1865 and was very active in this post, which he held until his death in 1881.

Charles Napier Hemy RA 1841–1917

Hemy was born in Newcastle-upon-Tyne and attended the Newcastle School of Art. He attained an intimate knowledge of the seafaring way of life at the Tyne harbour and made many sea voyages in his early youth, including visits to Australia and Malta. Hemy had an early persuasion towards a vocation in the church and entered a monastery for three years before deciding to pursue his painting career in earnest.

His early paintings were influenced by the Pre-Raphaelites and his exhibits at the RA from 1863 were coastal scenes featuring close and detailed observation of rocks. Hemy travelled to Antwerp to study with the historical painter, Baron Leys, and produced a series of paintings with subjects of a 16th-century pseudo-Gothic character. On his return to London he devoted himself to marine painting, beginning with pictures of the Thames from vantage points on the river itself.

Hemy spent the summers of the early 1880s painting along the south and south west coast of England at Littlehampton and Falmouth, and his marine paintings from this period secured his reputation, being particularly admired for their observation of the sea and the construction of waves. In 1888 he had a 'sea-going' studio built called the 'Van Der Meer', from which he could paint fishermen in their boats out at sea. Hemy moved to Falmouth in 1883. He was elected ARA 1898 and RA 1910.

Sir Hubert von Herkomer 1849–1914

Born at Waal in Bavaria, the son of a woodcarver who brought his family to live in Southampton in 1857. Herkomer studied at the Southampton Art School, with Professor Elcher in Bavaria, and in 1866 entered the South Kensington School of Art. From 1869 Herkomer worked for *The Graphic*, a magazine which published some of the strongest social-realist images of the late 19th century. His first contribution to *The Graphic* in 1871 was a wood-engraving of *The Last Muster*, which he later worked up into an oil. The scene is set in the chapel at Chelsea Hospital where, among the aged war veterans engaged in morning worship, a death has occurred. The oil version was exhibited in 1878 at the Exposition Universelle in Paris where it was awarded the *médaille d'honneur*. Other important social-realist pictures include *Hard Times* (1885) in which Herkomer depicts the fate of the family who have fallen on 'hard times' and who must travel with their belongings to look for work.

Herkomer also painted portraits of his friends and peers, among them, Ruskin and the composer Richard Wagner. Herkomer was an accomplished musician. He composed music including a few operas, as well as acting and designing stage scenery for his own theatre. He built an impressive castellated mansion in Bushey, Hertfordshire, called Lululand after his second wife, Lulu Griffiths.

Herkomer's philanthropic work extended to art education when, in 1883, he opened his own school of art at Bushey. Herkomer described his school in great detail in *My School and My Gospel* (1908). He was ennobled by the Emperor of Germany in 1899 (after which he used the prefix 'von' in his name) and knighted in 1907. He was elected ARA 1879 and RA 1890.

James Clarke Hook 1819–1907
Hook was born in London and first studied art by himself at the British Museum until he was admitted to the RA Schools in 1836. Hook won a travelling scholarship to Italy in 1846, where he was influenced by the strong colours of the Venetian Old Masters. He produced a series of paintings from Venetian history, real and fabled, such as *The Rescue of the Brides of Venice* (1851) and a scene from Shakespeare's *The Merchant of Venice*.

In 1854 Hook began to paint English landscapes and pastorals, which progressed to a preference for the marine subjects, often coastal scenes with sturdy fisherfolk picturesquely at work, for which he is best remembered. In 1859 *Luff Boy!* appeared and sealed his success in the new genre. He was elected ARA 1850 and RA 1860.

Hook travelled through Devon and Cornwall to the Isles of Scilly in 1861 and then spent two years in Brittany. In 1870, Hook visited Holland and then Norway the following year, a trip which resulted in new subjects for his pictures. Hook was a committed socialist and a keen fisherman, living in a state of self-sufficiency on a farm in Surrey.

John Callcott Horsley 1817–1903
Born in London, the son of a musician and composer William Horsley, whose glees were praised by Mendelssohn, and the nephew of the landscape painter Augustus Wall Callcott RA, Horsley enrolled at Sass's Drawing School, before entering the RA Schools in 1831. *Rent Day at Haddon Hall in the Time of Queen Elizabeth* (1837), exhibited at the BI, was praised by David Wilkie. Many of his subsequent works were set in interiors based on those at Haddon Hall and other Elizabethan or Jacobean houses.

In 1843 and 1847 Horsley entered the Houses of Parliament competitions, winning two prizes and painting the frescoes, *The Spirit of Religion* and *Satan Surprised at the Ear of Eve*. Large history paintings, however, were not really suited to Horsley's talents, and shortly afterwards, he returned to small-scale domestic genre subjects. Horsley bought a house in Cranbrook, Kent in 1858 and became a member of the 'Cranbrook Colony'. Other artists included Thomas Webster RA and A. E. Mulready. Their work was heavily influenced by the 17th-century Dutch School, especially by Pieter de Hooch. Amongst the best of these works is *The Banker's Private Room – Negotiating a Loan* (1870).

Horsley organised the first RA Old Master Winter Exhibitions and from 1875 to 1890 was untiring in his search for suitable pictures to exhibit. He was elected ARA 1855 and RA 1864 and was Treasurer of the RA 1882–97.

John Prescott Knight 1803–1881
Born at Stafford and son of the actor-comedian, Edward Knight (known as 'little Knight'). The family moved to London and Knight entered the employ of a West India merchant, but after the firm's bankruptcy he persuaded his father to consent to his enrolling at Sass's Drawing School. In 1823 Knight was admitted to the RA Schools.

The sudden death of Knight's father in 1826 left him to depend on his painting career as his only source of income. Knight's work during this time chiefly consisted of theatrical portraits, although he also painted genre subjects including pictures of smugglers and pedlars. He was elected ARA 1836, RA 1844 and was appointed Professor of Perspective at the RA 1852–60 as well as Secretary to the institution 1847–73. Around 1840, Knight resumed his portrait practice, obtaining much success, especially with male sitters. His group, *Heroes of Waterloo*, better known as the 'Waterloo Banquet', was exhibited at the RA in 1842 and bought by the Duke of Wellington.

Many of Knight's works were large presentation portraits, among them Sir George Burrows, Bart., for St Bartholomew's Hospital. He was appointed *chevalier* of the French Legion of Honour in 1878.

Charles Landseer 1799–1879
Older brother of Sir Edwin Landseer, Charles received his earliest art instruction from his father, an engraver, and from Benjamin Robert Haydon, prior to his admission to the RA Schools in 1816. In the early 1820s Charles travelled extensively in Portugal and Brazil and began exhibiting at the RA in 1828.

Charles painted subjects from the lives of the English kings and queens, and especially events from the English Civil War such as *Eve of the Battle of Edgehill* (1845), which illustrated the council of war held by Charles I at Edgecote on the day before the battle, and was widely considered to be his most important painting. He made a particularly careful study of accessories and costume, qualities which, rather than striking effects and grandeur of character, became a trademark of his work.

Influenced by the stories of Sir Walter Scott, Charles provided illustrations for the book, *Portraits of the Principal Female Characters in the Waverley Novels* (1833). Charles was elected ARA 1837, RA 1845 and was Keeper of the RA Schools 1851–73. Due to ill health he had to resign the post of Keeper, but on his death he bequeathed the sum of £10,000 to the Academy to found painting and sculpture scholarships.

Sir Edwin Landseer 1802–1873
Edwin was taught the rudiments of art by his father, an engraver, along with his brothers, Charles and Thomas, and studied anatomy with Benjamin Robert Haydon. At the age of 14 he was admitted to the RA Schools and also often visited the menagerie of wild animals at the

Exeter Change in London. He was elected ARA 1826 at the early age of 24 and RA 1831.

In 1824 C. R. Leslie took Landseer to visit Sir Walter Scott at Abbotsford, the first of many visits to the Scottish Highlands, which greatly influenced his work. From the late 1820s Landseer began to exhibit paintings of stags and other wild creatures of the Highlands, such as *Stag at Bay* (1846) and *Monarch of the Glen* (1851). When in Scotland, Landseer was often a guest of the Royal family, and Queen Victoria was a patron of his work.

Landseer's powerful ability to infuse into the characters of his animals an almost human element, became a hallmark of his style. His use of pathos to dramatic effect was demonstrated in *The Old Shepherd's Chief Mourner* (1837) where the mourning, faithful dog's head laid upon the coffin of his dead master captured the sympathetic bond between man and animal. Landseer also depicted more comical scenes such as *Dignity and Impudence*, in which a large, stately bloodhound shares a kennel with a small white terrier. He also used animals to satirise human affairs. He was knighted in 1850.

Benjamin Williams Leader 1831–1923

Leader was born in Worcester as Benjamin Williams, but later adopted the surname 'Leader' to distinguish himself from the Williams family of artists to whom he was not related. His father was an amateur painter. He was a student at the Worcester School of Design and in 1854 entered the RA Schools. Two years later, Leader visited Scotland where the mountainous character of the landscape made a great impression on him. Leader produced some landscapes with figures in the 1850s but then, in the 1860s, settled on 'pure' landscapes, demonstrating an awareness of the Pre-Raphaelite ideals of attention to detail and use of bright colours.

A favourite method of composition

adopted by Leader, and noted early in his career, was to place dark masses of trees as silhouettes against an evening sky, with the sunlight still glowing upon distant hills. Leader used this composition in his most successful work, *February Fill Dyke* (1881). Leader was elected ARA 1883 and RA 1898.

In addition to subjects from the Worcestershire countryside, the landscape of Wales was also a favourite with Leader. *The Churchyard at Bettws-y-Coed* (1863) was purchased by Prime Minister William Gladstone. In 1889 Leader moved to Burrows Cross in Surrey to live in a house built by Richard Norman Shaw RA and his later landscapes depict the Surrey countryside with broader, freer brushwork, showing the influence of the French Barbizon School. He was appointed *chevalier* of the French Legion of Honour in 1890.

Frederic, Lord Leighton Bt 1830–1896

Born in Yorkshire, son of a doctor, Leighton's family moved to London in 1832 and, following a brief trip to Paris, settled in Rome in 1840. Leighton received training in various European cities and in 1854 established a studio in Rome where he painted his first great success, *Cimabue's Madonna is Carried in Procession through the Streets of Florence*, (1855, Royal Collection).

In 1859 he moved to London and was elected ARA 1864 and RA 1868. Leighton's decorative work included the large *Arts of Industry* murals (1871–85) for the South Kensington Museum. His work of the 1860s was heavily influenced by the Aesthetic Movement. He is best known, however, for his cultivation in England of an 'Olympian' neo-classical style of painting that he absorbed in the course of his extensive continental training. The classical manner pervades all

his work, but some of the most impressive works are probably *The Daphnephoria* (1876), a classical procession in honour of the God Apollo, and the *Captive Andromache* (1888).

Trips to the Middle East, Egypt and Damascus between 1867 and 1873 inspired orientalist subjects such as *The Music Lesson*. Leighton's home in Holland Park was a shrine to orientalism and exoticism and in 1877 he had an 'Arab Hall' built with Moorish tiles and a fountain. Leighton was elected President of the RA in 1878, a role in which he exercised great influence in the shaping of artistic taste. Leighton realised his preoccupation with classical form in sculptures executed in the 1870s and '80s, including *Athlete Wrestling with a Python* and *The Sluggard*. He was raised to the peerage in 1896, the first artist ever to be honoured in this way, but died in the same year.

John Frederick Lewis 1805–1876

Lewis's father was a landscape painter but best known as an engraver, who taught his son the rudiments of draughtsmanship. Lewis was a talented watercolourist and in 1827 was elected an associate of the OWS and a full member two years later.

In the late 1820s, Lewis toured Europe and Scotland, producing watercolours of his travels and in 1832–4 visited Spain and Morocco. Lewis's travels inspired two books of lithographs, *Sketches and Drawings of the Alhambra* (1835) and *Sketches of Spain and Spanish Character* (1836). In 1837 Lewis left England once more to visit Paris and Italy, and in the early 1840s journeyed through Greece to Egypt, settling in Cairo in 1841, and remaining there for nearly ten years. During the 1840s, he produced drawings and watercolours of the people and buildings in Cairo but did not exhibit in England until 1850, when he showed watercolours such as *The Hhareem* at the OWS. Lewis's work was admired for its distinctive combination of microscopic detail, delicate line and compositional unity.

Lewis turned to oil painting in the late 1850s and was elected ARA 1859 and RA 1865. Lewis's work reveals a fascination with the play of light through ornate Islamic lattice screens. In *An Intercepted Correspondence, Cairo* (1869) he presented a colourful and idyllic vision of Near Eastern life and ignored the barbaric punishments meted out for such crimes as the adultery portrayed in this work.

Edwin Long 1829–1891

Born in Bath and the son of an artist, Long began his career as a portraitist. In 1857 he visited Spain on the advice of John Phillip (q.v.), a painter of Spanish subjects. He was to make two further visits and began exhibiting Spanish genre subjects, the first of which was *Bravo el Toro* (1859) which records a moment of tension in a Spanish bullfight.

After visiting Egypt and Syria in 1874, Long's work took a new direction, and he began to produce large historical works illustrating passages from the bible and the customs of the ancient civilisations of Greece, Rome and Egypt. The first of these canvases, *The Babylonian Marriage Market* (1875), was a great success and many were fascinated by its careful archaeological detail. Long's large canvases from ancient history were characterised by a knowledge and accuracy of architectural features and ancient artefacts. He was the immediate predecessor of the High Victorian Classicists chief among whom were Alma-Tadema, Leighton and Poynter (q.q.v.).

Long was elected ARA 1876 and RA 1881. In the late 1880s, the dealers Agnews commissioned Long to create a series of pictures illustrating types of national beauty, the head of a black woman, *Jamaica*, and of a swarthy beauty, *Ancient Cyprus* appearing in 1887. The popularity of Long's work enabled the artist to commission Richard Norman Shaw RA to design two houses for him in Hampstead.

Princess Louise, Duchess of Argyll 1848–1939

Princess Louise Caroline Alberta was the fourth daughter of Queen Victoria and a favourite of her father, Prince Albert. Taught drawing by the Royal art teacher, H. S. Corbould, she showed great talent in drawing, oils and watercolours and exhibited her work at the RWS 1880.

She was married in 1871 to the Marquess of Lorne, also a keen painter and art enthusiast, who became 8th Duke of Argyll in 1900. Louise spent much time decorating their various residences in Scotland and London, including mural painting at Inveraray.

In the mid-1870s, the couple moved to Kensington Palace, where a studio was installed for Louise and it was here that she entertained many artists and sculptors, including Alma-Tadema (q.v.) and Leighton (q.v.). It was Louise's skill as a sculptress, however, which set her apart from other artistic members of her family. From her mid-teens, she had shown a great interest in modelling and was given early lessons by the sculptress, Mary Thornycroft. Louise also enrolled at the South Kensington Schools and attended classes in modelling and also studied with J. E. Boehm. Louise modelled several busts of members of her family, including two of the Queen. Alfred Gilbert assisted Louise in her greatest achievement, the large, marble seated figure of *Queen Victoria* at Kensington Palace.

John Seymour Lucas 1849–1923

Lucas's early art education was provided by his uncle John Lucas, also a painter. He entered the RA Schools in 1871. Lucas was an early admirer of the novels of Sir Walter Scott and they stimulated his interest in the historical costume subjects that dominated his career. Lucas's first success at the RA as *By Hook or By Crook* (1875), which took its subject from the Jacobite uprisings. Roundheads

and Cavaliers were also included in many of Lucas's paintings. From about 1874 the influence of the work of Meissonier is evident in Lucas's work in his clustered groupings of figures engaged in contemplation or conversation and his attention to details of costume, ornament and architecture.

Lucas was intent on infusing as much realism into his scenes from history as possible and his studio in West Hampstead contained a collection of armour of the 15th, 16th and 17th centuries, as well as costumes, some of which still bore the bloodstains of war. Study of the work of Velazquez in Madrid lent a further verve and dash to Lucas's historical subjects. Lucas was elected ARA 1886 and RA 1898. In the late 1880s, Lucas turned increasingly to portraiture.

Robert Walker Macbeth 1848–1910

Born in Glasgow, the son of Norman Macbeth a portrait painter and member of the RSA, who gave his son his early artistic training. At 18 Macbeth entered the RSA briefly before moving to London in 1870. He worked for *The Graphic* and was admitted to the RA Schools in 1871. Macbeth exhibited his first painting at the RA in 1874 and the following year began the series of pastorals which made his reputation.

Macbeth was influenced by painters such as Fred Walker and G. J. Pinwell, whose best works were showing in London on Macbeth's arrival. Macbeth's choice of subjects however, was slightly different and his work was more robust and less idealised than theirs. Macbeth was inspired by an article in *The Times* on the subject of field labourers of Lincolnshire and he began to study from life their local manners and customs. *The Lincolnshire Gang* (1876) and *The Potato Harvest* (1877) were both exhibited at the

RA and were painted on a heroic scale. Other fen country subjects followed such as *Cambridgeshire Ferry* and *The Cast Shoe*, which was bought by the Chantrey Bequest.

In 1880 Macbeth visited Brittany, a trip which resulted in a few marine subjects. Macbeth settled in Somerset in 1884 where an entirely different landscape brought a softer charm into his pastorals. Works such as *Cider-Making* record Macbeth's study of the processes of rural life in Somerset. Macbeth was elected ARA 1883 and RA 1903.

Daniel Maclise 1806–1870

Born in Cork where his father was a tradesman. At the age of 16 Maclise entered the Academy for the Study of Fine Arts in Cork. Following the success of a portrait of Sir Walter Scott, Maclise made a profitable early career in sketching the portraits of officers stationed in Dublin. He entered the RA Schools in 1828.

Portrait sketches occupied Maclise throughout his career and included a vibrant likeness of the violinist Paganini in 1831. He also produced small cabinet pictures of literary genre, such as *The Vicar of Wakefield*, as well as more serious historical genre painting. He was elected ARA 1835 and RA 1840. In the 1840s Maclise became closely involved with the theatre, and in 1842 painted the well-known *Play Scene From Hamlet*, which conveyed well the drama of the scene but was rather overcrowded with figures, a common criticism of his work. In 1845 Maclise successfully entered the competition for the decoration of the Houses of Parliament and was commissioned to paint various frescoes including most importantly two monumental works for the Royal Gallery, *The Meeting of Wellington and Blücher* and *The Death of Nelson*. Each work was 48 feet long and was only completed five years before his death.

Maclise was also a prolific illustrator and provided the illustrations to Dickens's *The Chimes* (1844), among others. He contributed caricatures to *Fraser's Magazine* 1830–6, under the pseudonym 'Alfred Croquis'.

Henry Stacy Marks 1829–1898

Born in London, Marks studied at Leigh's Academy in 1845 and was admitted to the RA Schools in 1851. In 1853 Marks travelled to Paris with P. H. Calderon, where the two studied in the atelier of Edouard Picot. Marks and Calderon were two of the seven original members of the St John's Wood Clique, a group who made historical genre their speciality. Works taken from literature and imaginary scenes of life, chiefly from the Middle Ages, occupied Marks until about 1870.

A characteristic of Marks's work was his unashamed humour, evident in pictures such as *Toothache in the Middle Ages* (1856) and *The Franciscan Sculptor and his Model* (1861) in which the sculptor-friar is modelling a gargoyle from the ugly face of a fellow monk. In 1870 Marks exhibited *St. Francis Preaching to the Birds*, in which an astonishing display of exotic birds, storks, cranes, and common birds appear as St Francis's devotees. This painting revealed Marks's interest and knowledge of ornithology and his skill in drawing even the most exotic of species.

Marks was elected ARA 1871, RA 1878 and at this time embarked upon a commission from the Duke of Westminster for his new home, Eaton Hall in Cheshire, which included, among others, twelve decorative panels of birds for one of the dining rooms. His autobiography, *Pen and Pencil Sketches*, was published in 1894.

Sir John Everett Millais Bt 1829–1896

Millais was born in Southampton, although his family moved to London in 1838. Millais was a child prodigy, enrolling at Sass's Drawing School aged ten, entering the RA Schools two years later. His first exhibited work at the RA was a historical picture, *Pizarro Seizing the Inca of Peru* (1846), which won a RA gold medal for historical painting the following year. In 1848 Millais met Holman Hunt and Dante Gabriel Rossetti, and the three founded the Pre-Raphaelite Brotherhood with three other artists and one critic.

Millais's *Isabella* (1849) was the first work to demonstrate Pre-Raphaelite principles of attention to detail and bright colour. The initials 'P.R.B.' can be seen carved in wood on Isabella's stool. Millais's *Christ in the House of his Parents* was heavily criticised by Charles Dickens among others. However, in 1851 Ruskin openly supported the Pre-Raphaelite principles of 'truth to nature' and their adoption of the spirit of the Italian 'primitives' of the 14th and 15th centuries.

In 1853, Millais was elected an ARA, an event which effectively dissolved the Brotherhood. He visited Scotland with Ruskin and his wife, who was to become his own wife a few years later. At this time Millais began to turn away from Pre-Raphaelitism and came under the influence of aestheticism. *Autumn Leaves* (1856), a contemplative, poetical picture, with apparently no subject, marked this new direction. Millais turned increasingly to portraiture and portrait subjects in the 1870s and '80s. He was elected RA 1863, and made a baronet in 1885. Elected President of the RA in 1896 following the death of Leighton, he died a few months later.

Henry Moore 1831–1895

Born in York, the elder brother of Albert Moore, painter of aesthetic subjects. He trained first with his father, also an artist, and then at the York Schools of Design. Henry travelled to London in 1853 and was admitted into the RA Schools in the same year. He travelled in England as well as France and Switzerland, making many studies directly from nature.

For many years Moore exhibited nothing but landscapes, including views of

the Lake District, Devon and Switzerland, some of which demonstrated a certain amount of Pre-Raphaelite influence. In 1858 Moore began to take the sea as the subject for his paintings and was increasingly fascinated by the vastness of seemingly limitless water. Moore became known as a painter of 'pure' sea as the sea occupies the majority of the canvas.

Moore's work as a marine artist was compared with that of the older James Clarke Hook. It was said that he equalled Hook in 'robustness' yet also demonstrated a stronger sense of colour and truer judgement of tone relations. The intense blue of many of his paintings was instantly recognisable, leading the French to coin it as 'la note bleue de Moore'. Moore's large paintings were based on very careful studies and sketches made from nature and many of the smaller ones were done at sea. Moore was elected ARA 1885 and RA 1893.

Sir William Quiller Orchardson
1832–1910

Born in Edinburgh, son of a tailor, Orchardson studied art at the Trustees' Academy from 1845 with John Pettie (q.v.), a fellow pupil. In 1861 Orchardson exhibited portraits at the RSA and the following year he moved to London. His early work includes subjects suggested by old Scottish ballads, such as *Flowers o' the Forest* and subjects from Shakespeare.

Talbot and the Countess of Auvergne, exhibited at the RA in 1867, is an early example of Orchardson's sense of the drama of empty spaces and unusual angles. The subtlety of such devices contributed much to the success of his later psychological dramas of contemporary upper-class life, for which he is best known. In 1870 Orchardson visited Venice, where he shared lodgings with Frederick Walker ARA and, perhaps under his influence, he made sketches for a number of *plein-air* pictures which were painted in London in the early 1870s, such as *Moonlight on the Lagoons*, where the principal motif is an effect of light and atmosphere. Orchardson was elected ARA 1868 and RA 1877.

The first of Orchardson's psychological snapshots was *Mariage de Convenance* (1886), which achieved immediate success in its theatrical portrayal of a marriage thwarted by the lack of common interest between a rich old man and his young wife. Orchardson was also a portraitist, and his portraits often contained the same element of theatricality as his subject pictures. Orchardson was knighted in 1907.

John Pettie
1839–1893

Born in Edinburgh Pettie remained there with his uncle, a drawing master, when his parents moved to East Linton. He entered the Trustees' Academy at the age of sixteen, where he met Orchardson (q.v.). After achieving a measure of success at the RSA, Pettie moved to London in 1862, where he began illustrating for the journal *Good Words*. He soon, however, devoted himself entirely to painting. His early work consisted of scenes from Sir Walter Scott, whose novels of Scottish romance remained a strong influence throughout his career.

Pettie's first great public success was in 1864 when he exhibited his *Drum-Head Court-Martial*, which revealed his dramatic and vibrant use of colour. In 1877 Pettie returned to Scotland, a visit which led to several Scottish subjects including *Rob Roy*. In addition to producing a few light-hearted and comic costume pieces, Pettie was also a portraitist, and in the 1880s painted a number of single-figure studies of types in 17th-century costume, such as *A Boy in Van Dyck Costume*. Another younger painter of historical genre, John Seymour Lucas (q.v.), followed Pettie in this practice.

Pettie's chief patron was John Newton Mappin, founder of the Mappin Art Gallery, Sheffield, who bought many of Pettie's most important pictures. Pettie was elected ARA 1866 and RA 1873.

John Phillip
1817–1867

Born in Aberdeen, the son of a soldier, Phillip was apprenticed to a house painter. He received minor instruction from a local portrait painter and in 1837 entered the RA Schools. His early exhibits there were scenes from Scottish life in the manner of David Wilkie.

In 1852, Phillip left England for Spain and became fascinated by the work of the Spanish Old Masters, especially Velazquez and Murillo. He lived for a time in Seville and painted the picturesque peasantry of Seville, their rural customs and celebrations. *The Spanish Letter-Writer* (1853), bought by the Queen for the Royal Collection at Osborne, was a product of Phillip's first visit to Spain. However, it was not until his third visit in 1860 that Phillip brightened his palette to capture the colours and sunshine of Spain. He painted forty-two pictures and made many copies of works by Velazquez and it was upon the success of these works that his reputation principally rested earning him the nickname 'Spanish Phillip'. Although his chiaroscuro is often described as 'over-brown', Phillip used brilliant and gaudy colour to good effect and his technique is marked by vigour and spirit.

In 1860 Phillip was commissioned by Queen Victoria to paint *The Marriage of the Princess Royal*, a group portrait. He was elected ARA 1857 and RA 1859.

Frederick Richard Pickersgill 1820–1900

Pickersgill was born in London where his father, Richard Pickersgill, was an occasional contributor to the RA, and his uncle, H. W. Pickersgill RA, worked as a portraitist. Another uncle, W. F. Witherington RA, was responsible for Pickersgill's early art education. He was admitted to the RA Schools in 1840.

Pickersgill painted historical subjects suggested by Spenser, Shakespeare, Milton and the Greek tragic and lyric

poets. In 1843 and 1847 he entered the Westminster Cartoons competition for the decoration of the Houses of Parliament and although successful he confessed his inability to work in fresco, a medium that was virtually untried in Britain at this time.

Pickersgill's work in the mid-1850s revealed his debt to the work of William Etty, when he completed a series of nudes and semi-nude women. Pickersgill's use of strong colour shows also the influence of Titian and other Old Masters of 16th-century Venice. His later works include some scenes from modern life and landscapes which were much influenced by the Pre-Raphaelites, with their bright colours and minute attention to natural detail. Pickersgill was elected ARA 1847 and RA 1857 and was Keeper RA Schools 1873–87.

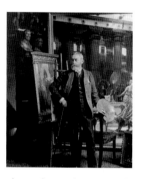

Sir Edward Poynter Bt 1836–1919
Born in Paris, the son of the architect Ambrose Poynter great-grandson of the sculptor Thomas Banks RA, Poynter's parents moved to England when he was still a child. In 1853 Poynter visited Italy, where he met the young Leighton (q.v.) who stimulated his interest in neo-classical art. On his return to London in 1855 Poynter was admitted to the RA Schools and then in 1856 entered the atelier of Gleyre and attended the Ecole des Beaux Arts in Paris.

Poynter returned to England in 1860 and undertook decorative work for the architect William Burges ARA and designed stained-glass windows. Later decorative projects included mosaics for the South Kensington Museum. Poynter also exhibited paintings such as *The Siren* (1864), a highly finished work in which Poynter demonstrated his skill in the handling of flesh tones and the female nude.

In 1865, stimulated by the recent excavations at Pompeii, Poynter exhibited the first of his genre pieces set in ancient Rome. In the 1870s and '80s Poynter began to paint mythological subjects, including his immense *Perseus and Andromeda* (1872), and several nude bathing subjects in classical settings in the manner of Alma-Tadema (q.v.).

Poynter was appointed Director of Art at the South Kensington Museum. He was elected ARA 1869, RA 1876 and was President of the RA 1896–1918 and Director of the National Gallery 1894–1906. His *Lectures on Art* (1879), emphasise the importance of studying the Old Masters.

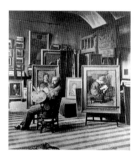

Valentine Cameron Prinsep 1838–1904
Born in Calcutta, the son of an Indian civil servant. Prinsep became a close friend of G. F. Watts (q.v.), who lodged with Prinsep's parents in Holland Park. It was Watts who encouraged Prinsep to turn to painting and offered him some tuition. In 1857 Prinsep assisted various Pre-Raphaelite painters in the decoration of the Oxford Union, and in 1859 left for France to study in the atelier of Gleyre where Poynter (q.v.) and Whistler were also pupils.

In 1860 Prinsep journeyed to Italy with Edward Burne-Jones. His early paintings, such as *The Death of Cleopatra*, exhibited at the RA in 1870, were influenced by the classical painting of Leighton (q.v.). In October 1876 Prinsep was asked to go to India and paint the ceremony held to mark Queen Victoria's accession to the title Empress of India. Prinsep spent a whole year making the necessary portrait studies which were to appear in an enormous 13 by 27 foot canvas exhibited at the RA in 1880. On his return to England Prinsep continued to paint Indian subjects, showing them up to 1888. Prinsep was elected ARA 1879, RA 1894 and was made Professor of Painting at the RA 1900–3. Prinsep was also a keen writer, publishing two plays and two novels.

Richard Redgrave 1804–1888
Born in Pimlico, London, Redgrave was employed in his father's manufacturing business where he made designs and working drawings for the draughtsmen. In 1826 Redgrave was admitted to the RA Schools. His first contributions to the RA exhibitions were mainly landscapes and a few historical and Shakespearean subjects.

In 1840 Redgrave was elected ARA and exhibited the first of a series of social conscience pieces that dealt with a moral applicable to modern life, such as *Going to Service* (1843), a picture that depicted the exploitation of girls coming to London to work in the millinery business, where women were often underpaid and not unusually turned to prostitution. *The Governess* (1845) highlighted the plight of another class of female workers who were often lonely, oppressed and separated from their families. These philanthropic paintings were the forerunners of the social-realist works of Herkomer (q.v.) in the 1870s.

From about 1852 onwards landscapes and cottage or semi-rustic genre became prominent features of Redgrave's work, often with close attention given to details of the plants and flowers. He was elected RA in 1851 and also about this time became deeply involved in administrative projects. He was Keeper of Painting at the South Kensington Museum, Surveyor of the Queen's Pictures from 1858 and he and his brother, Samuel, produced the well-known *A Century of British Painters* (1866).

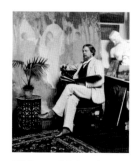

Sir William Blake Richmond 1842–1921
Richmond was born in London, the son of the painter George Richmond RA, a devotee of William Blake, who named his son after the artist. Richmond received a classical

education, learning Latin and Greek, and also came under the instruction of John Ruskin, a friend of George Richmond. He entered the RA Schools in 1858 and was a keen student of drawing from the Antique. He was, however, dissatisfied with the teaching and left shortly afterwards. In 1859 he made his first visit to Italy, where he copied Giotto's frescoes in the Arena Chapel, Padua, and was influenced by the rich colours of Titian in Venice.

Richmond's first RA exhibit in 1861 was a portrait group of his brothers, and portraiture continued to be a major part of his work throughout his life. His sitters included Darwin, Holman Hunt, Gladstone and Browning. Richmond was determined, however, to paint not only portraits, and therefore decided to return to Italy for a few years and also visited Algiers in 1870. Richmond began to paint high art subjects on a monumental scale and was also commissioned to paint frescoes and design mosaics for the ceiling of St Paul's Cathedral, 1891–4. Visits to Greece in 1882 and 1883 resulted in several epic classical works such as *Venus and Anchises* (1890) which combined classical forms and swirling drapery with minute attention to the details of plants and flowers. He was elected ARA 1888 and RA 1895.

Briton Riviere
1840–1920
Born into an artistic family and educated at Cheltenham College, where his father was master of the drawing school. As a child, Riviere made many trips to London zoo to sketch the animals there. He was taught by his father and John Pettie (q.v.), and also obtained a degree from Oxford. In 1859 Riviere exhibited *Cattle Going to Gloucester Fair* at the RA, which was reminiscent of the work of Thomas Sidney Cooper RA.

Riviere produced several landscapes in the Pre-Raphaelite manner which were mostly rejected at the RA, but in 1865 he found success when he brightened his palette and exhibited animal paintings

which demonstrated a feeling for the sympathetic relationship between man and dog.

Riviere worked as an illustrator between 1868 and 1871 for journals such as *Good Words* and *Punch*. In the 1870s Riviere produced several subjects that combined his talent for animal painting with classical or biblical history, including *Daniel in the Lion's Den* (1872) in which he ably portrayed animal behaviour and expression. Riviere's best known work is probably *Sympathy* (1877) in which a little girl in disgrace, sitting at the top of some stairs, is comforted by a pet greyhound who rests his head against her cheek. Riviere was elected ARA 1878 and RA 1896.

David Roberts
1796–1864
Born at Stockbridge near Edinburgh, the son of a shoemaker, Roberts was apprenticed to a house painter and in 1816 became an assistant scenepainter with a strolling theatre. This led to further employment in major theatres and in 1820 Roberts met Clarkson Stanfield RA while working at the Drury Lane Theatre in London. Their collaboration on designs for scenery won a high reputation for them both. On Stanfield's suggestion, Roberts sent some architectural oil works for exhibition and he gradually concentrated on painting only architectural subjects.

In 1824 Roberts visited Dieppe, Rouen and Le Havre, the first of many trips to sketch architecture throughout Europe. In 1832 the artist visited Spain, settling for a while in Seville, and in 1838, he embarked on a sixteen-month journey to Egypt, sailing down the Nile, and stopping to draw the temples at Dendara and Luxor. Roberts also travelled throughout the Middle East, visiting Jerusalem, Jericho and Beirut. On his return to England in 1840 he published *The Holy Land, Syria, Idumea, Arabia, Egypt and Nubia*, which included chromolithographs of his drawings.

He was elected ARA 1838 and RA 1841.

Roberts's work is very distinctive, conveying a unique sense of the grandeur of ancient temples and ruins by exploiting scale and height combined with a delicacy of line and detail. He often includes groups or single figures nestling at the foot of columns or sitting in the interiors of churches, who, dwarfed by the surrounding immensity, impress a sense of great awe upon the spectator.

James
Sant
1820–1916
Born in Croydon, London, Sant studied at the RA Schools 1840–4. He gained early success as a portrait painter and adopted this genre as his staple career, following little financial reward with subject pictures. However, his portrayal of his sitters was often very inventive. Sant also painted portrait pictures of figures from nursery rhymes or fairy tales, such as *Little Red Riding Hood* (1860) and *Turn Again Whittington* (1864). His depictions of *The Infant Samuel* (1853) and *The Soul's Awakening* (1888) delighted the British middle class with their sentimental portrayal of two boys placed in poignant contexts.

As a portrait painter Sant enjoyed the patronage of many noble and landed families, and the establishment of his reputation as a Society portraitist could be said to have begun in 1861. In this year 22 portraits of the friends and relatives of the Countess of Waldegrave, known as the 'Strawberry Hill Collection', were shown at the French Gallery, bringing wide acclaim to the artist. Sant was appointed portrait painter to the Queen in 1872 and principal portrait painter in 1878. Royal commissions included *The Royal Sisters*, which characteristically emphasise the large eyes and rose-bud lips of the demure princesses. Sant was elected ARA 1861 and RA 1869.

Charles Shannon 1863–1937
Born in Sleaford, Lincolnshire, where his father was rector of the Parish, Shannon studied the art of wood engraving at the City & Guilds Technical School, Lambeth, 1881–5. It was here that Shannon met Charles Ricketts RA, his great friend and collaborator.

Shannon exhibited oils and pastels at the Grosvenor Gallery and the New English Art Club 1885–99, and then made an agreement with Ricketts to withdraw from exhibitions for seven years to concentrate on graphic mediums such as lithography and wood engraving. He supported himself by teaching at Croydon School of Art and making drawings for magazines and books. In collaboration with Ricketts he contributed to Harry Quilter's *Universal Review*, *The Dial*, and also designed and illustrated *Daphnis and Chloe* and *Hero and Leander*, which were the earliest books published by Ricketts and Shannon's Vale Press. *The Fisherman and the Mermaid* (1901–3), the first and most powerful of Shannon's early full-scale oil paintings, was derived from his illustration of Oscar Wilde's story *The Fisherman and his Soul*. To their friend Oscar Wilde, Ricketts and Shannon were known as 'Orchid' and 'Marigold'.

Shannon had his first great painting success in 1897 at the New English Art Club, when he exhibited *The Man in a Black Shirt*, a self-portrait following a 16th-century Titianesque method of titling. The influence of Venetian Old Masters on Shannon's painting style and subject matter is evident in works such as *The Golden Age* (1922).

Between 1904 and 1919 Shannon returned to lithography working in a bolder and coarser style. Shannon was elected ARA 1911 and RA 1920.

Solomon Joseph Solomon 1860–1927
Solomon was born in London into a cultured and well-established Anglo-Jewish family. Solomon entered Heatherley's Art School in 1876 and the RA Schools the following year, aged sixteen years. In 1878 Solomon went to Paris and studied under Cabanel, a painter of female nudes, at the Ecole des Beaux Arts. He studied at the Academy at Munich and then travelled widely in Germany, Holland, Italy, Spain and Morocco. Solomon began exhibiting at the RA in 1881 and, although he was founding member of the New English Art Club in 1886, his painting was grounded in the academic practice of Cabanel and much influenced by the ideals of Leighton (q.v.) and Alma-Tadema (q.v.).

In 1887 Solomon moved to Holland Park, London, where G. F. Watts (q.v.), Prinsep (q.v.) and Leighton also lived. It was here that he painted his epic and theatrical *Samson* (1887), which was praised for the group of over life-size, intertwined male nude bodies in vigorous combat. Other biblical and mythological subjects followed in which Solomon demonstrated his mastery of the idealised nude. He was elected ARA 1896 and RA 1906.

Solomon was also a prolific portrait painter and was innovative in his settings and compositions. In 1910 he published *The Practice of Oil Painting and Drawing*, and during World War I, Solomon became a pioneer of camouflage technique, publishing a treatise on the subject in 1920.

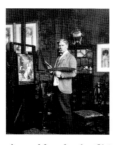

Marcus Stone 1840–1921
Born in London, Stone had no formal training and was taught by his father, the painter Frank Stone. Following the sudden death of his father, Marcus was forced to make his career as an artist lucrative and undertook commissions to illustrate novels including Charles Dickens's *Our Mutual Friend* and *Great Expectations* and Anthony Trollope's *He Knew he was Right* (1869).

Stone began by exhibiting historical subjects from the English Civil War and Napoleonic eras, but it was not until 1876, when Stone started to give greater emotional force to his work, that he gained more recognition. Often taking subjects from the period of the French Revolution as background, Stone's style underwent further change, and domestic idylls, played out in quiet garden arbours, became the formula for his historical genre pieces. These works secured his reputation and remain his best-known works. *In Love* (1888) is an example of Stone's mature style and it was recognised by Stone himself as his best work. A statue of Eros and ripe apples fallen from the trees symbolise the tender sentiment of the soldier in the cocked hat who gazes at the girl sewing opposite.

Stone controlled his output carefully, generally restricting himself to one major picture a year. He was elected ARA 1877 and RA 1887.

Sir Hamo Thornycroft 1850–1925

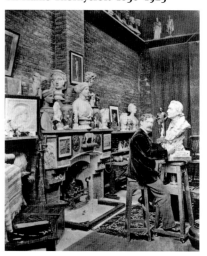

Born in London, Hamo was the son of the sculptors Mary and Thomas Thornycroft. Hamo worked in his father's studio and in 1869, he entered the RA Schools where he met the sculptor, John Henry Foley RA.

In 1871 Thornycroft left for Italy where he was greatly influenced by the work of Michelangelo. On his return he helped his father in the execution of the

Park Lane fountain where the figure of 'Fame' blowing a trumpet was entirely devised and modelled by Hamo. He achieved great success in 1880 with his statue of *Artemis*, which was noted for its portrayal of movement and the intricate modelling of the muslin drapery. Of all major British sculptors Hamo Thornycroft was the least concerned with decoration and most interested in the modelling of the figure for its own sake. His statue of *Teucer* reveals closely observed musculature in the outstretched arm and torso.

In 1884 Thornycroft made an entirely new departure in British sculpture with *The Mower*, a modern-day mower dressed in peasant clothes and hat, resting with a large scythe. Among Thornycroft's public commissions was a statue of General Gordon (1887) for the Victoria Embankment and a stone frieze for the Institute of Chartered Accountants, London (c. 1891). He was elected ARA 1881 and RA 1888.

John William Waterhouse 1849–1917

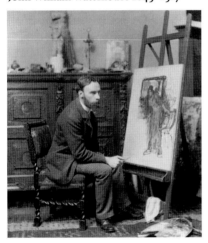

Waterhouse was born in Rome but moved to England five years later and was educated in Yorkshire. His father was also a painter and copyist and Waterhouse worked in his studio, painting in the backgrounds of portraits. He entered the RA Schools in 1871.

Waterhouse's early subjects were much influenced by the Greek and Roman genre scenes of Alma-Tadema (q.v.), although his attention to archaeo-logical detail was not as accurate nor as finely detailed as Alma-Tadema's. In 1877 Waterhouse travelled to Italy and

visited Pompeii, which stimulated his interest in real figures from Roman history. In 1883 he exhibited *Favourites of the Emperor Honorius*, an episode from the life of a Roman emperor who cared more for pigeons than for his Empire. Waterhouse did not consult classical history for his subject but rather illustrated a passage about Honorius from Wilkie Collins's Roman novel, *Antonina*. In the mid-1880s, Waterhouse produced several subjects set in Egypt.

He was elected ARA 1885 and RA 1895 and in the same year began to focus on the mythology of ancient Greece with works such as *Hylas and the Water Nymphs* (1896). This was very well received and showed an emotionally charged and poetic depiction of the mythological subject. Waterhouse later evolved a more intimate mode couched in medievalism, in which he produced many of his best known works, such as *The Lady of Shallott* (1888) and *La Belle Dame sans Merci* (1893).

G. F. Watts RA 1817–1904

Born in London, Watts was a sickly child and did not attend school but taught himself art instead. Watts made frequent trips to draw from the Elgin marbles in the British Museum and later, like Leighton (q.v.), kept casts of them in his studio. Watts entered the RA Schools in 1835 and *The Wounded Heron* (1837) was

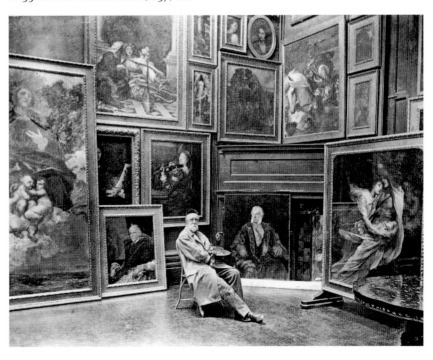

his first RA exhibit.

Watts entered the Westminster Cartoon competitions and won prizes in 1843 and 1847. He also visited Italy in 1843–7 and spent much time in Florence as the guest of Lord and Lady Holland. Watts's ambition was to paint large allegorical pictures and his first exhibited effort at the RA was *Time and Oblivion* (1848). He was elected ARA and RA in 1867. Watts was very interested in the interrelation of painting and sculpture and this was to be a constant theme of his work. He was a practising sculptor after 1870 and his bust, *Clytie*, was well received. He was nicknamed the 'English Michelangelo' and his allegorical works were popularised in a one-man show at the Grosvenor Gallery in 1881–2.

In 1851 Watts became a permanent resident at the home of Prinsep (q.v.) in Holland Park, London. Watts was also a very successful portraitist and was credited with giving fresh inspiration to the art of English portraiture. Among his sitters were Gladstone and Cardinal Manning. Watts is known also by his short-lived marriage to the actress Ellen Terry, when she was just sixteen years old. Watts moved to Compton, Surrey with his second wife, where after his death, the Watts museum was founded.

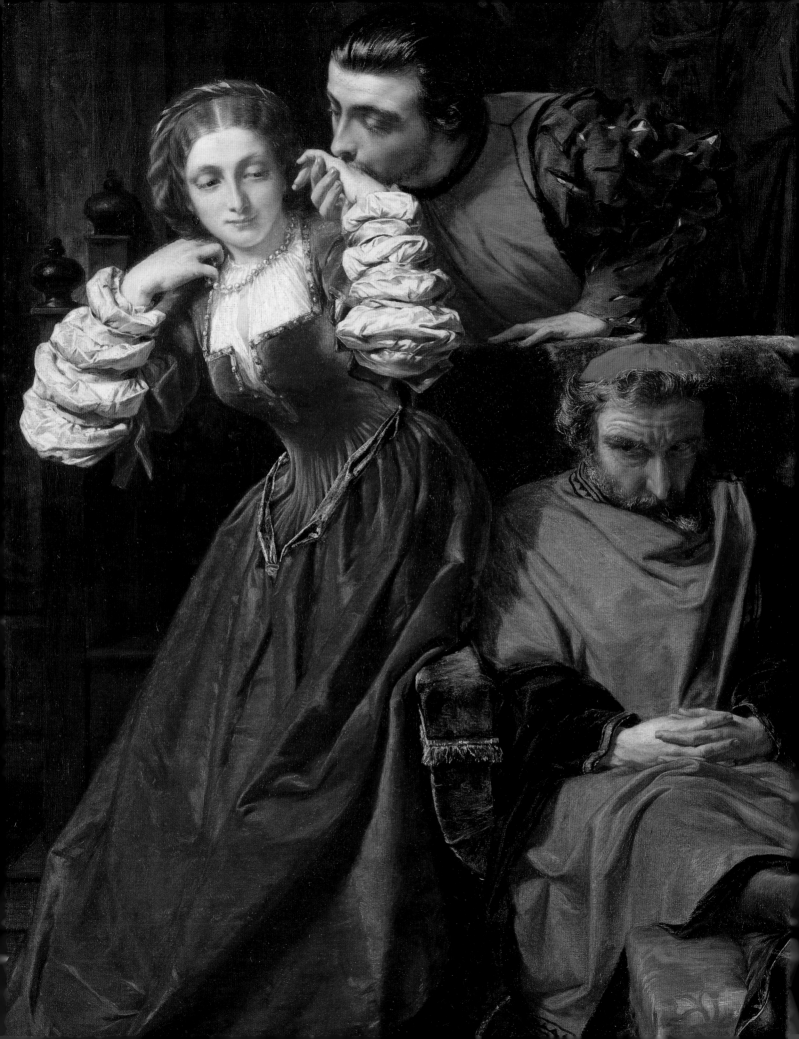

Chronology

1837
Accession of Queen Victoria

Edwin Landseer's *The Old Shepherd's Chief Mourner* (Victoria and Albert Museum) exhibited at the Royal Academy

Royal Academy moved to east wing of the National Gallery building in Trafalgar Square

Sir Martin Archer Shee President of the Royal Academy 1830–50

John Constable dies

1838
Official public opening of the National Gallery in Trafalgar Square

People's Charter with six points for democratic reform

1839
First issue of *The Art-Union*, later known as *The Art Journal* (1849–1912)

Rejection of Charter led to riots

First Opium War between Britain and China

1840
Marriage of Queen Victoria to the German Prince Albert of Saxe-Coburg-Gotha

Rebellion of slaves on the Spanish ship *Amistad*

Penny Post established

1841
Foundation of Art Union of London. Subscribers paid one guinea and received an engraving after a famous painting by an English artist and the chance to win a painting in a lottery

Satirical magazine *Punch or The London Charivari* founded

Henry Fox Talbot invented Calotype process of positive negative photography

1842
J. M. W. Turner's *Peace – Burial at Sea* (Tate Gallery, London) exhibited at the Royal Academy

First Issue of weekly *Illustrated London News*

Rejection of second Chartist Petition led to further riots

Mine owners banned from employing women and children underground

1843
Publication of Thomas Carlyle's *Past and Present* in which he compared modern Britain with the Middle Ages, finding the former lacking in social stability and religious faith

First volume of *Modern Painters* by John Ruskin published (5 vols, 1843–60)

Exhibition at Westminster Hall of cartoons entered for the competition to paint frescoes in the New Palace of Westminster (Houses of Parliament)

1844
J. M. W. Turner's *Rain, Steam, and Speed – the Great Western Railway* (National Gallery, London) exhibited at the Royal Academy

First issue of *The Economist*

1845
Loss of the potato crop in Ireland leads to the Irish Famine, resulting in deaths of more than a million people and extensive emigration

1846
William Dyce's *Madonna and Child* (Royal Collection) exhibited at the Royal Academy

Repeal of the Corn Laws which had regulated grain imports

Mexican War in which Texas becomes a State and the California and New Mexico territories are appropriated

Foundation of the Smithsonian Institution in Washington DC

1847
Robert Vernon's gift of 157 paintings to the National Gallery including works by William Etty, Edwin Landseer and William Mulready

First Meeting of the Printsellers Association, founded to register and control the distribution of fine prints

New British Museum building opened in Great Russell Street, its address today. The great circular reading room was completed in 1857.

1848
Year of revolutionary uprisings throughout Europe

Publication of the *Communist Manifesto* by Karl Marx and Friedrich Engels (English translation 1850)

Free exhibition near Hyde Park Corner, London of F. M. Brown's *The First Translation of the Bible into English: Wycliffe Reading His Translation of the Bible to John of Gaunt* (Bradford City Art Gallery)

Foundation of the Pre-Raphaelite Brotherhood by William Holman Hunt, John Everett Millais and Dante Gabriel Rossetti while students at the Royal Academy Schools

1849
John Ruskin's *The Seven Lamps of Architecture* published

John Everett Millais's *Isabella* (Walker Art Gallery, Liverpool) exhibited at the Royal Academy

Free exhibition of Rossetti's *The Girlhood of Mary Virgin* (Tate Gallery, London)

1850
Charles Lock Eastlake elected PRA (1850–65)

Tensions between high and low church Anglicans revealed by Gorham Judgment. High churchmen or Tractarians held that views of the Revd Gorham, a vicar, were heretical. A judicial committee of the Privy Council found in Gorham's favour. Several churchmen seceded to the Church of Rome

J. E. Millais's *Christ in the Carpenter's Shop* (Tate Gallery, London) exhibited at the Royal Academy

Alfred Tennyson named poet laureate

1851
The Great Exhibition of the Works of Industry of All Nations opened by Queen Victoria

John Ruskin's *The Stones of Venice* published (1851–3)

Edwin Landseer's *The Monarch of the Glen* (John Dewar and Sons) exhibited at the Royal Academy

Death of J. M. W. Turner

previous page: Alfred Elmore RA
Two Gentlemen of Verona (detail, cat. 17)

1852
William Holman Hunt's *The Hireling Shepherd* (Manchester City Art Galleries) and J. E. Millais's *Ophelia* (Tate Gallery, London) exhibited at the Royal Academy

1853
William Dyce's *Jacob and Rachel* (Kunsthalle, Hamburg) exhibited at the Royal Academy

1854
Declaration of war against Russia, leading to the Crimean Campaign which ended inconclusively 1856
Florence Nightingale took nurses to Scutari and began her campaign to reform army hospitals and medical practices
W. P. Frith's *Life at the Sea-Side (Ramsgate Sands)* (Royal Collection) and William Holman Hunt's *The Awakening Conscience* (Tate Gallery, London) exhibited at the Royal Academy

1855
Lord Leighton's *Cimabue's Celebrated Madonna is Carried in Procession through the Streets of Florence* (Royal Collection) exhibited at the Royal Academy
Opening of the Exposition Universelle in Paris

1856
Over 100 paintings and 19,000 drawings by J. M. W. Turner were given to the National Gallery as part of the Turner Bequest
Arthur Hughes's *April Love* (Tate Gallery, London) and Holman Hunt's *The Scapegoat* (Lady Lever Art Gallery, Port Sunlight) exhibited at the Royal Academy
G. F. Watts began work on his 'Hall of Fame', a series of portraits of eminent Victorians

1857
Manchester Art Treasures Exhibition opened by Prince Albert seen by over one million visitors and included over 16,000 objects, all from British collections
John Brett's *The Glacier of Rosenlaui* (Tate Gallery, London) exhibited at the Royal Academy
Outbreak of Indian Mutiny which marked the end of the East India Company and the establishment of crown rule in India
Opening of South Kensington Museum which contained objects purchased from the Great Exhibition and paintings from the John Sheepshanks collection of modern British pictures
Rossetti began work on murals based on the Arthurian legends for the new Union Debating Hall in Oxford and was joined by William Morris, Edward Burne-Jones, Val Prinsep and others
Opening of exhibition featuring the Pre-Raphaelites at the National Academy of Design, New York

1858
W. P. Frith's *Derby Day* and Augustus Egg's *Past and Present* (both Tate Gallery, London) exhibited at the Royal Academy

1859
Letter signed by 39 women artists sent to the Royal Academicians urging the admission of female students to the Royal Academy Schools
Charles Darwin published *On the Origin of Species by Means of Natural Selection* which among other ideas proposed that man was descended from primates

1860
Laura Herford admitted as the first female student in the Royal Academy Schools
William Dyce's *Pegwell Bay* (Tate Gallery, London) exhibited at the Royal Academy
Thomas Agnew and Sons, Manchester and Liverpool-based dealers specialising in contemporary British art, opened a London gallery

Garibaldi's Expedition of the Thousand to unify Italy
Abraham Lincoln elected American president

1861
Death of Prince Albert from typhoid
William Morris and his associates founded the design firm of Morris, Marshall, Faulkner & Co. (after 1874 Morris & Co.)
American Civil War begins (1861–5)

1862
Beginning of Lancashire Cotton Famine as a result of the Union blockade of the South during the American Civil War; many textile mills closed in the north of England
Opening of the International Exhibition, South Kensington
Whistler's *Symphony in White, No. 1: The White Girl* (National Gallery of Art, Washington) rejected by the Royal Academy; subsequently exhibited at the Salon des Refusés, Paris, 1863

1863
Royal Commission on the Royal Academy
Emancipation Proclamation in which slaves in the Confederate States are set free

1864
Edwin Landseer's *Man Proposes, God Disposes* (Royal Holloway College, University of London) and J. F. Lewis's *The Hosh of the House of the Coptic Patriarch, Cairo* (private collection) exhibited at the Royal Academy

1865
Exhibition of Ford Madox Brown's paintings including *Work* (Manchester City Art Galleries) at 191 Piccadilly, London
Whistler's *Symphony in White, No. 2: The Little White Girl* (Tate Gallery, London) exhibited at the Royal Academy
Publication of Lewis Carroll's *Alice's Adventures in Wonderland*

1866
Francis Grant elected PRA (1866–78)
Algernon Charles Swinburne published his first series of *Poems and Ballads* which were later withdrawn

1867
Matthew Arnold's *Culture and Anarchy* published as a series of articles in *The Cornhill Magazine*
Passage of the Second Reform Act by Parliament
Dominion of Canada established

1868
Royal Academy moved to Burlington House
Benjamin Disraeli became prime minister but defeated soon after, in the general election, by William Gladstone

1869
The Graphic founded; featured engravings by Luke Fildes, Hubert von Herkomer, etc.
First Royal Academy exhibition at Burlington House
Suez Canal and transcontinental US rail link completed

1870
The art periodical *The Portfolio* founded (1870–93)
Metropolitan Museum of Art, New York and Museum of Fine Art, Boston given charters
Franco-Prussian War declared
Unification of Italy
Elementary Education Act provided for local 'board schools', though elementary education was not yet compulsory

1871
Slade School of Art founded
Bismarck achieved unification of Germany

1872
Whistler's *Arrangement in Grey and Black: Portrait of the Painter's Mother* (Musée d'Orsay, Paris) exhibited at Royal Academy

1873

Walter Pater's *Studies in the History of the Renaissance* published, which included the influential phrase 'art for art's sake'

Death of Edwin Landseer

1874

Election of Benjamin Disraeli as prime minister for second time

Luke Fildes's *Applicants for Admission to a Casual Ward* (Royal Holloway College, University of London) exhibited at the Royal Academy

Factory Act reduced working week to 56.5 hours

1875

Herkomer's *The Last Muster: Sunday at the Royal Hospital, Chelsea* (Lady Lever Art Gallery, Port Sunlight) exhibited at the Royal Academy

1876

Founding of the Fine Art Society which promoted contemporary one-artist exhibitions

Queen Victoria declared Empress of India

Alexander Graham Bell invented the telephone

1877

First exhibition of the newly founded Grosvenor Gallery which represented artists associated with the aesthetic movement such as Edward Burne-Jones and Whistler

Opening of the Walker Art Gallery, Liverpool

Queen Victoria proclaimed Empress of India at a ceremony in Delhi

End of American Reconstruction

1878

Lord Leighton elected PRA (1878–96)

The art periodical *The Magazine of Art* founded (1878–1904)

Whistler–Ruskin trial: Ruskin, reviewing an exhibition of Whistler's work, accused him of 'flinging a pot of paint in the public's face'. Whistler sued for libel and won but was nevertheless bankrupted by the cost of the trial.

1879

Edward Burne-Jones's *Pygmalion* series (Birmingham Museums and Art Gallery) exhibited at the Grosvenor Gallery

Zulu War in South Africa

Thomas Edison perfected electric light

1880

Election of William Gladstone as prime minister for second time

Outbreak of First Boer War

1881

Opening of Gilbert and Sullivan's opera *Patience* which satirised the Aesthetic Movement

Major retrospective exhibition of the work of G. F. Watts at the Grosvenor Gallery (1881–2)

1882

Opening of Manchester City Art Gallery

Oscar Wilde gave lecture on 'The English Renaissance of Art' at the Chickering Hall, New York City

Death of Dante Gabriel Rossetti

Phoenix Park murders

1883

Royal Academy's memorial exhibition of Rossetti

1884

William Quiller Orchardson's *Marriage de Convenance* (Glasgow Museums: Art Gallery and Museum, Kelvingrove) exhibited at the Royal Academy

Third Reform Act

1885

Opening of Birmingham Art Gallery

Whistler delivered his 'Ten O'Clock Lecture' at Princes Hall, London

1886

Retrospective of J. E. Millais's work at the Grosvenor Gallery

New English Art Club founded to exhibit artists influenced by the French School of *plein-air* painters, notably Jules Bastien-Lepage

Royal Holloway College opened by Queen Victoria with gallery displaying modern British paintings

The Statue of Liberty erected in the USA

1887

Fiftieth anniversary of Victoria's reign, the Golden Jubilee

Invention of celluloid film

1888

The New Gallery founded in Regent Street by former directors of the Grosvenor Gallery; exhibited *The Doom Fulfilled* by Burne-Jones (Staatsgalerie, Stuttgart)

1889

Goupil Gallery showed London Impressionist Exhibition including the work of Philip Wilson Steer and Walter Sickert

Eiffel completed his tower in Paris

First American skyscraper completed, in Chicago

1890

Oscar Wilde's *The Picture of Dorian Gray* published

Death of Vincent van Gogh

1891

Lord Leighton's *Perseus and Andromeda* (Walker Art Gallery, Liverpool) and Luke Fildes's *The Doctor* (Tate Gallery, London) exhibited at the Royal Academy

1893

The art periodical *The Studio* founded

Lumière brothers invented the cinematograph

1895

Oscar Wilde wrote *The Importance of Being Earnest*

1896

Death of Lord Leighton; J. E. Millais elected PRA but also died in 1896

Sir Edward Poynter elected PRA (1896–1918)

National Portrait Gallery opened in premises next to the National Gallery

Establishment of the Nobel prizes

1897

Majority of British collections in the National Gallery moved to newly opened Tate Gallery which included Sir Henry Tate's collection of Victorian paintings and works purchased through the Chantrey Bequest

Sixtieth anniversary of Victoria's reign, the Diamond Jubilee

1898

Death of Edward Burne-Jones

Spanish–American War in which Cuba and the Phillipines taken from Spain

1899

Foundation stone laid by Queen Victoria for the new premises for the South Kensington Museum which was renamed the Victoria and Albert Museum

Outbreak of Second Boer War

1900

Death of John Ruskin

Publication of Freud's *The Interpretation of Dreams*

1901

Establishment of Commonwealth of Australia

Death of Queen Victoria

Bibliography

PRIMARY SOURCES

Royal Academy Council Minutes, Royal Academy of Arts Archives, London

Royal Academy General Assembly Minutes, Royal Academy of Arts Archives, London

Royal Academy Annual Reports, 1860–. Royal Academy of Arts Archives, London

SECONDARY SOURCES

Allan, William. 'Sir William Allan', Connoisseur, June 1974, pp. 88–93

Armstrong, Walter. 'Briton Riviere, R.A., His Life and Work', Art Annual, London, 1891

Baldry, A. L. 'George Henry Boughton, R.A.', Christmas Art Annual, London, 1904

Baldry, A. L. 'Robert Walker Macbeth, A.R.A.', Art Journal, 1900, pp. 289–92

Barringer, Tim. The Cole Family: Painters of the English Landscape 1838–1975, exhibition catalogue, Portsmouth City Museums, 1988

Beattie, Susan. The New Sculpture. London and New Haven, CT, 1983

Becker, Edwin and Prettejohn, Elizabeth. Sir Lawrence Alma-Tadema, exhibition catalogue, Van Gogh Museum, Amsterdam and Walker Art Gallery, Liverpool, 1997

Bell, Quentin. The Schools of Design. London, 1963

Bendiner, Kenneth. An Introduction to Victorian Painting. New Haven, CT and London, 1985

Bills, Mark. Edwin Longsden Long R.A. London, 1998

Blunt, Wilfrid. 'England's Michelangelo': A Biography of George Frederic Watts, O.M., R.A. London, 1975

Borzello, Frances. The Artist's Model. London, 1982

Bowness, Alan (ed.) The Pre-Raphaelites, exhibition catalogue, Tate Gallery, London, 1984

Brodie, Alexander (ed.) The Reminiscences of Solomon Alexander Hart, R.A. London, 1882

Brook-Hart, Denys. British 19th-Century Marine Painting. London, 1974

Casteras, Susan and Parkinson, Ronald. Richard Redgrave 1804–1888, exhibition catalogue, Victoria and Albert Museum, London, 1988

Casteras, Susan. The Substance and the Shadow, exhibition catalogue, Yale Center for British Art, New Haven, CT, 1982

Caw, J. L. Scottish Painting Past and Present (1620–1908). Edinburgh, 1908

Christian, John (ed.) The Last Romantics: The Romantic Tradition in British Art, Burne-Jones to Stanley Spencer, Barbican Art Gallery, London, 1989

The Cranbrook Colony, exhibition catalogue, Wolverhampton Art Gallery, 1977

Dafforne, James. 'British Artists Their Style and Character, No. XXIII: Alfred Elmore R.A.', Art Journal, 1857, pp. 113–15

Dafforne, James. 'British Artists Their Style and Character, No. IV: Frederick Goodall A.R.A.', Art Journal, 1855, pp. 109–12

Dafforne, James. 'British Artists Their Style and Character, No. VII : Frederick R. Pickersgill, A.R.A.', Art Journal, 1855, pp. 233–6

Dibdin, E. R. 'The Art of Frank Dicksee, R.A.', Art Annual, London, 1905

Dorment, Richard. Alfred Gilbert: Sculptor and Goldsmith, exhibition catalogue, Royal Academy of Arts, London, 1986

Eastlake, Sir Charles Lock. Materials for a History of Oil Painting. 2 vols. London, 1847–69

Eaton, F. A. 'The Royal Academy Schools', The Nineteenth Century, February 1904, pp. 1–9

Fenn, W. W. 'Our Living Artists: Philip Hermogenes Calderon, R.A.', Magazine of Art, 1878, pp. 197–202

Fenn, W. W. 'James Clarke Hook, R.A.' in Some Modern Artists and their Work (edited by Wilfrid Meynell), London, 1883, pp. 160–5

Field, George. Chromatography; or a treatise on colours and pigments. London, 1835

Forbes, Christopher. The Royal Academy Revisited (1837–1901): Victorian Paintings from the Forbes Magazine Collection (edited by Allen Staley). [New York, 1975]

For King Or Parliament?, exhibition catalogue, Wolverhampton Art Gallery and Sheffield Art Gallery, 1978–9

Frederic, Lord Leighton 1830–1896, exhibition catalogue, Royal Academy of Arts, London, 1996

Frith, W. P. My Autobiography and Reminiscences. 2nd edition. 3 vols. London, 1887–8

Gillett, Paula. The Victorian Painter's World. Gloucester, 1990

Gosse, Edmund. 'The New Sculpture (1879–1894)', Art Journal, 1894, pp. 138–42, 199–203, 277–82, 306–11

Grant, Col. M. H. A Dictionary of British Sculptors from the XIIIth Century to the XXth Century. London, 1953

Graves, Algernon. The Royal Academy of Arts: A Complete Dictionary of Contributors and their Work from its Foundation in 1769 to 1904. 8 vols. London, 1905–6

Greg, Andrew. Charles Napier Hemy, R.A. 1841–1917, exhibition catalogue, Laing Art Gallery, Newcastle-upon-Tyne, and City Art Gallery, Plymouth, 1984

Guiterman, Helen and Llewellyn, Briony. David Roberts, exhibition catalogue, Barbican Art Gallery, London, 1986

Hardie, Martin. John Pettie, R.A., H.R.S.A. London, 1908

Hardy, William. Sir William Quiller Orchardson, R.A., exhibition catalogue, Scottish Arts Council, Edinburgh, 1972

Harrington, Peter. British Artists and War: The Face of Battle in Paintings and Prints (1700–1914). London, 1993

Haworth-Booth, Mark (ed.) The Golden Age of British Photography 1839–1900, exhibition catalogue, Victoria and Albert Museum, London, Alfred Stieglitz Center and Phiadelphia Museum of Art, 1984

Hemingway, Andrew and Vaughan, William (ed.) *Art in Bourgeois Society 1790–1850*. Cambridge, 1998

Hilton, Tim. *The Pre-Raphaelites*. London, 1989

Hobson, Anthony. *J.W. Waterhouse*. Oxford, 1989

Horsley, J. C. *Art Schools and Art Practice in their Relation to a Moral and Religious Life* (reprinted from official report of the Church Congress). Derby and London, [1885]

Hutchison, S. C. *The History of the Royal Academy of Arts 1768–1986*. London, 1986

Irwin, David and Francina. *Scottish Painters at Home and Abroad 1700–1900*. London, 1975

Jewish Artists of Great Britain (1845–1945), exhibition catalogue, Belgrave Gallery Ltd., London, 1978

Joseph Farquharson of Finzean, exhibition catalogue, Aberdeen Art Gallery and Museums, 1985

Leslie, G. D. *The Inner Life of the Royal Academy*. London, 1914

Lewis, J. M. H. *John Frederick Lewis*. Leigh-on-Sea, 1978

Liversidge, Michael and Edwards, Catharine (ed.) *Imagining Rome: British Artists and Rome in the Nineteenth Century*, exhibition catalogue, Bristol City Museum and Art Gallery, 1996

Lucas, E. V. *Edwin Austin Abbey, Royal Academician: The Record of His Life and Work*. 2 vols. London and New York, 1921

Lusk, Lewis. 'B.W. Leader, R.A.', *Art Annual*, London, 1901

Maas, Jeremy. *Victorian Painting*. London, 1969

Maas, Jeremy. *The Victorian Art World in Photography*. London, 1984

Macdonald, Stuart. *The History and Philosophy of Art Education*. London, 1970

Mackenzie, Tessa (ed.) *The Art Schools of London: A Description of the Principal Fine Art Schools in the London District*. London, 1896

McConkey, Kenneth. *Sir George Clausen, R.A., 1852–1944*, exhibition catalogue, Bradford Art Galleries and Tyne and Wear County Council Museums, 1980

McKerrow, Mary. *The Faeds: A Biography*. Edinburgh, 1982

Marks, H. S. *Pen and Pencil Sketches*. 2 vols. London, 1894

Merrifield, Mary P. *Original Treatises dating from the XIIth to the XVIIIth Centuries, on the Art of Painting*, London, 1849

Meynell, Wilfrid (ed.) *The Modern School of Art*. 4 vols. London, [1885–7?]

Morgan, H. C. 'The Lost Opportunity of the Royal Academy: An Assessment of its Position in the Nineteenth Century', *Journal of the Warburg and Courtauld Institutes*, vol. XXXII, 1969, pp. 410–20

Morgan, H. C. 'The Schools of the Royal Academy', *British Journal of Educational Studies*, vol. XXI, no. 1, February 1973, pp. 88–103

Morris, Edward and Frank Milner. *And When Did You Last See Your Father?*, exhibition catalogue, Walker Art Gallery, Liverpool, 1993

Noakes, Aubrey. *William Frith, Extraordinary Victorian Painter: A Biographical and Critical Essay*. London, 1978

Nunn, P. G. *Victorian Women Artists*. London, 1987

Ormond, Richard. *Sir Edwin Landseer*, exhibition catalogue, Philadelphia Museum of Art and Tate Gallery, London, 1981

Ormond, Richard. *Daniel Maclise 1806–1870*, exhibition catalogue, National Portrait Gallery, London, and National Gallery of Ireland, Dublin, 1972

Payne, Christina. *Toil and Plenty: Images of the Agricultural Landscape in England 1780–1890*. New Haven, CT and London, 1993

Pointon, Marcia. *William Dyce 1806–1864*. Oxford, 1979

Read, Benedict. *Victorian Sculpture*. New Haven, CT and London, 1982

Redgrave, Richard and Samuel. *A Century of British Painters*. New edition. London, 1947

Report from the Select Committee on Arts and their Connection with Manufactures; with the Minutes of Evidence. London, 1836

Report of The Commissioners Appointed to Inquire into the Present Position of the Royal Academy in relation to the Fine Arts; together with the Minutes of Evidence. London, 1863

Reynolds, Simon. *William Blake Richmond: An Artist's Life 1842–1921*. Norwich, 1995

Reverie, Myth, Sensuality: Sculpture in Britain 1880–1910, exhibition catalogue, Stoke-on-Trent City Museum and Art Gallery, and Cartwright Hall, Bradford, 1992

Roberts, Jane. *Royal Artists from Mary Queen of Scots to the Present Day*. London, 1987

Robertson, David. *Sir Charles Eastlake and the Victorian Art World*. Princeton, NJ, 1978

Smith, Alison. *The Victorian Nude: Sexuality, Morality and Art*. Manchester and New York, 1996

Solomon J. Solomon, R.A., exhibition catalogue, Ben Uri Gallery, London, 1990

Spielmann, M. H. 'Edwin Austin Abbey R.A.', *Magazine of Art*, 1899, pp. 145–50, 193–8, 247–53

Spielmann, M. H. 'Glimpses of Artist-Life: The Royal Academy Schools', *Magazine of Art*, 1888, pp. 55–62

Staley, Allen (et al.) *Victorian High Renaissance*, exhibition catalogue, Manchester City Art Gallery, Minneapolis Institute of Arts and Brooklyn Museum, 1978

Stevens, MaryAnne (ed.) *The Edwardians and After: The Royal Academy 1900–1950*, exhibition catalogue, Royal Academy of Arts, London, 1988

Stevens, MaryAnne (ed.) *The Orientalists: Delacroix to Matisse: European Painters in North Africa and the Near East*, exhibition catalogue, Royal Academy of Arts, London, 1984

Sweetman, John. *The Oriental Obsession – Islamic Inspiration in British and American Art and Architecture (1500–1920)*. Cambridge, 1991

Temple, A. G. *The Art of Painting in the Queen's Reign*. London, 1897

Treble, Rosemary. *Great Victorian Pictures: Their Paths to Fame*, exhibition catalogue, Arts Council of Great Britain, 1978

Trodd, Colin. `The Authority of Art: Cultural Criticism and the Idea of the Royal Academy in mid-Victorian Britain', *Art History*, vol. XX, no. 1 (March 1997), pp. 3–22

Victorian Olympians, exhibition catalogue, Art Gallery of New South Wales, Sydney, 1975

Warner, Malcolm. *The Victorians. British Painting 1837–1901*, exhibition catalogue, National Gallery of Art, Washington, 1997

Waterfield, Giles. *Rich Summer of Art: A Regency Picture Collection Seen through Victorian Eyes*, exhibition catalogue, Dulwich Picture Gallery, London, 1988

Weaver, Mike (ed.) *British Photography in the Nineteenth Century: The Fine Art Tradition*. Cambridge, 1989

Wood, Christopher. *Dictionary of Victorian Painters*. 3rd edition. Antique Collector's Club, 1995

Wood, Ruth. *Benjamin Williams Leader, R.A. 1831–1923: His Life and Paintings*. Suffolk, 1988

Yeldham, Charlotte. *Women Artists in Nineteenth-Century France and England*. New York and London, 1984

Artists Represented

Photographic Credits

All works of art are reproduced by kind permission of the owners. Specific acknowledgements are as follows:

Aberdeen, City of Aberdeen Art Gallery and Museums Collection, p. 21, fig. 10

London, The Bridgeman Art Library, p. 20, fig. 9; p. 39, fig. 8

London, Helen Glanville, p. 51, fig. 7

London, The Illustrated London News Picture Library, p. 38, fig. 7

London, © National Gallery, p. 27, fig. 1

London, Nicholas Eastaugh, p. 50, fig. 4

London, Punch Library and Archive, p. 44, fig. 4

London, © Royal Academy of Arts, frontispiece, p. 35, fig. 5; p. 37, fig. 6; p. 42, fig. 1, 2, 3; p. 45, fig. 5; p. 47, fig. 6, 7; p. 51, fig. 8; photo: cat. 9, 27, 32, 52, 61, 63, 70, John Hammond, cat. 3, 10, 12–16, 18–23, 25, 26, 29–36, 43–47, 49, 50, 53–55, 57–59, 62, 65–69, 71–75, Marcus Leith, cat. 11, Paul Highnam, cat. 2, 4–8, 37–42, Prudence Cuming, cat. 1, 17, 24, 28, 48, 56, 60, 64, 76

London, UCL Painting Analysis Ltd., photo: Libby Sheldon and Catherine Hassall, p. 52, fig. 2; p. 53, fig. 3, 5, 6

London, Victoria and Albert Picture Library, p. 13, fig. 1; p. 32, fig. 2

London, © Tate Gallery 1998, p. 14, fig. 2; p. 23, fig. 13; p. 34, fig. 3

Manchester City Art Galleries, p. 18, fig. 6, 7

Merseyside, The Board of Trustees of the National Museums and Galleries on Merseyside, p. 16, fig. 4; p. 17, fig. 5; p. 22, fig. 12; p. 25, fig. 15

Merseyside, Unilever PLC, cat. 56

Newcastle upon Tyne, Laing Art Gallery, p. 21, fig. 11; p. 25, fig. 14

Sheffield Galleries and Museum Trust, p. 14, fig. 3

Surrey, Royal Holloway College, University of London, Egham, p. 19, fig. 8

Windsor, The Royal Collection © 1999 Her Majesty Queen Elizabeth II, p. 34, fig. 4

Biographies: Photographs

Cambridge, © Fitzwilliam Museum: Charles Shannon

Leicestershire, © Leicester City Museums: Mary Grant

London, © National Portrait Gallery: Sir William Allan, Frank Cadogan Cowper, Sir John Watson Gordon, John Seymour Lucas

U.K., courtesy of Mary Powell: Charles Napier Hemy

All other photographs from the Photographic Archive, Royal Academy of Arts, London

Abbreviations used in Biographies

ARA	Associate of the Royal Academy
BI	British Institution
OWS	Old Watercolour Society
NWS	New Watercolour Society
PRSA	President of the Royal Scottish Academy
RA	Royal Academician or Royal Academy of Arts
RCA	Royal College of Art, London
RI	Member of the Royal Institute of Painters in Watercolour
RIBA	Royal Institute of British Architects
RSA	Royal Scottish Academy or Member of the Royal Scottish Academy